TEXAS PISTOLEERS

TEXAS PISTOLEERS

the True Story of Ben Thompson AND KING FISHER

G.R. WILLIAMSON

THE
History
PRESS

Published by The History Press
Charleston, SC 29403
www.historypress.net

First published 2010
Second printing 2011

Manufactured in the United States

ISBN 978.1.60949.000.3

Williamson, Ron, 1943-
The Texas pistoleers : the true story of Ben Thompson and King Fisher / G.R. Williamson.
p. cm.
Includes bibliographical references and index.
ISBN 978-1-60949-000-3
1. Thompson, Texas Ben, 1842-1884. 2. Fisher, King, 1854-1884. 3. Outlaws--Texas-
-Biography. 4. Frontier and pioneer life--Texas. 5. Frontier and pioneer life--West (U.S.)
6. Texas--Biography. 7. Thompson, Texas Ben, 1842-1884--Legends. 8. Fisher, King,
1854-1884--Legends. 9. Thompson, Texas Ben, 1842-1884--Death and burial. 10. Fisher,
King, 1854-1884--Death and burial. I. Title.
F391.T5125W49 2010
364.1092--dc22
[B]
2010025318

Dedicated to:

J.A.,
Kat and Cody
and
the Sonora Sisters

Contents

Contents

Preface

If you look up the word *pistoleer* in a dictionary, you will probably find a very tepid definition, usually something along the lines of "one who uses a pistol." In a few older dictionaries, you may find the word defined as "one skilled in the use of a pistol." None of these definitions comes even remotely close to the meaning held by most of the people of the mid-1880s. The term was reserved for someone who was not only highly skilled in the use of a pistol but also more than willing to use it in a lethal way. Later, the word *pistolero* was used along the Rio Grande River in reference to a gunfighter or "hired gun"—someone willing to kill for money. The practice of hiring Mexican *pistoleros* or paid assassins to eliminate political enemies in Texas extended into the twentieth century.

Another word used to describe dangerous gunfighters of the Old West was *desperate*. The word was often used as an adjective but in some cases as a noun, as in "the desperate shot it out with the law." Today, the word has a totally different meaning—that of abject hopelessness or being in dire straights. In the 1880s, the word meant reckless, without regard for danger. Later, the word *desperado* evolved, which meant a desperate or violent criminal.

Regardless of which term was used, Ben Thompson and John King Fisher were the most feared pistoleers, desperates or desperadoes of their time. Both men were highly skilled in shooting pistols, and as a result they dispatched a number of men to early graves with a bullet from one of their revolvers. The exact number of men each killed during his lifetime is hard to pin down—possibly as few as a half dozen, but some accounts put the figure

at more than two dozen men. Allowing for the preponderance of "bar room tales," which greatly exaggerated body counts, the number of causalities was no more than six or seven men for each of the two shooters. Regardless of the number of dead men, Thompson and Fisher maintained a reputation that made people pause when they heard their name.

Because newspapers of the day often got the facts wrong or quoted unreliable sources—some even skewing stories to suit editorial opinions—the truth of their exploits with pistols remains clouded. Perhaps the best description of the blurring of facts was offered by Hugh Nugent Fitzgerald in a newspaper article he wrote forty-two years after the deaths of the gunfighters in San Antonio. Writing about Ben Thompson in the March 14, 1926 issue of the *Austin American*, Fitzgerald presented a long preamble that included this observation:

> *Truth is stranger than fiction. Tradition for the most part is a musty old liar. A thousand writers have written stories of the noted Ben Thompson…A thousand newspapers have published these stories. No two stories were alike. They were not based on facts. They were more than 75 percent imagination with a garnishment of tradition.*

Acknowledgements

In writing a nonfiction book, I found that I had much in common with a one-armed wallpaper hanger—we both needed a lot of help from others to get the job done.

First, I would like to thank those who have split from the herd and now ride for the boss man in the sky. J. Frank Dobie and Walter Prescott Webb provided the interest and inspiration to dig into the fascinating world of researching Texas history—warts and all. I also owe a large platter of gratitude to my grandfather, Jim Williamson, who called me "high pockets" as a tall, gawky kid. He instilled the gift of curiosity and the pleasure that comes from storytelling. Then there was Salvador Galvan, who lived around the corner from my home in Crystal City. He was a master storyteller, relating tales of the early days of our area in the Nueces Strip while he artfully rolled and smoked Bull Durham cigarettes.

As I evolved from simple curiosity to an intense desire to do serious research on the Texas gunfighters, I had the pleasure of meeting a large number of very helpful people along the way. Of particular note was John Anderson, the preservation officer at the Texas State Library & Archives Commission; Eric Travis, librarian at the Austin History Center in the Austin Public Library; and Jason dePreaux, from the Center for American History at the University of Texas in Austin, as well as a long list of other helpful librarians whose names I failed to record.

I want to thank Kurt House and Chuck Parsons for their help in steering me in the right direction and assisting me in gaining access to photographs

used in the book. Bob McCubbin was most helpful in allowing me to use some of the extraordinarily rare photographs from his wonderful collection in Santa Fe.

Frank Harris, an old high school pal, deserves a hearty thank-you for cutting a path through waist-high grass and prickly pear that allowed me to photograph the gravestone of King Fisher's daughter, who died a few months after being born. The grave is located in a small, private cemetery on his ranch.

I got access to a great deal of information on King Fisher from descendants of his wife's family, the Vivians. In particular, Larry Vivian provided photographs and family stories, while Jeanne Solansky provided access to the journals written by Fisher's daughter, Florence Fenley. In addition, I would like to thank Anne Beck, the great-granddaughter of Ben Thompson, for her consultation.

Another person who deserves my heartfelt appreciation is John Walker Williamson. He helped me knock the "rocks, sticks and rattlesnakes" out of the final drafts of the manuscript. His knowledgeable "eagle eye" for detail worked wonders on his uncle's storytelling efforts.

And finally, there is Lady J, who stood by me through the whole journey and kept me inspired. Sometimes, when you choose a woman to share your life, you just get lucky. I sure did.

Introduction

As a kid growing up in the rough mesquite and cactus brasada of south Texas, I was intrigued with the tales of border bandits and outlaw exploits, as well as the lawmen who brought them to justice. John King Fisher's headquarters on the Pendencia Creek was located about twenty miles from my home. As a Boy Scout, I camped in the brush country that Fisher had claimed in the infamous Nueces Strip. Many of the old-timers could still spin tales about the bandit chieftain. It was exciting to hear about this flamboyant Texan who was both loved and feared by the people of his time.

In the mid-1960s, King Fisher's casket was moved from its prominent place in the city square of Uvalde to a pioneer cemetery. The *Uvalde Leader News* carried a feature article on the occasion, describing the iron casket with a glass porthole over Fisher's head. Those doing the excavation said that the corpse was in very good condition, "considering he had been buried in 1884." The sharp lines of his once handsome face were still evident, as was the dark hair that swept across the forehead. Peering through the portal, it was also possible to see the bullet holes that accounted for his early death in San Antonio.

For a brief moment, John King Fisher lived again in the hearts and minds of south Texans. The flashy outlaw who reformed and became a well-respected deputy sheriff was the stuff of myths and legends. A true Texas pistoleer who could shoot with either hand or both at the same time, Fisher took on and lived a Robin Hood persona that few "bad men" of the West could match.

Fascinated, I read everything I could find on Fisher, eventually becoming equally intrigued with his partner in death, Ben Thompson. A seasoned pistol fighter, Thompson was several years older than Fisher but carried the same outlaw mystique. During his lifetime, Thompson was a Confederate cavalry officer and later a spy behind Federal lines, he fought as a mercenary for Emperor Maximilian in Mexico, he was a fearless Indian fighter and he was a prominent gambler in every cattle town of the West.

In researching the two men, I found it impossible to determine the number of men they killed in confrontations, but it seems clear that both men appeared to have adhered to the frontier code of protecting themselves in a gunfight. In their version of each shooting, it was merely a case of self-defense, which was not considered an illegal action. These were dangerous men living in dangerous times, when disputes were often settled with gunfire. Were these two men coldblooded killers? I doubt it. Were they men who broke the law and deserved to be brought to justice? Definitely.

This book is written with respect for the men, as well as for the mythology of the times. I have tried to collect as much information as possible, from many different sources, and then tell the story as true to the recorded accounts as I could. Historians differ on a number of details with regard to their lives. Cutting down the middle, I have tried to present a factual account of the two pistol fighters' lives and the events that led up to their demise in 1884. The dialogue in the quotations is exactly as it appeared in the listed sources.

There are very few books dedicated exclusively to either of the two historical figures. William M. Walton wrote what he termed was the true story of Ben Thompson's life, as the gunman told it to him. The book, *Life and Adventures of Ben Thompson*, was published in 1884. Walton was Thompson's lawyer and defended the gunman in his 1882 murder trial.

Floyd B. Streeter wrote a thoroughly researched book on Ben Thompson in 1957 entitled *Ben Thompson: Man With a Gun*. His book relied heavily on Walton's book but provided a great deal of new information, as well as criticism of some of the details related in Walton's 1884 publication.

Then in 1966, O.C. Fisher, a direct relative of King Fisher's family, wrote a book entitled *King Fisher: His Life & Times*. The book was based on personal research and family stories.

In addition, many articles were written on the two men that described various events in their lives. Most of the events related in the articles had at least two different versions of the story and sometimes several more—so

it becomes very difficult to come to any firm conclusion as to what was the "true" story.

As with other larger-than-life characters in Texas history, stories of these pistol fighters have been handed down to us in a mixture of fact, myth and embellishment. Quite often, it is very difficult to ferret out the truth about them. My efforts in this book are to provide a factual account of their lives using the stories most likely to be accurate.

So pull up a good chair and explore the fascinating lives of two of the most infamous characters of the American West: the Texas pistoleers Ben Thompson and King Fisher.

Chapter 1
Shoot-out at the Vaudeville Theater

They called King Fisher and Ben Thompson bad men, but they wasn't bad men;
they just wouldn't stand for no foolishness, and they never killed any one unless
they bothered them.
—Deputy Sheriff Tom Sullivan, Medina County, Texas

About midnight on March 11, 1884, Ben Thompson and John King Fisher pushed though the saloon doors of the Vaudeville Theater in San Antonio. Fresh from a performance of *East Lynne* at the Turner Hall Opera House, they were in fine spirits. Moving to the bar, they ordered drinks and greeted friends with cheerful smiles.

Not everyone in the popular saloon was smiling at the pair's arrival. All of the barroom regulars knew that there was a blood feud between Thompson and the current owners of the saloon, Billy Simms and Joe Foster. Some edged toward a door for a quick exit, while others stood pat but kept their eyes glued on the men. They knew that the situation was as explosive as a lit lantern in a powder magazine.

Two years earlier, Thompson had shot and killed Jack "Pegleg" Harris, who at the time owned the theatre and saloon with Billy Simms. Before the shooting, Joe Foster, a dealer working for Harris, had won all that Thompson had on him one night. Furious, Thompson drew his pistol and declared that Foster was cheating. Scooping up the cash on the card table, Thompson backed his way out of the saloon with his pistol aimed at those who witnessed the fracas. No one moved an inch, but when he was gone Harris announced

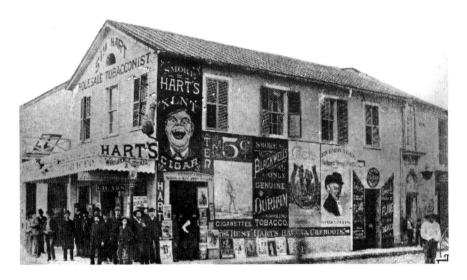

The Vaudeville Theater was owned by Jack Harris, who was killed by Ben Thompson in 1882. *Courtesy University of Texas Institute of Texan Cultures, University of Texas San Antonio.*

that he would personally kill Thompson if he ever came into his saloon again. As it turned out, it was the other way around. Four thousand people attended Harris's burial in San Antonio.

Billy Simms and Joe Foster took over the saloon after Jack's death, and they issued a warning that Thompson was not to set foot in the Vaudeville again. They hired several private duty policemen to make sure that Thompson understood that they meant their threat to kill him.

But on that cool March evening in 1884, the threat seemed to be forgotten. Within a few minutes, Simms appeared and walked to the men at the bar. Then, instead of a gun smoke confrontation, the trio had a tense but still cordial conversation.

"Simms, I want to talk to you and tell you I haven't anything against you," Thompson stated flatly. "People might think I was taking chances coming in here, but I'm surrounded by my friends."

Simms seemed relieved to hear that Thompson wasn't challenging him and assured him that there would not be any trouble that night. Managing a weak smile, he offered them the best seats in the house for viewing the stage show going on in the theatre behind the saloon. Jacobo Coy, a policeman

hired by the saloon, walked up and greeted the men as they left the bar for the stairs. Then, with Coy and Simms staying at the bar, everyone gave a collective sigh of relief as they watched the two notorious pistol fighters go upstairs to the theatre balcony.

Seated at a balcony table, Fisher ordered drinks and cigars. A short time later, Billy Simms arrived at their table and sat down. Then Coy walked up and also joined them in what appeared to be a friendly conversation. After a few more drinks, Joe Foster walked over to their table. Then things turned ugly.

Thompson stood up and offered to shake his hand, but Foster refused. "I've said, Ben, I can't shake hands with you. I've said all I ask, Ben, is to be let alone," Foster replied coolly. "The world is wide enough for the both of us, Ben."

Thompson stood there with his hand extended. "Don't treat me this way. Don't force me to extreme measures." He waited a second. When Foster stood unmoving, he pulled his pistol. Coy grabbed the revolver. Within a few seconds, the thunderous roar of gunfire filled the upstairs room with black smoke and blood.

Amid the swirl of smoke, King Fisher's lifeless body lay on the floor beside Thompson with his arm across the dead man's chest. The best pistol fighters in the West had been struck down in a gunfight without firing a shot from their own weapons. Riddled with bullets in plain view of a room full of witnesses, Thompson and Fisher met their death at the hands of Joe Foster and Jacobo Coy in a self-defense shooting.

Well, that is what the rushed coroner's inquest ruled after hearing accounts of the incident by Simms, Coy and a few other witnesses. Justified homicide by reason of self-defense—that was the ruling. No charges were brought against anyone.

Back at the saloon, some of the other witnesses were telling a very different tale. Assassins hiding behind a wooden screen had ambushed the two gunfighters. They never stood a chance. It had been a well-rehearsed assassination. The triggermen had opened up on the pair as Simms, Foster and Coy moved back from them as a signal to start the shooting.

At the time of the massacre, John King Fisher was the deputy sheriff of Uvalde County, Texas; Ben Thompson had just finished a successful stint as the city marshal of Austin, Texas. To put this in the context of the times, it is important to explain that both Thompson and Fisher had spent most of

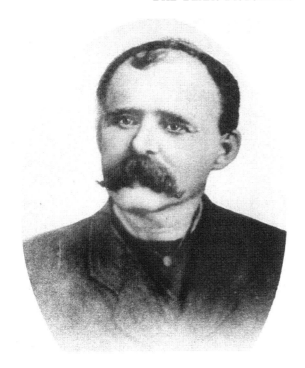

Drawing of Ben Thompson by J.F. Eaton as it appeared in W.M. Walton's book *Life and Adventures of Ben Thompson the Famous Texan*, published in 1884.

their lives on the other side of the law badge, dodging warrants or spending time in jail on a variety of offenses that ranged from stealing horses to capital murder. Both men had a reputation for being fast and deadly with a pistol. It is hard to be exact, but between the two of them, they were credited with sending more than thirty men to an early departure from this world.

Yet oddly enough, the chronicles of the Old West have largely ignored the two pistol fighters. While volumes of books and accounts have been written about the exploits of their contemporaries, very little has been written about the lives of Thompson and Fisher and their lethal skills with a pistol. Wild Bill Hickok, Billy the Kid, Wyatt Earp, Jesse James, Clay Allison and Bill Longly were all immortalized in dime novels, newspapers, magazines, books and even theatrical performances. The lives of these men became the bedrock for the mythology of the Old West gunfighters. In the view of some of the western writers today, none of these shooters would have emerged the winner in a stand-up, face-to-face fight with either of the two Texas pistoleers.

In his book *Gunfighters of the Western Frontier*, Bat Masterson wrote that his close friend, Thompson, "was a remarkable man in many ways, and it is very

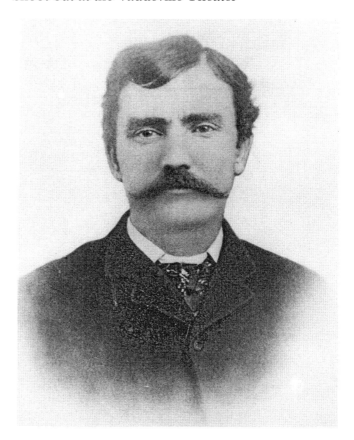

John King Fisher,
deputy sheriff of
Uvalde County.
*Courtesy Lawrence
Vivian.*

doubtful if in his time there was another man living who equaled him with the pistol in a life and death struggle." Masterson had seen all of the gunfighters in action as a cattle trail gambler and later as a lawman during the turbulent years of the wild frontier. He went on to write that Thompson "was a past master in the use of the pistol and his aim was as true as his nerves were strong and steady. He had during his career more deadly encounters with a pistol than any man living and won out in every single instance." Masterson concluded his assessment of Thompson's shooting skills by writing, "Others missed at times, but Ben Thompson was as delicate and certain in action as a Swiss watch."

An 1880s reporter for a San Antonio newspaper wrote:

> *Ben Thompson was one of the noted, or rather notorious characters of the Southwest. A gambler by profession and inclination, a gunman through the necessity of his calling and his environment, he lived in those eventful times*

when a man's life often depended upon his ability to draw quickly and shoot straight. That Ben Thompson possessed those attributes to a wonderful degree is beyond question.

When Annie Oakley, the famous trick shooter for Cody's Wild West Show, gave her view on the finest marksmen in the world, she wrote:

After traveling through fourteen countries, meeting and competing with the best marksmen…I can safely say America leads the world in shooting. The cowboy and bad man have had their day, but when they were a plenty they were very much over-rated. There were exceptions to this, however, one of whom was Ben Thompson, a Texan. He was an exceptionally fine shot, and so quick was he with a revolver that his opponent had little chance if any.

In his thoroughly researched book, *The Men Who Wear the Star*, Charles Robinson described the "Big Four" of Texas gunmen as John Wesley Hardin, John King Fisher, Bill Longley and Ben Thompson. "Of the four, the [Texas] Rangers were most concerned with Hardin and Fisher, a frustrating situation because those two, together with Thompson, were almost folk heroes in Texas and often more popular than the lawmen who hunted them."

Western writer Leon Metz, in his highly acclaimed book *The Shooters*, came to a similar opinion of King Fisher when he wrote, "Some men become local legends in their time and place, but never achieve a national reputation. By all odds King Fisher should have become a better-known figure than Billy the Kid or John Wesley Hardin. He had all the attributes: good looks, youth, style, color, deadliness and cold courage."

George Durham, a Texas Ranger under Captain Leander McNelly, was with the rangers when King Fisher and his men were first arrested on his ranch in Dimmitt County. Durham got to know the outlaw well while the rangers continued in their efforts to secure a case against him or kill him in the process. In his book *Taming the Nueces Strip*, Durham stated that Fisher "killed clean with either hand; he was one of the genuine two-pistol shooters."

Perhaps the reason that these two men were relegated to the back pages of western history lies in the fact that they were seen as "man killers" rather than murders. This may seem like hairsplitting by today's standards, but

in their time there was a significant difference. All of the men they were reputed to have killed were in the act of trying to kill them first. All of the shootings were committed in self-defense, or so the lawyers argued in court. In the frontier code of conduct, it was considered a man's legal right to defend himself. Ben Thompson once told a New York reporter, "I always make it a rule to let the other fellow fire first. If a man wants to fight, I argue the question with him and try to show him how foolish it would be. If he can't be dissuaded, why then the fun begins and I always let him have first crack. Then when I fire, you see, I have the verdict of self-defense on my side. I know that he is pretty certain in his hurry, to miss, I never do."

Bat Masterson, who personally observed Thompson and his use of pistols, explained this concept when he later wrote in New York:

Thompson killed many men during his career, but always in an open and manly way. He scorned the man who was known to have committed murder, and looked with contempt on the man who sought for unfair advantage in a fight. The men who he shot and killed were without exception men who had tried to kill him, and an unarmed man or one who was known to be a non-combatant was far safer in his company than here on Broadway. He was what could be properly termed a thoroughly game man, and like all men of that sort never committed murder.

Both Thompson and Fisher knew how to use the legal system as well as their pistols. When confronted by lawmen, they never resisted and willingly handed over their guns. They were aware that some officers, especially the rangers, would have killed them if they offered any resistance to being arrested. With the best criminal defense lawyers at their disposal, they took their chances in court rather than a gunfight with lawmen.

At the time of their deaths, both men were well known and had reputations so overwhelming that most adversaries gave way without either man having to draw his pistol. Yet surprisingly enough, taken as a whole, they were well liked by most people of that day. Throngs of people mourned their deaths at the separate burials in Austin and Uvalde. Ben Thompson's lawyer, W.M. Walton, quickly wrote and published a book entitled *Life and Adventures of Ben Thompson, the Famous Texan*. The book described Thompson's life and eulogizes him as a caring husband and father. In Uvalde, the citizens were shocked at Fisher's death and described him as being a devoted family man

with several daughters. They all agreed that he would have been a "shoo-in" for sheriff of Uvalde County in the upcoming election in November.

With this in mind, it is hard to fathom how a hastily conducted coroner's jury could quickly dismiss the shooting without any murder charges being brought against the saloon owners Simms and Foster. To understand, you have to look at the events that led up to that fateful day in 1884. Both men belonged to an age in frontier history that truly was the "Wild West." Between 1860 and the late 1880s, Texas and the western states were very dangerous territories. Indian raiding parties, Mexican bandits, Civil War renegades, Reconstruction carpetbaggers, ruthless landowners and bootleg politicians kept things in a constant turmoil. By the mid-1880s, the great cattle drives were over. The influence of John W. "Bet-a-Million" Gates and his barbed wire fence, as well as the extension of the railroad lines, brought the curtain down on the cattle drives. It also meant the end to the gambling halls in Kansas, where drovers wagered, and usually lost, their hard-earned pay at the end of a drive.

It was a winding down of a turbulent era that had seen a number of infamous gunfighters meet their fate, usually with their boots on. With most of the notorious gunfighters gone by 1884, time was also running out for Ben Thompson and King Fisher. They had outlived the wild and woolly days of the cattle drives, as well as the railhead gambling halls. Slowly but surely, the times were changing to the point where a dangerous pistol fighter would not be tolerated, regardless of his reputation.

To understand what led up to the 1884 San Antonio saloon murders, you have to explore their individual lives and the events that propelled them to their destiny on that chilly night in March.

Chapter 2
Ben Thompson

The Early Years

Justice is always violent to the party offending, for every man is innocent in his own eyes.

—Daniel Defoe

William Thompson stopped his wagon on Congress Avenue in Austin, Texas. In 1851, the street was little more than a rain-rutted trail between a few scattered structures leading to the capitol building, which at the time was a rough-hewn log fortress with a surrounding fenced stockade. This was the seat of government for the new state of Texas.

It had been a long journey from their home above the limestone ridges of the small river port town of Knottingley, England. William, his wife Mary and their three children (Benjamin, Billy and Mary Jane) looked around at the rough scattering of a town. They must have wondered if they were up to the task of starting a new life in this wild, untamed land.

Austin at the time, as described by W.H. Walton, was little more than "a small village with just a few thousand inhabitants—a frontier town. Indeed the whole country to the west of Austin, divided by a line north and south, was a frontier…into which the Indians made frequent incursions and often killed men, women and children."

Mary and the children were looking forward to finding a new home, while William was looking around for a saloon. He could stand a good shot of rye whiskey, several in fact. William had given up a good life in England for this godforsaken place called Texas. But then there were always the comforts of a good saloon to soothe the regrets and make life tolerable.

Early photograph of Knottingley, England, where Ben and Billy Thompson were born. They moved to Texas in 1851. *Courtesy O.T.T. Collection.*

Benjamin, or Ben as he was later called, was the oldest of the Thompson children. He could remember what it was like back in the security of England, though he also could remember the problems caused by his father's drinking. Maybe it would be different here in this wildly exciting land. Perhaps their relatives living in Austin would help them start a new life without the nagging remnants of the past.

Unfortunately for Ben and his family, it was not to be. Shortly after their arrival, a runaway slave murdered their relatives. It was now up to William to provide for the family. Accounts differ on his training—possibly a mariner, a grocer or a printer. Regardless, the best that he could do to support the family was commercial fishing on the Colorado River. It was up to Ben and his brother Billy to deliver the fish to customers, collect the money and try to keep their father from spending it all in the saloons.

In the spring of 1859, Ben's sister, Frances, was born in Austin—the first true Texas Thompson. Far from being elated at the arrival of his fourth child, Ben's father saw the birth as one more mouth to feed and offered little assistance to his wife in tending to the infant.

Eventually, at the age of seventeen, Ben (with his brother's help) had to take over the support of the family when his father took off for the seafaring life again. William never returned to Austin; it was said that he was lost at sea, though there are no clear records of his death.

So Ben and Billy fished the Colorado and did other odd jobs to supplement their mother's meager income as a seamstress. Eventually, Ben went to work at an Austin newspaper and learned the printing trade.

When he was not working to support the family, Ben usually did as he pleased. This often meant spending time with some of Austin's tough young boys. As a result, his first shooting scrape came before he was barely shaving. In October 1858, he shot another boy with a single-barreled shotgun.

Accounts of the shooting differ to some extent, but all agree that Ben shot another boy named Joe Smith. Joe was about a year older than Ben and was said to be a bully.

Apparently, the two got into an argument, and Ben ran to his house to get his shotgun. Returning, he caught Joe running away and opened up on him with a round of bird shot. Fortunately for Joe, he was not seriously injured, suffering only a few tiny pellet wounds to his back and head. He was taken home and, after the bird shot was picked out of his wounds, recovered quickly.

Ben was arrested for the shooting and appeared before Justice E.F. Calhoun. No witnesses showed up for the hearing, so the judge released him. Some in the community saw Ben as a budding hardcase and pressed for another hearing, this time in front of Justice Graves. After witnesses testified, Ben was bound over to appear at the next district court. To keep him out of jail during that time, Ben's family and friends posted a security bond of $300.

District court opened on December 6 with Judge A.W. Terrill presiding. The jury listened to the witnesses and then handed down a guilty verdict of aggravated assault with a deadly weapon. They recommended mercy since he was a teenager and did not have a previous record. He was fined $100 and sentenced to sixty days in the county jail. After he went to jail, a petition was sent to Governor Hardin R. Runnels asking for clemency. The governor reviewed the case and issued an order to rescind the fine and release Ben from jail after court costs were paid.

A few months later in 1859, Ben found it easy to again resort to gunfire to settle a dispute while hunting geese on the Colorado River. He and a group of boys hid out on each side of the river, waiting for the geese to land. As a

flock approached, the boys across the river from Ben opened fire too quickly, scaring off the birds. Furious, Ben hurled a few choice words across river. Soon the two groups of boys were blasting away at each other with their shotguns. Finally, Ben halted the gunfire and challenged the leader of the other side to a duel.

Facing each other at a distance of forty feet, the two boys blazed away with their shotguns. When the smoke cleared, both boys were wounded. Ben walked home, but his opponent had to be carried.

And so Ben Thompson's legacy began. He became known as a dangerous person and someone who would not hesitate to shoot when threatened or challenged.

The following year, he added to his fast-growing reputation, this time as a heroic Indian fighter. Answering a call to arms, he rode with an Austin posse that tracked down and ambushed an Indian raiding party holding five captured children. Ben was the first to start shooting; he dropped the leader with a single shot. Then all hell broke loose as the posse opened up with pistols, rifles and shotguns. After the fighting ended, all of the children were saved, but only one of the Indians made it out alive.

Fortunately, through it all Ben was able to attend school. With the financial support of a family friend, Colonel John A. Green, he was able to attend two additional years at a private school.

Working as a printer's assistant, setting type at the Austin daily newspaper the *Southern Intelligencer*, Ben developed into a handsome young man full of promise. Smart and industrious, and with a quick wit, he made friends easily and seemed headed for a respectable place in the community. People knew that he could be dangerous with a pistol, but he appeared to have moved on from his juvenile transgressions and was on his way to becoming a decent citizen of Austin.

Then in 1860, he moved to New Orleans and went to work for Samuel W. Slater, a friend of the Thompson family who operated a bookbindery. Slater had previously operated a bindery in Austin and knew of Ben's ability as a printer. Working as an apprentice, Ben learned quickly and soon developed a strong relationship with his mentor. In many ways, Slater was the father figure that Ben had never experienced with his own drunken father. This close relationship would continue throughout Ben's life.

Life was good in New Orleans. Ben had a promising career ahead of him, and he was popular and seemed well on his way to becoming a respected

member of the New Orleans community. But this was not to be; Ben's quickness with a gun or knife dictated otherwise. Accounts are sketchy, but reports indicate that Ben had several dangerous scrapes in the Crescent City. The first occurred when Ben shot and wounded a man who had barged into the bindery trying to take some of Slater's possessions in a dispute over a bill. Ben was quickly tried for the shooting but was acquitted.

The second episode, most often mentioned, involved an encounter with a belligerent Frenchman named Emil DeTour. According to the accounts, Ben was riding in an omnibus, the public transportation of the day, when the drunken Frenchman tried to kiss a young woman riding across from Ben. She pleaded for help, and Ben warned the whiskey-laced man to leave her alone. Enraged that his actions were questioned, DeTour called Ben an "American puppy" and slapped him across the face. True to his nature, Ben quickly pulled a dagger and stabbed the man in his shoulder. When this did not stop the Frenchman, Ben struggled to send the dagger into his neck but was pulled back by DeTour's friends. They quickly ushered the wounded man off the vehicle for medical attention, while Ben fled the omnibus in a dead run.

As it turned out, DeTour was a prominent social figure in the Creole society and a respected duelist. A few days after the altercation on the omnibus, a representative for DeTour marched into the bindery and presented Ben with a challenge to a duel. Without hesitating, Ben accepted the challenge. His terms were pistols at ten paces.

When DeTour heard the terms of the duel, he refused to use such a "barbarous" means and demanded swords. After some haggling, it was agreed that the two would use daggers and that the fight would continue until one man was dead.

A few days later, Ben and his friends met the Frenchman and his entourage at an abandoned icehouse on the edge of the city. Each was given a dagger and positioned across from the other in a dark room. The door was closed, and immediately Ben called out, "Are you ready?" The Frenchman lunged across the room at the sound of Ben's words, but the Texan had moved to another position and deftly sent his dagger into the startled man's chest.

In a few minutes, the door opened and out walked Ben, calmly telling DeTour's friends that the Frenchman did not need a doctor, but rather a priest for last rites. He then smiled at his astonished friends, who quickly ushered him away to avoid being killed by DeTour's party. A large reward

went out for Ben's capture, but he managed to hide out with friends in the Sicilian quarter until he could get across the Mississippi River to Algiers. From there, he quietly rode back to Texas.

If this account is true, and there is some controversy regarding its authenticity, the episode marked the beginning of a pattern that would be repeated several times in Ben's life and ultimately would be a factor in his death. Under the cloak of chivalry, Ben would stand and challenge men who were abusive to women. Usually the men would not heed his warnings, and a fight would ensue. Each time, Ben would finish the fight and walk away while his opponent lay dying from a fatal wound.

As to why Ben felt that it his duty to defend women to the point of killing another man, it is important to remember that he and his mother were both victims of abuse when his father was drinking—which was most of the time. Being thrust into providing for and protecting his family at an early age, Ben developed a very close relationship with his mother. He saw himself as her guardian and defender until her death in 1882. Perhaps it is this keen sense of responsibility that fueled his aggressiveness in defending the honor and safety of women throughout his life.

Chapter 3
The Civil War Years

If you must play, decide upon three things at the start: the rules of the game, the stakes, and the quitting time.

—Chinese proverb

Upon arriving in Austin, Ben Thompson found the city bristling for war against the North. Sam Houston had narrowly beaten incumbent Hardin Runnels in a heated election for governor. Then, after Lincoln won the presidential election in November 1860, South Carolina left the Union to form the Confederacy. One by one, many Southern states decided to join South Carolina until, ultimately, the decision fell to Texas.

In late summer of 1860, there was a disturbance in north Texas that led to public hysteria over a series of mysterious fires that caused massive property damage to some slave owners. Known as the "Texas Troubles," people feared that there was an abolitionist plot to destroy slavery and ruin the countryside. Vigilantes quickly shot or hanged all slaves or whites suspected of being connected to the plot.

Then, after the public outcry for secession gathered momentum, a State Secession Convention was called in January 1861. In spite of Sam Houston's efforts to halt the convention and keep the state in the Union, the Ordinance of Secession was passed by a vote of 166 to 8. After being approved by the voters of Texas by a 3 to 1 margin, the state was declared out of the Union and aligned with the Confederacy.

Houston refused to accept the authority of the convention and would not sign an oath of allegiance to the new government. The convention then declared his office vacant and elected a new governor. Houston went home to Huntsville in disgrace, still warning of the perils ahead for Texans hell-bent on fighting the powerful forces of the North.

Texas militia quickly surrounded U.S. general David Twiggs in San Antonio and forced him to surrender all Federal property in Texas. Twiggs and 2,700 Union troops stationed at the various frontier forts were escorted out of the state, leaving behind all munitions and equipment. Ben and Henry McCullough, as well as John S. "Rip" Ford, recruited troops and prepared for war.

Ford had picked up the nickname Rip while fighting in the Mexican War under Colonel Jack Hays. Serving as an adjutant of the regiment, Ford was required to send out lists of those killed in the war. Being a man of letters, he added "Rest in Peace" to his death notices. After the first few notices, he shortened it to "R.I.P." Soon the men started calling him "Old Rip," and it stuck with him the rest of his life.

Ben Thompson, along with other eager young fighters, enlisted in Rip Ford's battalion in May 1861. The troops headed to the Rio Grande to guard the border from Brownsville to El Paso. In the absence of Federal troops, Ford's men fought against raiding Indians and Mexican bandits. They took on Juan Nepomuceno Cortina, a particularly bad character who had led several very bloody raids into Texas. Heralded by some factions in Mexico as a fearless hero, Cortina had a large band of fighters who wreaked havoc on towns and villages of the lower Rio Grande. At one point, he and his men sacked Brownsville and killed many Texans who tried to stop him.

Serving as a private, Ben followed Rip Ford's orders to confront Cortina, and after several pitched firefights, the Mexican was driven back across the border. There are no accounts of Ben's action along the border, so we don't know if he proved to be capable soldier. In fact, one misguided old-timer claimed that he was sure that Ben fought alongside of Cortina instead of against him.

As seen in a large number of other episodes in his life, several versions of the same event have Ben portrayed in a very different light depending on who is telling the story. We do know that in May 23, 1861, Ben enrolled as private in the Second Regiment Texas Cavalry (Company H) commanded by Captain H.A. Hamner. At the time, Company H was stationed at Fort Clark, a former Federal outpost located in Kinney County.

It was while he was stationed at Fort Clark that Ben is reputed to have killed his second man. According to the account given in Walton's book, Ben showed up late for his ration of candles and bacon. The sergeant issuing supplies, a gruff man named William D. Vance, told him that all of the rations had been issued. Without offering protest, Ben turned to leave the tent. On the way out, he picked up an allotment rations belonging to the laundress. Vance didn't see Ben pick up the supplies, but within minutes he noticed the theft. He stormed out of his tent, shouting, "What damned thief stole the rations of the laundress?"

Ben calmly turned and faced the sergeant. "I took them but did not steal them; you can replace them out of the over-issue of rations you made to your mess."

Vance was furious and started toward Ben. "You did steal them, and you have to surrender them right now, and as to my making an over-issue of bacon and candles to my own mess, that's a lie."

Ben stood his ground and warned, "Don't come any nearer, Sergeant Vance; if you do you will repent it."

Vance kept coming and drew his pistol as he neared Thompson. Ben drew his revolver and returned fire after the sergeant popped a quick shot at him. Untouched by the pistol shot, Ben hit Vance dead center. The bullet went through the officer's body and through both legs of an unfortunate soldier standing near by.

At this point, Lieutenant Hagler rushed to the scene and, without saying a word, swung at Ben with his sword. Ben parried the sword with his pistol and fired point-blank at the lieutenant.

Then, as both officers lay wounded on the ground, Captain Hamner appeared and found Ben standing there with a smoking pistol. He demanded that Thompson hand over his gun and surrender.

Ben handed his weapon to the captain and is quoted as saying, "Captain, I surrender to you, and would have yielded to them had they sought to arrest me instead of killing me."

Thompson was locked in the guardhouse; the sergeant slowly recovered, but unfortunately the sword-welding lieutenant died a few weeks later. Chained to the guardhouse floor, Ben did not require a guard to watch over him. After a short while, he managed to secure some matches, which he used to set the guardhouse on fire. Pulled from the blazing hut, Ben was chained to a tree.

A few days later, he took advantage of a smallpox scare to escape his imprisonment. A friend of his became ill, and it was thought that he had the deadly disease. The only thing that could be done for the soldier was to quarantine him in a tent at some distance from the camp. Ben offered to take care of the sick man who, as it turned out, had nothing more than chickenpox. As soon as the friend had recovered, the two snuck back into camp one night. They quietly managed to collect their belongings and get away on horses before their escape was noticed.

Ben and his friend hid out until the Second Texas Cavalry was reorganized in the fall of 1862. They enlisted in Company F under William G. Tobin. For some unknown reason, Ben was never tried for the shooting episode at Fort Clark. Perhaps the shortage of volunteers for service to the Confederacy played some role in his eluding punishment.

A few months later, while camped outside of San Antonio, Ben suffered a serious leg injury when he was pinned under his horse while smuggling whiskey into camp. After spending six weeks in a hospital, he managed to escape punishment again and join up with his company shortly before it fought in the heated battle at Galveston to reclaim the port from the Federal troops occupying the city.

It is during this time that we find the first reported episode with his close friend, Phil Coe. Before reaching Galveston, Thompson and Coe hatched up a plan to steal an old horse and trade it for a gallon of extremely bad whiskey. To improve the taste, they steeped the whiskey with a quart of wild cherries. As soon as it was tolerable, Coe started downing the concoction until he was thoroughly slouched; for some reason, Thompson stayed away from the spiked liquor. Soon, Coe was complaining of a poisoned belly and was rushed to a hotel in the closest town, where Thompson called for a doctor. While waiting for the doctor, several ladies took note of the pathetic-looking young man and asked what was ailing him. Without missing a beat Thompson, looking grim, replied, "Poisoned."

The women were quite disturbed, thinking that the rather handsome man might be dying. They quickly took charge of comforting Coe until the doctor arrived. Finally, when the doctor arrived and examined Coe, he quickly declared, "Why, the scamp is only dead drunk."

Ben and Coe were arrested and placed under guard at the rear of the company. Coe recovered and eventually left the camp and fled to Mexico.

Though still struggling with the leg injury, Ben managed to catch up with his outfit as it neared Galveston. He fought alongside his brother, Billy, and fellow soldiers until the Union forces finally surrendered. Ben was said to have distinguished himself by delivering dispatches under fire, often crossing into enemy lines. But the effects of the harsh weather and an aggravated leg injury eventually sent him back to hospital confinement in San Antonio.

After a long convalescence, Ben recovered enough to marry Catherine Moore, the daughter of a wealthy Austin merchant named Martin Moore. A short time later, he transferred to Rip Ford's regiment and left for Eagle Pass on the Rio Grande.

It was while he was stationed on the Mexican border that we first get a glimpse of Thompson's penchant for the excitement of gambling. In his book written shortly after Ben's death, Walton quotes Thompson's account of the camp gambling episode in the gunman's own words:

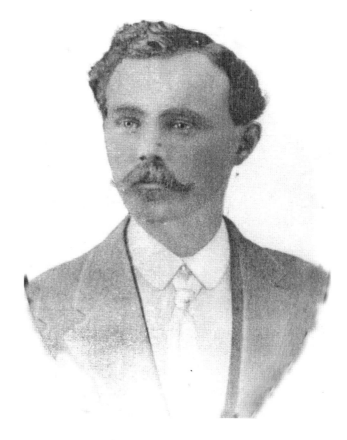

Early photograph of a young Ben Thompson. *Courtesy N.H. Rose Collection.*

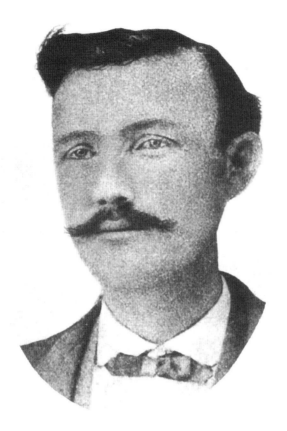

Early photograph of a young Billy Thompson. *Courtesy N.H. Rose Collection.*

The colonel was unable to give the men soldierly employment. The Indians had gone into Mexico, and the Federals retreated southward, beyond our reach; our own lawless men move quick. We were camped near Eagle Pass, a town on the east bank of the Rio Grande River. We had no money. Our pay consisted totally in Confederate money, and that was as worthless as blank paper in trade with the Mexicans, and we could trade with no others. I was entirely without money. Some of the men had money they had brought from home or picked up trading. Whether by nature or not, I am from habit a gambler, willing to take the delights of the excitement that belongs to such character, and yet not afraid to meet and contend with the adversities that in due and natural course meet such men. Sooner or later, however prosperous a gamble may be he meets with an untimely death; if not from the pistol or dagger, then from fatal disease contracted by dissipation and exposure consequent on such life. Every time a man sits

down to a card table to gamble he takes his life in his hands and lays it down between him and his adversary. Fatal difficulties arise from cause and from no cause; men are killed in their own difficulties and in those of others. I have a son, and I had rather follow him to the grave than see him contract the habit of gambling. Yet I continue in that line of life; but, so help me God, I never have and never will give countenance and assist, encourage, influence any boy, youth or man to engage in the hell-earning business, which I will probably follow until I am dead. My brother Billy had also obtained a transfer from the command from which we had both belonged, to the regiment of Col. Ford. When he came it was but natural I should meet him gladly and eagerly. We are brothers and devoted ones. Together we have seen many hardships and undergone great dangers. He was ever true as tested steel. With him he brought about seventy dollars in gold. This we agreed should be the talisman to lead us to successful fortune. He gave it to me; I ventured it. Being a skilled dealer at monte, I did not hesitate to let the Americans bet against me. Winnings and losses for a time were mutual; but in the long run I was ahead about two hundred dollars in good money.

After cleaning out the pockets of all of the available soldiers, teamsters and cotton yard workers, Ben was out of players. Up to this point, he had not allowed Mexicans to play against him because he felt they were masters at the game and too tough to deal against. Finally, against his better judgment, he felt he could take them on in the perilous game of monte. (For information on the game of monte, see Appendix I.)

Thompson's account of playing against the Mexicans continues: "They are indeed experts. I opened the game for them, and in less than five hours I did not have a cent. I even put up my silver spurs and the gold cord that ornamented my hat; it was of no use; money, spurs, hat, cord, and all, went; and the cigarette-smoking devils grinned as they won."

When the Mexicans rode back across the border, they took with them all of Ben's money and belongings—with one exception, his pistol, which he had to retain as a soldier. Busted flat, without funds, he could do little but carry on his monotonous camp duties until the regiment was ordered to relocate downriver. He managed to convince Colonel Ford that he could cross over to the Mexican side and take a stage to their new location—arriving early to scout the area.

Before crossing over to Piedras Negras, Ben frantically tried to raise funds for another run at the Mexicans' wallets with his monte game. No luck—everyone was broke. Finally, a group of the soldiers said they planned to rob the customhouse on the American side of the river and wanted him in on the raid. Although tempted, Ben refused, but he was afraid that if the robbery took place, he might be accused of being a part of the gang. He quickly gathered a friend, Julias Brown, and headed across the river to the stage line, where he talked the driver into taking them downriver with payment to be made at the end of the ride. Most drivers would have laughed at the idea of riding first and payment later, but as it turned out, the two previous stages had been robbed by Mexican bandits, and the driver needed the armed men along on his run.

Arriving in Nuevo Laredo, Ben looked up an old friend, Joe Buck, to stake him in a monte game. Buck came through with $300 and Ben was back in business. Continuing his story:

> *I won from the start; during the night's play my gains were over twelve hundred dollars. I handed Joe Buck back his money, and as is usual in such cases, I divided my winnings with him. I paid the stage man his fare, and refunded the borrowed five dollars to Mr. Munger, and still had about four hundred dollars. I met then, about twenty Californians, as rough a set as ever lived, but true and brave as men are made.*

They were staying at the house of Mr. Riddle, a wealthy, liberal, hospitable gentleman who had been in California and, having made a fortune, had returned to this out-of-the-way place to enjoy it.

The next day, Ben crossed over to Laredo, Texas, where he met his brother, Billy, and the rest of the Confederate soldiers. One of the companies was headed by a Captain Santos Benivedas and contained a large number of Mexicans. Ben went back into business dealing monte and continuing his account:

> *It was not long before I opened a game for the soldiers. They had no money… they proposed to venture their six-shooters; this weapon is a necessity on the frontier, and is almost as current in trade, barter and gambling as a twenty dollar gold piece. I dealt and Billy was my look-out, Julius Brown near at hand. I rated each pistol at so much. My recollection now is that it was twenty-two dollars for Colts, eighteen dollars and fifty cents for Remington,*

and sixteen dollars for the self-cocking pistol, used generally by the Federal cavalry. Of the pistols there were thirteen of the first, seven of the second and three of the latter kind. It would be tedious to detail the ebbs and flows of the game. I can say it was a hard one to beat; some won, others lost: the losers would borrow from those who won. Gradually, however, and surely the sums advanced on the pistols found its way back into the bank. The setting was a long one; the betting close and very cautious; but the tide was my way, and before twelve o'clock at night all the pistols were mine.

As quickly as the pistols were won, Ben shuffled them off to Julius Brown for safekeeping, thinking there might be trouble when the game ended and the Mexicans left empty-handed. As it turned out, the game ended peacefully. The soldiers left that night vowing to return the next day after getting paid to win back their money and pistols.

Shortly after their evening meal the next day, the Mexicans made good on their vow and were ready for another game. Ben set up the game and quickly started winning their pay. After a while, he noticed that they were starting to cheat in their play. Thompson described the method of cheating this way:

The cards are shuffled, and handed to the better to cut. In cutting, if he is very expert, and the dealer and lookout not extremely careful, the one who cuts will let a card stick to his hand. When this is done the cutter, at the earliest safe moment, ascertains what the card is. Suppose it is the Jack. Then there would be left but three Jacks in the pack when there ought to be four. Now for the application of the theft. The thief better waits for a Jack lay-out. Suppose it is made, and it is Jack and King. The better can bet on either card, and the dealer is bound to take the other. The card that comes first wins. There are three kings and only two Jacks left in the deck. After the lay-out, one Jack being stolen, of course the better selects the King, because thereby he has three chances to win; each King is a chance for him, while the dealer has but two chances, there being but two Jacks in the pack, one being stolen and another in the lay-out. The bet then is three to two in favor of the better on the king and against the dealer, who necessarily takes the Jack.

Wise to their cheating, Ben knew the way they would bet, and he was counting on them betting their last dollar, which they did. About two o'clock

in the morning, he had won more than $1,800 from the Mexicans, and they were starting to grumble at his continued luck. Billy was getting tired and had pulled off one of his new boots that was hurting his foot. Ben took it all in and knew that things could get dicey if the Mexicans turned ugly on him. He told it this way:

> *I felt that a crisis was at hand. I had been told by some friends during the day that if the Mexicans could not win my money they would raise a row, knock out the lights and rob me, not only what I had won, but would take the bank money too. My life was of never so much value to me that fear of losing it would deter me from maintaining my rights. A gambler is possessed of some rights, if not under and by the law, certainly from his fraternity, and those who consort with him. It is a sorry dog, indeed, that will eat dog. Just then noticing that Billy did not have his pistol, I spoke to him in a quiet way and low tone: I said, "Go and get your pistol."*

Billy's foot had swollen, and it took him awhile to get his boot on and leave the game. Ben kept playing, hoping that his brother would return before trouble started. Finally, he gathered up the cards and called for a new deck. While the cards were being delivered, he put all of his winnings in a canvas sack. The cards came, and Billy had still not returned. Ben knew that things were coming to a boil and tried to close the game. A tall Mexican by the name of Martino Gonzales stood and objected.

"Mr. Ben, you can't close this game."

Ben replied, "The game is closed."

"Then you will have to give the money back to these men out of which you have cheated them."

Ben smiled and said, "Lieutenant, you are not in earnest, are you?"

"Yes; not only in earnest, but you shall return the pistols you took from them on yesterday. They are government arms; where are they?"

Still smiling, Ben again said, "Lieutenant, I won the money fairly, and I won the pistols in the same way; the pistols are the private property of the soldiers, as I am informed. Surely, under these circumstances, you will not insist on your demand."

"But I do insist on it, and will see that you comply with it, and that, too, without any delay."

Knowing that all hell was about break loose, Ben prepared for a fight. Gonzales drew his pistol and swiped at the candles that lit the tent. He missed one of the candles, which was all Ben needed to see another man draw a pistol and fire at him. The shot missed Thompson, but he got a shot off, hitting the man in the head. He then turned to Gonzales and shot him in the chest.

By this time, the remaining candle had been knocked out, and mass pandemonium reigned. Bullets were flying in every direction as Thompson made his way out through the door of the tent. Continuing his story:

> *Pushing through the mass of confusion, I found myself out of the door, on the edge of a deep tank; at which moment a Mexican, who by some means had obtained an escopet* [a carbine], *recognized me, and, in trying to shoot me, so alarmed another Mexican that he ran against and knocked me into the tank. As I fell, the escopet was fired at me and the shot tore off both skirts of a new broad-cloth coat I had bought the day before. I dived and swam as far as I could under water and then scrambled up the further bank. The Mexicans had fled. Just as I got out of the water I met Billy, who hurriedly asked if I was hurt. I answered "No," but really did not know whether I had been hit or not. I knew, however, that I had not been disabled. I urged him to get out of town as rapidly as he could. We started, but got separated at once. There was a great breastwork of cotton bales very near the tank and extended back to the walls of the buildings. He went on one side of the bales and I on the other.*

Separated, Ben ran up a street and quickly met a squad of cavalrymen. He stepped aside and let them pass. As they did, an officer noticed him standing there dripping wet:

> *The officer in charge of the squad asked me what all that shooting meant. I told him it was a bawdy house, down by the river, that I suppose the boys were having some fun with the women; off they went on the false scent, while I pushed for the chaparral as fast as my legs could carry me…I was not uneasy about Billy, because he had not been at the shooting, nor taken any part in the killing of Gonzales and Zertuche, both of whom, died that night, as I was afterwards informed, and also Juan Rodriquez, another Mexican, who was shot on the same occasion, but by whom I do not know.*

I shot three times, but whether Rodriquez was killed by me or by his friends in firing at me, no one perhaps will ever know.

Ben hid in a graveyard until the cavalrymen returned looking for him. Hurrying down to the Rio Grande, he stripped off his shot-up coat and laid out a monte betting hand that he knew would be found by the Mexicans at daylight. In spite of his quandary, he was bound to show contempt for his pursuers. He then fashioned a float from a bundle of bushes and managed to ford the river. Reaching the other side, he emerged in tattered shoes and clothes, still clutching his pistol and a few gold coins.

As the sun was about to rise, he quietly entered Nuevo Laredo, trying hard not to awaken sleeping residents. After being bitten from his heals to his hip by a few stray dogs,

> *I was bloody from the waist down, and as full of pain as if a strong man had taken a pair of pincers and torn out pieces of flesh. At last, however, I got to Mr. Riddle's house, knocked up the inmates, and stated to them whether they would give me asylum for a day or two. Their response was as hearty as man could wish. They said "Yes; you can remain here and no one shall take you away against your consent until we are all dead or so disabled that we cannot fight." My leg wounds were dressed, washed in ammonia and bound up as well as possible, considering their locality; then I retired and slept for several hours, and rose much refreshed, but very sore, yet ready for anything that might present itself. I have never known why Zertuche did not kill me; whether a button or something else turned the bullet I cannot say, but sure it is I was not even slightly wounded by gun-shot; but the dogs gave me many a one, the marks of which I bear to this day and will carry with me to the grave.*

Billy had passed the night away on top of the flat roof of a vacant house. Later the next day, he spotted some of his friends from another Confederate company in the area. They had ridden into Nuevo Laredo for supplies. Billy got their attention and, after changing clothes with a soldier, rode back across the border with his friends.

Julius Brown made his way to Ben's hideout at the Riddle house in Mexico and warned that a band of Mexicans were planning an attack to get Ben. Fearing that his friends might be killed on his behalf, Ben left the house and

hid in the chaparral. He sent Julius back across the river with instructions to contact some of his friends from a company of soldiers led by Captain Carrington. They were to meet him at a known spot on the east bank at three o'clock the next day.

Ben arrived at the designated location and managed to float across the river with the Mexicans hot on his trail. Rescued by his friends, Ben and the troops returned to the Carrington's camp only to find that the authorities in Laredo had sent word that he was to be turned over to them. Carrington felt duty-bound to honor the orders but allowed Ben to slip away from the camp on the back of a wild Mexican mule.

After dodging the Mexicans for several days, he eventually rode the mule, now named Dan, into the camp of a small group of men led by Captain Gardner. The captain vowed to protect Ben and actually fired cannons on the Mexicans who came to take him. Ben was able to obtain a decent horse and eventually made it back to Austin, where he found his mother, wife and a new baby waiting for him.

A few weeks later, after he had healed from his dog bites and other wounds, Colonel Ford detailed Thompson to raise a company and join the regiment of Colonel Beard. The regiment was to operate in the northwest against the Indians.

Ben declined the commission of captain but instead suggested that a man by the name John Rapp be appointed captain. Thompson had known Rapp for a long time and knew that he would be a good leader. Together, they set about to recruit what they could from the few remaining men of the area. As it turned out, there were not many left; most of the reliable men were either off fighting or dead from fighting in the war. They had to pick the best from the worst, and even then the numbers were limited.

Rapp and Thompson quickly found out that they were being falsely accused by some of Austin's home guard of recruiting guerrillas to loot banks and rob cotton exporters. The home guard had a number of malcontents who circulated the rumors and were generally hostile toward Rapp as the captain of the company. Chief among these belligerents was a very violent character by the name of John Coombs.

Coombs held a particularly bad grudge against the leader of the home guard, Captain L.D. Carrington, who was a close friend of Rapp's. Whenever possible, Coombs kept the rumors flying about Rapp and tried to provoke him in any way he could.

One evening, a drunken Coombs found Rapp drinking with friends at John Wahrenberger's beer hall. He proceeded to make wild accusations about Captain Carrington. Rapp, a generally hot-tempered man, tried hard to let the matter pass without response. When he failed to get a rebuttal from Rapp, Coombs grew louder and asked, "Captain Rapp, as the proposed commander of robbers, what do you say as to the truth of my assertions in regard to the honor of L.D. Carrington?"

Rapp tried to dodge the drunken challenge. "Mr. Coombs, it would be better for us not to discuss that matter as this time." Donning his hat, he prepared to leave. "You will excuse me."

Coombs drew and cocked his revolver. Rapp reached over and caught the weapon at the hammer. Coombs pulled the trigger, and the hammer pinned the gun to Rapp's hand. Coombs cursed and wrenched the gun from Rapp, tearing out the flesh between the thumb and forefinger. People tried to restrain Coombs, but he tore away from them with his knife drawn. He swung at Rapp, catching him in his other hand and rendering it a bloody mess.

Coombs was finally brought under control, and a physician treated Rapp. Then, a short time later, Rapp, in blood-soaked clothes, went to Thompson's house and told him what had happened. He asked Ben to go with him to get some fresh clothes at his room in the Brown Building. He said that he had heard that Coombs and some of the other malcontents where out to arrest Ben and himself.

Ben got his gun, and the two walked to the Brown Building, which by this time was dark, with very few lighted windows. At the clock corner, just before the Brown Building, they were tipped off that Coombs and about twenty men were hiding in an alley behind a livery stable with the intent of killing Rapp and Thompson.

Within seconds, Coombs and his men swung out of the alley and into the street. Coombs spoke first. "Where are the sons of bitches, let them show themselves." Ben looked at Rapp. "Come on Captain Rapp, you hear those men." Rapp did not hesitate, "I come."

Coombs and his men opened fire with their guns, and the fight was on. Thompson rushed a man standing behind a post and shot him. Then turning, he shot another man on a horse. Suddenly the fight was over—the rest of the mob faded into the shadows.

With the shooting over, people rushed to the scene with lanterns. In the faint glow of burning coal oil, they found Coombs behind the post, dead. The man shot off his horse was wounded but later recovered.

The next day, City Marshal W.H. Sharp met Thompson on the street and informed him that he had a warrant for his arrest. When told the warrant was for the killing of John Coombs, Thompson was cooperative at first and responded, "Well, that is all right. When do you want me for trial?"

Marshal Sharp said, "I don't know; but I must arrest you and take bond."

Thompson knew that Coombs's friends would be gunning for him. "That won't do, Mr. Sharp. If Coombs is dead I can't give bond. I do not propose to go to jail, but will appear at any time and place for which the examining trial may be appointed; but I shall not disarm or go to jail."

Seeing that he could not handle Thompson, Marshal Sharp arrested Rapp and took him into custody. Later, at a bond hearing for Rapp, both he and Thompson paid bail. Both were tried after the war ended and acquitted of the charges.

Rapp and Thompson continued to raise the recruits for a company and joined the regiment in a camp near Waco. There they waited for orders to march on the Indians, who by that time had stopped their raiding parties. Finally, after several weeks in camp, word came that the war was over. With the Confederacy broken, the regiment was disbanded, and Thompson returned home to his family in Austin.

Chapter 4
A Mercenary in Mexico

I forgive everybody. I pray that everybody may also forgive me, and my blood which is about to be shed will bring peace to Mexico. Long live Mexico! Long live Independence!

—Emperor Maximilian's last words

The last battle of the Civil War took place in Texas more than a month after General Robert E. Lee surrendered at Appomattox. On May 13, 1865, the Texas Confederate forces defeated the Federals at the Battle of Palmito Ranch near Brownsville. Colonel Rip Ford with his Second Texas Cavalry and Colonel Santos Benavides's Texas Cavalry Regiment took on Colonel Theodore H. Barrett's five hundred Union troops. Outmaneuvered, outgunned and fearing a complete rout, the Federals were forced to make a fast retreat to Brazos Island, where the Texas forces finally held up. A few days later, Union officers met with General Slaughter and Colonel Ford in Brownsville to arrange for a truce.

The Texas Confederate fighters did not want to stop fighting, but they could see that it was futile to continue a lost cause. Their state had been spared the savage effects of four years of war that most of the other Southern states had suffered, but they soon learned that the hardships of their rebellion would come after the war—during Reconstruction.

When Ben Thompson returned to his family in Austin, it was a bittersweet reunion. He and his brother, Billy, made it back to Austin to find the city under military control and struggling with severe shortages of food and

other supplies. Texas governor Pendleton Murrah had fled to Mexico, with Lieutenant Governor Fletcher S. Stockdale taking his place until Andrew J. Hamilton could take over as the first of the Reconstruction governors. Eventually, the controlling forces allowed for the election of James W. Throckmorton as governor of Texas in 1866. Then, in July 1867, General P.H. Sheridan removed Throckmorton and replaced him with a series of provisional governors. Economic and political power was shifted away from the founding families and given to those "loyal to the Union." It was a time of turbulence and harsh treatment for a majority of Texans.

Lieutenant Colonel A.S. Badger, commander of the First Louisiana Cavalry, arrived in Austin in June 1865. His military occupying forces took control of the city and Texas government. A few days after his arrival, he issued an order for Ben Thompson's arrest. Though the order did not specify the charges brought against him, the Austin newspaper, the *Daily Statesman*, stated that he was being held for shooting some soldiers just outside the city. He was held without a hearing and was not allowed to post bail for his release.

At the time of Ben's incarceration, agents for Emperor Maximilian were actively seeking recruits to join the imperial army of Mexico. The rebelling liberals were wrecking havoc with the ruling powers of the conservatives and clergy of Mexico. Ferdinand Maximilian Joseph, a Hapsburg prince, had been installed as the ruler of Mexico by Napoleon to ensure the payment of debts owed to the French. As the American Civil War wound down, Maximilian's agents were recruiting ex-Confederate fighters to serve as mercenaries to quell the rebellion. After many weeks of imprisonment in Austin, Ben decided that this was his only way out of a bad situation that looked stacked against him. Through intermediaries, he was provided with the money to bribe his way out of prison and join Maximilian's forces at Matamoros.

Late one Sunday night in October, Ben slipped out of his prison dressed as a Federal soldier, mounted his waiting mule and then headed for the border. Ben, riding old Dan, plus some of the guards who defected with him, arrived in Matamoros a few days later. They enlisted in a company of independent fighters under the command of Captain Frank Mullins. Signing on as lieutenants, they reported to Captain Gilly. The following morning, at dawn, Ben's company saw action against the insurgents, who mounted an assault against the fortifications that protected Matamoros. Newspapers of

the day reported the details of the heated battle in which the liberals were repelled and badly beaten, estimating that nearly five hundred had been killed or wounded. Following the battle, the leader of the imperials, General Tomas Mejia, reviewed the battlefield reports and saw that he had a real fighter in Ben Thompson. He immediately issued a field promotion to the rank of captain.

Ben and his fighters had orders to defend the cities of Matamoros and Bagdad, a vital port on the gulf. This was the primary supply line for the much-needed goods and munitions coming in on the French ships. Both cities were heavily fortified, and for a while, the imperial garrisons were able to keep the liberals' commander, General Escabedo, and his forces at bay.

After being made captain, Ben asked for permission to break through the enemy lines and search for their supply trains. Mejia approved the plan, and Ben left with a company of fifty of his best fighters. They made their way through the enemy lines and over to the Rio Grande, where they headed northwest. Eighteen miles later, they spotted a train of supply wagons guarded by a poorly equipped company of about eighty men. Ben and his men opened up on the enemy troops with their rifles, and then, with a rebel yell, charged with blazing six-shooters. After a brief fight, the outgunned Mexicans left the wagons and headed into the mountains. Ben's men then unhitched the mules from the wagons, set the wagons on fire and drove the mules to the Rio Grande. Driving the mules across the river, Ben turned the animals over to a rancher named James Mason. The rancher agreed to sell the mules and deposit the proceeds to Ben under his wife's name in a San Antonio. Leaving the ranch and heading downriver, they crossed into Mexico. Ben reported later in a newspaper article that he never saw the mules, the money or Mason again. "Some men are ungrateful rascals."

Reporting the wagon raid to General Mejia, Ben was offered the rank of major, which he refused. He did accept the general's offer to take some time off and let his men rest. Given time off, Ben did what he liked to do best: he made the rounds of the gambling tables. He and Captain Gilly finally wound up in a gambling house, where they were cleaned out—losing several hundred dollars, their watches and a diamond ring. Gilly had been drinking heavily and started yelling about his displeasure of losing all he had with him. He punctuated his lamentations with shots from his pistol.

Immediately, a squad of Mexican police rushed to the scene to confront the American fighters. With guns drawn, they demanded that Ben and

Gilly throw down their weapons and head down to the city jail with them. On their way to the jail, Ben spotted one of his men. Speaking rapidly in English, he was able to instruct him to get the rest of the men and meet them at the market house that was on the way to the jail. One of the Mexicans understood Ben's instructions and proceeded to pistol-whip him about the neck and head. Before he could finish the job of killing Ben, his men arrived, shooting at the Mexican policemen. Ben explained in a newspaper article that the man that went for help had garbled the story:

> *The men understood that the police had killed me at the market house. They waited for no further information. Not liking the police anyway, they grabbed their arms, and in undress rushed out into the street and commenced firing at every policeman they saw, and they made deadly work of it too, eleven or twelve were killed and as many wounded, and many more would have met like fate had not the firing aroused the camps.*

The next day, General Mejia sent for Ben to explain what had happened at the market house. The general accepted his account but warned him to stay away from the gambling houses and the Mexican police. Ben was quoted in the newspaper account as saying, "The fact is the life of a Mexican policeman was not valued very highly."

Shortly after the market house shooting, things started to turn against General Mejia and the imperial forces. On January 5, 1866, sixty-five riders from Texas crossed the Rio Grande and captured the garrison stationed at Bagdad. This was a group of freebooters, both American and Mexicans, who took advantage of the internal conflict to sack the port city and return to Texas with their loot. The liberals moved a small contingent of troops into Bagdad after the looters left for the border. They maintained control of the port for a few weeks until the imperial troops finally routed them.

This incident marked the beginning of the end of Maximilian's control of the country. One by one, the imperial military garrisons of Chihuahua City in the north, Mazatlan in the south and other cities fell to the insurgents— with most of the surrendering troops being executed. Commerce was suffering from the effects of liberal attacks on supply wagon trains from the interior. Merchants lost merchandise and supplies to the point that they now demanded that imperial troops accompany the trains for protection. In April, liberal forces attacked a large supply train headed for Matamoros.

General Mejia and Colonel Lopez with his regiment managed to fend off the raiders after a bloody fight. Then, after reloading in Matamoros, the wagon train was to return the two hundred miles to the city of Monterrey. General Mejia sent a force of two thousand men to escort the convoy, called a "conducta," to the interior city. Ben Thompson and his company rode point guard for the wagon train. He later recalled:

> *I was informed my company would be ordered, with a brigade of other troops, as an escort for a treasure train…My company was the advance guard on the march. No danger was looked for. Escabedo was thought to be many miles in the interior, and no other enemy force had been reported…We marched and camped and marched the next day until nearly four o'clock, when I was ordered to join the main body, as an attack was threatened from the rear…but by the time I reached the command, the attack had been made and the fight became general.*

It was a bloody battle, with imperial forces suffering heavy causalities. Ben reported that 1,100 of the 1,400 soldiers in the main body of troops were killed. His own company had been cut from 58 fighters down to 17 still able to ride. The defeat was devastating, as he later related the details: "Mules in every team had been killed. We were terribly whipped; the treasure lost. Nothing could be saved but the lives of the few who remained. It was suicidal to fight longer. The general gave the order to retreat, and in darkness and silence we left our dead comrades to the mercy of the jackals and crows."

During the fight, called the Battle of Camargo, several of Mejia's battalions defected to the liberals' side, further eroding the faith of his remaining troops. It was a dismal contingent that returned to Matamoros—in addition to the causalities, they had lost 250 wagons and merchandise estimated to be worth several million dollars. General Mejia issued an urgent call for reinforcements from the French general Douay in Vera Cruz. When Douay refused, Mejia knew that it was impossible to continue the fight. He contacted General Escobeda, who at this time was preparing to storm the fortifications of Matamoros. After some negotiations, Escobeda agreed to let Mejia surrender the city peacefully. In return, Mejia and his troops were allowed to keep their weapons and march to Bagdad to board French vessels.

During the time that Mejia was negotiating for surrender, Ben took the opportunity to take a last shot at the gambling houses of Matamoros. Once

again he was cleaned out at the monte tables, so he sought out the fandango (dance) halls for entertainment. While dancing with a woman, Ben spotted the policeman who had pistol-whipped him a few months before. The man saw him, walked over and asked Thompson to step outside. Ben obliged and later told the story of facing the Mexican this way:

> *He then had his hand on his knife. He seemed to hesitate a moment, but only a moment, drew quickly and dashed at me. I was just in time: a step sideways and backwards avoided the blow. I struck him on the head with my pistol, and then, as rapidly as thought, shot him four times. I don't think he even moved after he fell—and he commenced falling on the first shot—nor did I shoot after he touched the floor. The sound of the report had not ceased before I was out at the door and in the dark. Pursuit was made, but I was some distance ahead and safely reached the quarters of General Mejia…I explained to him, he said "Never mind, we will soon be far from here." He handed me two rolls of gold—two thousand dollars—and remarked: "Every man must be his own commissary."*

Ben thanked the general, took the money and, after writing a letter to his wife, sent a note to friend of his on the other side of the river. He asked the man to come over and get his mule, ol' Dan, for safekeeping until Ben returned to Texas. Ben planned to stick by his friend, General Mejia, and make the march to Bagdad with the imperial forces.

Maximilian's situation was deteriorating rapidly now. He had sent his wife, Carlota, back to Paris pleading for more troops, supplies and munitions. Napoleon refused, knowing that now that the United States had ended its civil war, it would be coming after him for treading on the tenets of the Monroe Doctrine. Tampico, a critical gulf port town, fell to the liberals after a long siege. Bagdad and Vera Cruz were under constant fire as the French troops retreated to ships bound for France.

Finally, the emperor was forced to flee Mexico City and retreat to Queretaro. He ordered Mejia and his other generals to meet him there for a stand against the liberal forces. This proved to be Maximilian's final military blunder. His garrison could not be defended from the shelling and gunfire from the surrounding hills. On March 5, 1867, General Escabedo and a force of forty thousand surrounded the city and laid siege. The siege lasted seventy-two days, with several bloody attempts to break out. Finally, with

the food supplies running bare and no water, some of the emperor's officers accepted a bribe and capitulated to General Escobedo's men. Maximilian and his two faithful generals, Mejia and Miramon, were captured and held for trial. A few weeks later, the three were tried and led before a firing squad. Maximilian handed each man in the firing squad an ounce of gold and asked that they take good aim on his heart, so his corpse would not have a disfigured face when it was returned to Austria for burial. He then pinned a scarlet piece of cloth over his heart to serve as their target, and each rifleman nodded his head. Satisfied with their compliance, Maximilian stepped to the spot he was to stand and calmly said, "I forgive everybody. I pray that everybody may also forgive me, and my blood which is about to be shed will bring peace to Mexico. Long live Mexico! Long live Independence!"

As the emperor was being executed, Ben Thompson managed to escape with a friend and in later years recounted:

> *Jean Lefebre and I determined to escape if we could. The capture of the Emperor and his two most trusted generals, Miramon and Mejia, gave a confused rejoicing to the enemy that permitted escapes that would otherwise have been impossible. We did escape from the town, changed our horses by force, or fraud, if you choose to call it so, and fled in the direction of Vera Cruz, wither we knew General Bazaine had withdrawn the French troops, the desire of our lives was to reach and get inside French lines… Two hundred and eighty miles; no American, no Frenchman, who was… [a] friend to Maximilian; the country aroused; every Mexican an enemy, and none but Mexicans on the line of flight.*

Ben and his friend did make it back to Vera Cruz and the safety of the French forces. Shortly after arriving, he contracted yellow fever and nearly died. He later recalled:

> *I had by great effort, fought blighting disease, and beat it back from me, but at sight of the city, energy gave and I was seized with the most malignant type of the yellow fever. The conviction fastened itself upon me that this sickness would end in death. I had seen thousands die; so few recover in sickness so deadly as mine. But I did not die; the sickness was long, and I rose a skeleton. Months had elapsed. The French were gone, and I, indebted for my life to the noble sisters of Charity…When I was sufficiently*

recovered to think and look about me, I found my money greatly decreased, though I know as I live that all the missing coins had been expended on me in my sickness and invalidism; besides, a stray newspaper, the New York Herald, found its way to me, and from it I learned that the civil government had been established in Texas, J.W. Throckmorton elected Governor. My heart longed for home. There was no barrier to my return; no reason why I should longer expatriate myself. I had done nothing for which I was afraid to meet the gaze of twelve jurors and hear the charge of any honest judge.

Returning to Austin, Ben had to face the reality that the military still controlled the state government and that his murder indictments were still active. He was wanted for killing John Coombs and for wounding the soldiers that resulted in his imprisonment before his escape to fight in Mexico. Knowing that he could be arrested if seen in Austin, Ben stayed with relatives in the county and only rode into town at night. His manner of dress reflected his years in Mexico; in his book, Walton described his appearance:

He was dressed in a thoroughly Mexican fashion—blue pants, with silver cords down the seams, buckskin jacket, embroidered in a hundred beautiful figures, wide stiff brim, low-crowned hat, with a golden snake coiled around it, as a band, and about his waist a red sash, covering his pistol belt and tied on in a double knot over his pistol and hiding it.

Dressed in this fashion and riding a fine thoroughbred horse with a silver mounted bridle and saddle, he found it easy to venture into Austin at night.

It was the horse that betrayed his disguise, drawing the attention of soldiers camped near the city. He left the horse at a farrier to be reshod, and when he returned, the soldiers were waiting. Walton described the verbal exchange between Thompson and the soldiers when he took up the horse's bridle rein and prepared to leave.

"Hold on, Mexico, what do you mean?"

"What is that to you," replied Thompson.

"You can't take that horse."

"Why not, he's mine."

"Who are you?" asked the soldier, seeing that it was an American dressed like a Mexican.

"I'm the owner of this horse, Let him loose." The soldier had caught hold of the bridle on the other side.

"This is Ben Thompson's horse," remarked the soldier somewhat excitedly.

"I know it," replied Ben.

"Then I arrest you," exclaimed the man, and he moved as if he would take hold of Thompson, drawing his pistol at the same time. But Thompson as quick as thought presented his pistol at the soldier's breast and said, in a tone that admitted of no hesitancy on his part, "Give me your pistol, or I shoot!"

Ben's determination persuaded the soldier to hand over his weapon and let go of the horse's reins. Thompson took off on his horse with a squad of soldiers hot on his trail. After a long chase, with the soldiers blazing away with their pistols and rifles, Ben was able to leap a fence and elude his pursuers.

Knowing that it was just a matter of time before he was arrested or killed, Ben contacted his lawyers and prepared to face trial for the charges against him. His gamble paid off, and he was eventually acquitted of all charges. Now free to practice his trade as a professional gambler, he turned to the tables to earn a living and further his reputation as a dangerous man capable of standing his own in any game.

As luck would have it, about this time Phil Coe and his partner Tom Bowles opened up a fine saloon in Austin. Coe was more than happy to grant the gambling concession to his old cavalry buddy and good friend Ben Thompson. The relationship and the business flourished, with Ben developing a sizable bankroll from his gambling table. Soon he was looking for bigger games in the towns surrounding Austin.

It was just such a game that he took on "Big King," owner of the Blue Wing Saloon in Bryan, just east of Austin.

Thompson was the dealer in a game of monte, with Big King being the bettor. When Ben cleaned him out, King put up the saloon—lock, stock and barrel—as collateral. The two men stayed at the game over the course of a day and night until King finally lost the last hand. Without a word he got up, pitched the keys to the saloon on the table and walked away.

Thompson's Blue Wing Saloon was short-lived. A few days later, a group of sore losers broke into the saloon and destroyed everything in sight. Not having the capital to replace all of the whiskey and broken fixtures, Thompson chalked it up to a bad run of luck and walked away from the saloon business in Bryan.

Chapter 5
Gambling in the Kansas Cow Towns

The Texas cattle herder is a character with but few wants and meager ambition. His diet is principally plug [tobacco] and whiskey and the occupation dearest to his heart is gambling.

—Topeka Commonwealth, *1871*

Ben Thompson did not have time to lament over the loss of his saloon business in Bryan. His brother Billy had killed a soldier in Austin and was on the run from the authorities. From what Ben could piece together, his brother had shot the soldier in a dispute at a sporting house. Following the incident, Billy took off for a hiding spot in the hills west of Austin. Eventually, with Ben's help, he managed to quietly make his escape to the Indian Territory in Oklahoma.

Following his brother's escape in the summer of 1868, Ben again felt the brutality of the Reconstruction forces that controlled civilian life in Austin. When a local man by the name of McGuire was jailed for killing some soldiers, Ben took up the man's cause and eventually shot a soldier by the name of Theophilus Brown. The soldier was wounded but did recover. Thompson and McGuire both wound up chained up in the "bull pen," a tortuous military stockade in Austin, where they were badly beaten and abused until their trial in September. Both men were found guilty; McGuire was sentenced to ten years in prison, while Ben was handed a four-year sentence.

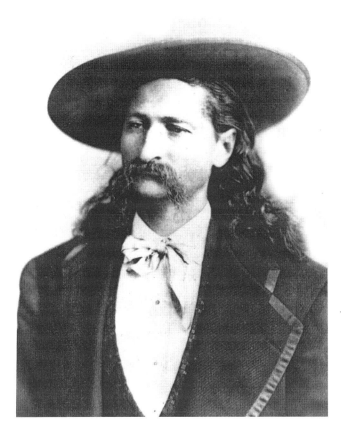

James Butler "Wild Bill" Hickok, the city marshal of Abilene, Kansas, who killed Ben Thompson's close friend Phil Coe. *Courtesy N.H. Rose Collection.*

After recovering from the wounds he received in the "bull pen" before the trial, Ben was forced to do hard labor at the Huntsville prison. Eventually, two years later, the political winds of Reconstruction started to shift, and he was granted a parole. He returned home to his family in Austin.

Soon, Ben was back at his gambling haunts and proving that his stay in prison had not diminished his skills at winning. Eventually, he won enough money to provide for his family and pay for his passage to the fertile gambling fields of Kansas. With thousands of Texas steers headed to Abilene, that was where the money could be made. Thompson knew that he could not allow this prime opportunity to pass.

In 1871, 150,000 Texas cattle were herded from Texas to Abilene, Kansas, for shipment to the eastern markets. Even more cattle were expected the following year, so Ben, along with other gamblers, wanted in on the pickings when money changed hands at the end of the trail drive. They arrived as

part of a horde of thugs, thieves, con men, cutthroats, murderers, prostitutes and other assorted characters eager to get in on the action. Abilene was a wide-open town full of saloons, gambling halls and bordellos.

The section south of the railroad tracks was referred to as "Texas Town," with Texas Street being the main thoroughfare. This street eventually led out to the cattle grazing grounds west of town on Mud Creek, so it became the daily routine for cowboys to ride up Texas Street looking for every vice that could be bought for the right price. At the corner of Texas and Cedar Streets, Jake Karatofsky had a general merchandise store heavily stocked with a large assortment of liquors. From this corner to the southeast corner of Mulberry and Texas were wall-to-wall saloons, gambling halls and sporting houses. From the northeast corner of Texas and Cedar Streets down to the Gulf House was another solid row of saloons and gambling halls.

These dens of iniquity ran twenty-four hours a day during the entire season that the cattle were being loaded onto freight cars. Brass bands, string bands, pianos, hurdy-gurdies and bawdy dance hall singers beckoned the cowboys to come in and spend money. After several months on the trail with little to look forward to but hot, hard work, the cowboys were eager to cut loose and have fun.

When Ben arrived about April 1871, the population was reported to have been less than five hundred people. By the time the season hit its peak in June, the population had swelled to seven thousand. The money was flowing, and Ben was in the thick of it. After having to hock his pistol several times, he finally managed to build a stake of just over $2,500 dollars. Phil Coe, his old army pal, arrived about this time with several thousand dollars in his pocket, eager to get in on the gambling traffic. Together they opened a saloon and gambling hall called the Bull's Head Saloon. Because they personally knew most of the Texas drovers, the saloon was a smashing success, and the money poured in.

The spring of 1871 also brought another notorious character to Abilene: James Butler Hickok—"Wild Bill" as he loved to be called—was hired as the city marshal and charged with the responsibility of "putting a lid" on the rowdy Texas cowboys. Apparently, the mayor and city council were pleased with the way he took control of the town. The mayor in particular thought that Hickok was honest and trustworthy; he was quoted as saying, "He was the squarest man I ever saw." In his book on Thompson, Walton took a different view of the lawman:

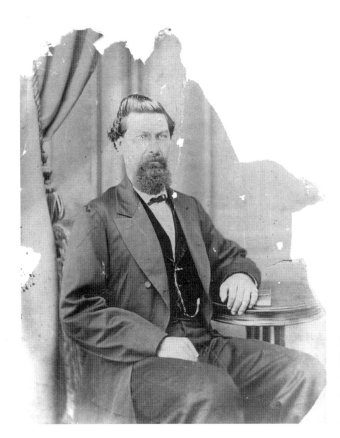

Phil Coe, close friend
of Ben Thompson.
They were partners in
the Bull's Head Saloon
in Abilene, Kansas.
*Courtesy Texas State
Library Archives.*

*About him, around him, with him were associated and congregated the worst
set of men that ever lived. He and the city authorities were in colleague, and
in all things acted together—whether in the murder of a man for money, or
picking the pocket of a sick stranger. The sure thing men, three-card-monte
boys, top and bottom scoundrels, red and black devils, dollar store thieves,
confidence gentlemen, pocketbook grabbers, and ropers-in were the intimate
friends, and shared their plunder with Wild Bill, he doing his part by
protecting them from the fangs of the law.*

Granted that Walton, being Thompson's friend, probably depicted
Hickok in the direst terms. This view, however, was also prevalent among
most of the Texas cattlemen and the cowboys at the time. They did not like
this frontier dandy with long blond hair, a drooping mustache and custom-
made boots. Standing slightly over six feet, he weighed two hundred pounds

and definitely caught the attention of the ladies. General Custer's wife, Libbie, described Hickok in a book she wrote in 1890: "Physically, he was a delight to look upon. Tall, lithe, and free in every motion, he rode and walked as if every muscle was perfection, and the careless swing of his body as he moved seemed perfectly in keeping with the man, the country, the time in which he lived."

What Libbie Custer did not mention in her book was the fact that along with the wide-brimmed black hat and Prince Albert frock coat, Wild Bill wore a pair of ivory-handled Navy Colts in a special rig that held the pistols butts forward. He also carried a brace of single-shot derringers in his coat and a large Bowie knife in a back holster. Having the reputation of killing

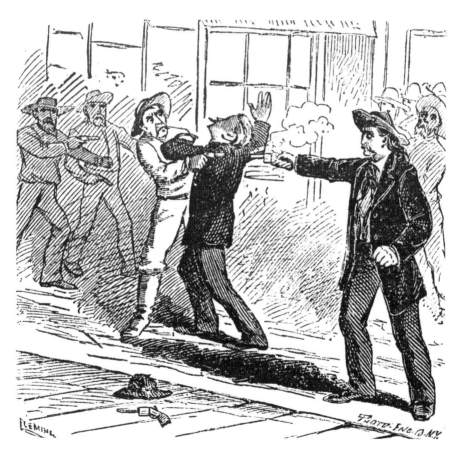

A drawing showing "Wild Bill" Hickok killing Phil Coe from W.M. Walton's book *Life and Adventures of Ben Thompson the Famous Texan*, published in 1884.

several men in brawls and shootings, he wanted all who came near him to see that he was armed and ready to use the weapons if needed. He was cool, calculating, coldblooded and most of all brutal.

Wild Bill took over the position of the town marshal after the previous marshal, Tom Smith, was killed in the line of duty. Marshal Smith's trademark was upholding the law without carrying a firearm—which, though noble, proved to be his downfall. A local farmer had attacked him with an axe, nearly decapitating the lawman. Abilene's mayor wanted an iron-fisted marshal to replace Smith—one who could use a gun and not be afraid to take on the wild bunch of people associated with the cattle drives.

Hickok was paid $150 per month and got a percentage of the fines that were levied. Undoubtedly this proved to be quite lucrative for Hickok, and if reports are true, he took great pleasure in his harsh dealings with the Texans. Various accounts relate how this ex-Union soldier relished the opportunity to humiliate and derogate these unrepentant Confederates from Texas. Whether these accounts are accurate is hard to determine, but it remains a well-established fact that there was a great deal of bitterness between the Abilene marshal and the Texans.

Ben Thompson, Phil Coe and the Bull's Head Saloon represented the focal point of activity for the Texans and Wild Bill. Bad blood developed between the saloon owners and Hickok immediately. Rumors began to swirl around town that Ben and Phil had offered John Wesley Hardin, a young gunfighter, a sizable sum of money to kill Hickok. For his part, Wild Bill let it be known that he was "keeping his eye on the saloon and its owners." Things continued to boil until there was a tragic shoot-out in the streets of Abilene in which Hickok shot and killed Phil Coe, as well as a private duty deputy, Mike Williams.

How and why the shooting occurred has become muddled with the passing of time. There are at least three versions of the story, and historical research has found flaws in each version.

John Wesley Hardin's version illustrates the most oft-repeated story, from his memoirs written many years later. He said that the killing came about as the result of the city council's objections to a sign that appeared over the saloon. Hardin wrote:

> *Phil Coe and Ben Thompson at that time were running the Bull's Head saloon and gambling hall. They had a big bull painted outside the saloon*

as a sign, and the city council objected to this for some reason. Wild Bill, the marshal, notified Ben Thompson and Phil Coe to take the sign down or change it somewhat. Phil Coe thought the ordinance all right, but it made Thompson mad. Wild Bill, however, sent up some painters and materially changed the offending bovine.

Contrary to what Hardin wrote in his version of the story, Thompson apparently was not too upset about Wild Bill's sign painters reworking the bull's anatomy. A short time later, he left town to meet his wife and son in Kansas City for a family vacation. While there, they were involved in a buggy accident that left Ben with a broken leg and his son with a fractured ankle. His wife, Kate, was the most seriously injured and eventually had to have her arm amputated. They were taken to the Lindell Hotel in Kansas City, where they spent three months in convalescence before returning to Texas.

During this time, while Ben and his family were confined to bed care, trouble continued to build between his partner and Hickok. Finally, on a cold night in October, the bitterness came to a head on the streets of Abilene. Here is where many of the details vary, depending on who is telling the story. Newspapers of the day and eyewitnesses later related that the city council members had decided that they could live without the cattle trade. Wild Bill was instructed to shut down the crooked games in the back rooms of the saloons and generally clean up the Texas Town section. Finally, at the end of the cattle season, the city officials came to an agreement with the Texas cattlemen that called for them to move the destination of the following year's cattle drive to Ellsworth.

Walton told another version of the story in his biography of Thompson. He wrote that the trouble began between Coe and Hickok over a "scarlet woman" by the name of Jesse Hazel. He described an incident in which a very drunken Wild Bill found Jesse and Coe drinking wine in the parlor of the Gulf House. Infuriated, Hickok attacked Jesse:

Wild Bill came in and roughly kicked at her. He struck her under the chin and knocked her senseless. Phil did not have time to move until it was all over; it was done so quickly. But he did move, in a decided way. He kicked Wild Bill out of the room and down the stairway, bruising him up badly, and would have killed him had not Jesse's situation called for aid.

Drawing of Ben Thompson weeping by Phip Coe's casket by J.F. Eaton as it appeared in W.M. Walton's book *Life and Adventures of Ben Thompson the Famous Texan.*

Walton continued the story, saying that as soon as Coe had taken care of Jesse, he got his pistol and started searching for Hickok. By this time, Wild Bill was not to be found; he had wandered off and passed out somewhere, dead drunk. The next morning, Hickok sobered up and apologized to Coe, but the stage was set for the final showdown to come a few months later.

According to Walton, at the time the cowboys were preparing to leave, they decided to have one last fling in town. Phil Coe and a bunch of the Texans spent the late afternoon drinking and carousing in the streets of Texas Town. Finally, Phil and his drinking buddies had a dog charge at them, as Walton relates the story:

> *Phil and his friends went westward to the corner, when a savage dog tried to bite him. He pulled out his pistol and shot him, and then turned up the street northward and stopped in front of a saloon and leaned against a post. Wild Bill had heard the shot, and passed from the clothing store into an alley that ran alongside, and up the alley until he got in the rear of the saloon in front of which Phil was standing. He passed into the rear of the saloon, and through it to the front. Arriving at the front he stopped and said,*

"Phil Coe, you ought not to have shot your pistol off," and this he said in a laughing and kindly way. At this moment something further up the street occurred, and one of the boys said, "Look yonder, Phil." Coe looked, and as he did so Wild Bill pulled two derringer pistols from his pocket and emptied them both without a word, sign or warning, into the heart of Coe, and at once jumped back behind the door. Coe was mortally wounded, but he did not fall. Instead of falling, he pulled out his pistol and shot three times at the assassin. But his nerves were too unsteady. The bullets only hit in the door facing and glanced away.

It is at this point that Mike Williams, the private duty deputy working for the Novelty Theater, ran up to help Hickok in the gunfight. Wild Bill turned and saw a man running at him with a gun in his hand. It was dark, and by this time glaucoma had taken a toll on his vision, so acting on instincts he hit him with two deadly shots.

Theophilus Little, an eyewitness to the shooting, later recalled that after killing both Coe and Williams, Hickok turned to the rest of the cowboys and calmly said, "If any of you want the balance of these pills, come and get them." Suddenly, the crowd sobered up and went quiet. Hickok stared at them for a moment and then said, "Now every one of you mount his pony and ride for his camp and do it damn quick."

Whatever the cause or circumstances of the shooting were, when it was over Hickok was still standing, and two men later died. Some accounts even say that he cried over killing Williams and called a preacher for Coe. Melodramatic or reality, it is hard to say this far removed from the incident. As it turned out, Wild Bill was discharged from his job a short time later. He never killed another man.

The following day, a Texas cattleman, Bud Cotton, left Abilene with Coe's remains in a wagon. On his way back to Texas, Cotton came across Ben Thompson and his family riding a stagecoach. They were traveling back to Austin to finish recovering from their injuries and had heard nothing of the Abilene shootings. Cotton broke the news to Ben and showed him the coffin that was in his wagon. Walton said in his book that Cotton told Thompson that he was there at the time of the shooting and could report the truth, "the way, and why, and manner of the killing of Phil Coe." He said that Coe never stood a chance because the mayor wanted him out and didn't care how Hickok did it:

In a few hours poor Phil died, and here I have his body to bury in the soil he loved so well. It was necessary for me to see the mayor before I could remove the body. On my application to remove, he wrote on the back of it: "The law has been well executed on Phil Coe. I have read what the faithful Wild Bill says about the killing. His body may be removed."

Thompson agonized over his best friend's death and vowed that he would even the score with Hickok. At the time, he could do little more than get his family back to Austin and recover from his injuries. It was a long recovery, but finally, after nearly a year, he returned to the cattle towns of Kansas. This time he went to Ellsworth, which had taken Abilene's place at the railhead for the cattle drives. Most of the saloons and businesses simply pulled up stakes in Abilene and set up again in Ellsworth. The business district was approximately three blocks long on each side of the railroad tracks—with two main streets, North and South, running parallel to the tracks. The market had been profitable in 1872 for the people of Ellsworth, and 1873 was predicted to be bigger.

The herds started arriving in May, and soon the money was flowing again. Ben and Billy Thompson arrived in early June and checked into the Grand Central Hotel. Having lost all he had in the Bull's Head Saloon, the best Ben could do was to pawn jewelry and borrow money for a stake to set up shop with the gambling tables in the back room of Joe Brennan's saloon. The saloon was located on South Main, and Ben quickly developed a lively trade at his tables. Once again the money rolled in. Things were looking up for the Thompson boys, but not for long.

After a few weeks of fast and lucrative business at his gambling tables, Ben faced another major turning point in his life. One day, as the gambling money was rapidly changing hands, a man by the name of Neil Cain was dealing monte to a player named Cad Pierce. Cad had a large stake and wanted to raise the betting limits over what Neil was willing to take. Cad asked Ben to see if some of the other gamblers would cover what bets Neil could not take. Ben walked over to Bill Martin, a real high roller, and asked if he wanted in on covering Cad's bets. Martin replied, "Ben, I'll take him for all Neil don't want, but say, Ben, if I win, consider yourself one half in."

The play continued, with all eyes on the monte table. Martin was drinking as he watched Cad lose more and more money. Finally, after Martin had won $1,000 from Cad, he abruptly gathered up his winnings, stuffed it in his

pockets and walked toward the door. According to Walton, Ben called for his share of the winnings: "Hello, Bill, ain't you going to divide the velvet?"

Martin replied, "No; I am not going to divide, damn you," and then continued, "You don't claim any of my winnings, or if you do, you'll get none." This he said abruptly and in the most insulting manner.

Ben said, "I did not care anything about the matter, but since you act as you do, I do claim an interest."

"Well, you can claim on, that will be all, for of this money you get none," Martin replied; without warning, he struck Ben in the face.

Ben drew his pistol and would have shot Martin but was prevented by a city policeman, "Happy Jack" Morco, who happened to be in the saloon at the time. The lawman promised to take care of the man and that there would not be any further trouble. Walton continues the story: "In a few moments Martin returned and had with him some armed companions, he himself having a double barrel shotgun. When he got to the door, or near to it, he cried out loudly: 'Come out here you Texas fighting sons of bitches,' and the parties flourished their weapons in the most threatening manner."

Ben ran to a back room and got a Henry rifle, while Billy grabbed up a shotgun. They ran to the door, and as they did, Billy's shotgun accidentally discharged. He had been drinking, and the gun was thought to have had a hair trigger. The blast narrowly missed a bystander but did no damage.

Outside, Martin and his crowd thought that the Thompsons were making a firefight of it and took cover. Ben and Billy rushed through the door and into the street, finding cover behind a fire engine as gunshots roared from Martin's side of the street.

Happy Jack and Ed Hogue, another policeman, were a part of the Martin faction and were blazing away at the pair behind the fire engine. Finally, Sheriff Chauncey Whitney arrived on the scene. Being a personal friend of Ben's, he managed to get everyone to stop shooting and went to the fire engine to talk with the brothers. After a brief conversation, Ben and Billy agreed to accompany the sheriff to the safety of the Grand Central Hotel. They promised not to shoot at anyone unless someone shot at them. The sheriff and Billy walked a few feet ahead of Ben while he kept a close eye on their rear. Walton gives Ben's account of what happened next:

Glancing behind me when near the hotel, I saw Happy Jack, about sixty yards away, come around the corner of a store, gun in hand, and in the

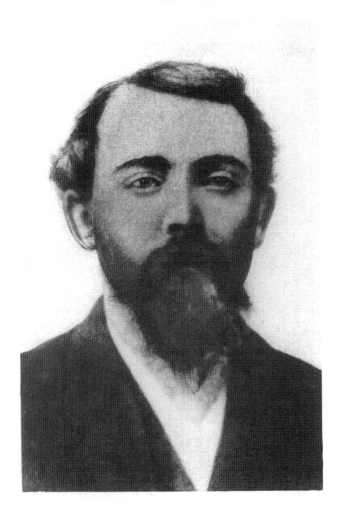

Sheriff Chauncey Whitney, a friend of the Thompson brothers. Billy accidentally shot and killed him in a shoot-out in Ellsworth, Kansas, in 1873. *Courtesy N.H. Rose Collection.*

attitude of presenting it at me, though to have shot would have as likely hit the Sheriff and Billy as me. I right-about faced instantly, and drew my gun down on him and fired, but he dodged behind the corner from which he had come, too quick for me. This conduct on his part enraged me, and for that reason started at a rapid pace toward him. This shooting drew the attention of the Sheriff and Billy, the latter of whom stopped, while the other started toward me. Just then Happy Jack stepped from behind the corner again in an excited manner, holding his gun in both hands. I heard the report of a gun from behind me, and, turning, found that Sheriff Whitney had been shot. I ran to him, all thought of Happy Jack leaping

out of my mind. I also saw Billy lowering his gun; I exclaimed, "My God, Billy, what have you done; you have shot our best friend." He came running up, and said, "Christ, what a misfortune! I tried to shoot Happy Jack, I stumbled and shot Whitney."

Billy, standing there in a drunken daze, watched his brother tend to the sheriff, who lay dying in the street calling for his wife. After Ben saw that the man would not make it, he turned to his brother, gave him a pistol and some money and told him to get out of town. A friend supplied a fast horse, and Billy was able to get away before being shot by the opposing mob.

Ben stood off the mob with his Henry rifle until the mayor of town arrived. After a brief discussion, Ben was able to broker a deal to surrender

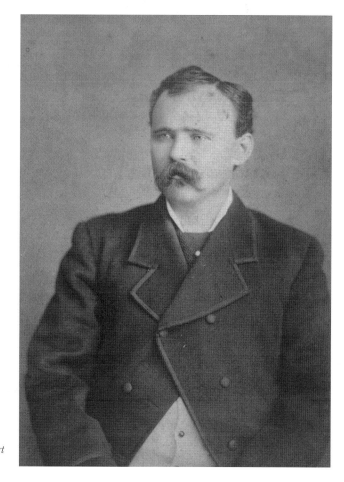

Rare photograph of Ben Thompson taken in 1879 while he was working the gambling tables in the cattle towns of Kansas. *Courtesy Robert McCubbin Collection.*

to the mayor if Happy Jack and Ed Hogue would disarm. Later, under the mayor's protection, Ben was able to post bond and return to his room at the Grand Central Hotel.

This event in Ellsworth's history is yet another tale with multiple versions. Some accounts have Ben using a Henry rifle to hold off the mob, while others say he reloaded the shotgun and threatened to kill any and all who tried to take him. Between Ben's account, eyewitness accounts and newspaper reports, all differ on a number of key details. Even Wyatt Earp, in his memoirs, claimed that he stood down Ben after the killing and took the shotgun from his hands. There is no evidence to support Earp's claim, but the story is still passed around in other written accounts of the shooting.

That night, while attending a theatre, Ben got word that Billy had returned to town. He found him hiding in an upstairs room, sober as an undertaker and frantic with fear. There had been too many men looking for him, and Billy thought he stood a better chance coming back to disguise himself. Finally, after cutting his hair, dying his skin and dressing the part, Billy rode out to the herds at the edge of town as a very convincing Mexican vaquero. Eventually, he was able to get away to a safe location several hundred miles from Ellsworth.

Ben later had a lawyer try to shake him down for $500 to defend him in the case. According to Walton, the crooked lawyer wanted the money for his services, as well as bribes for the judge and the state attorney. Thompson refused to pay the money and stood his ground. Eventually, he was acquitted of charges and left town for Kansas City.

Before he left town, Ben had a talk with his old friend, Cad Pierce. He warned him about the threats of vigilantes that had formed to rid the town of the undesirable Texans. Cad elected to stay put, and a short time later he was confronted by Ed Hogue, who was now the city marshal, and his deputy, Ed Crawford. After a bitter exchange of words, Crawford drew his pistol and shot Pierce. Then, following the wounded man into a clothing store, Crawford finished the job by pistol-whipping Pierce to death. This killing marked the beginning of the end of Ellsworth as a cattle town. The vigilantes continued to make life difficult for the remaining Texans until most of them boarded trains and left. But before leaving, three unidentified men caught Ed Crawford in a bordello and put thirteen bullet holes in him before he could button up his pants. The next night, five men rode up the street where Happy Jack was standing and filled him full of lead. Later,

the city council fired the entire police force, including Marshal Ed Hogue, who was run out of town and eventually hanged in another community for horse stealing.

Ben soon left Kansas City and went to St. Louis. He then traveled by riverboat down to Cairo and on to New Orleans. A few weeks later, he was back at home in Austin, and he returned to his established business of working the gambling tables in saloons.

During the winter of 1875–76, Ben moved his operations to Sweetwater (now called Mobeetie) in the Texas panhandle. Located near Fort Elliott, Sweetwater at the time was a haven for buffalo hunters and soldiers—all eager to risk their earnings at the gambling tables. Charles Goodnight described the town as being "patronized by outlaws, thieves, cut-throats, and buffalo hunters with a large per cent of prostitutes. Taking it all, I think it was the hardest place I ever saw on the frontier except Cheyenne, Wyoming."

Ben's brother Billy, still dodging the law, briefly ran a Sweetwater dance hall that featured a woman named Mollie Brennan. She had followed Billy to Texas from Ellsworth, where the two had been lovers. When Billy smelled the law closing in on him, he quickly disappeared, leaving Mollie to fend for herself. She was working in the Lady Gay dance hall when Bat Masterson, a noted buffalo hunter and army scout, spied her and quickly replaced Billy in the woman's affections. At the same time, an army sergeant by the name of Melvin A. King from the nearby fort decided that he would claim Mollie for himself. King was known as a bully and was used to getting his way through intimidation or outright brawls. On a bitterly cold night on January 24, 1876, King decided to eliminate his competition once and for all. What happened next comes to us in several versions, all passed down verbally as there were no newspapers in Sweetwater or official reports filed. The story told by Wyatt Earp's biographer, Stuart N. Lake, reflects Earp's memories of Masterson's description of the story when he arrived in Dodge City later that year.

According to Wyatt Earp, Mollie was dancing with Masterson in the Lady Gay dance hall when King arrived with some of his soldiers, all thoroughly drunk and ready for a fight. King drew his revolver and fired at the couple on the dance floor, striking Mollie in the abdomen and Masterson in the groin. Both of them slumped to the floor, but as they did Masterson managed to pull his Colt .45 and shoot King. The sergeant died instantly with a bullet hole through his heart. Mollie also died, and Masterson lay wounded on

the dance floor. King's friends pulled their pistols and would have killed Masterson had Ben Thompson not been present. Whether the two knew each other at the time is unknown, but according to Earp's account, Ben jumped up onto a faro table, pulled his pistol and warned the soldiers he would kill anyone who tried to finish Masterson. Though drunk, King's friends had enough sense to see that Ben meant what he said, and they backed away so Masterson could be removed for medical treatment. He was later taken to the surgeon at Fort Elliott, who removed the bullet and looked after him until he could ride on to Dodge City. As a result of the wound, Masterson walked with a limp for the rest of his life.

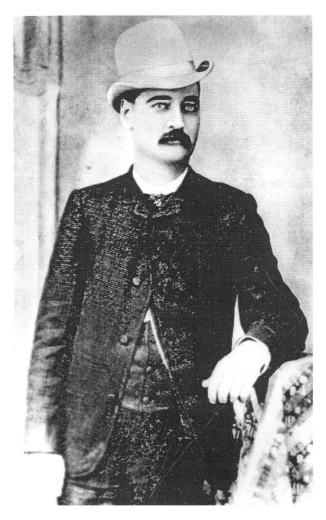

Bat Masterson and a dance hall girl named Mollie Brennan were shot in a Sweetwater, Texas saloon. Ben Thompson was credited with saving Masterson's life after the shooting. *Courtesy National Archives and Records Administration.*

After his brief stay in Sweetwater, Billy Thompson resumed running from the law by moving from one point to another in Texas. During the fall of 1876, he was working cattle for Neil Cain, who lived northeast of Austin. Late in October, Captain J.C. Sparks of Company C, Frontier Battalion of the Texas Rangers, raided the Cain ranch looking for stolen cattle. In the process, they found Billy, who was unarmed at the time and surrendered without resistance. They arrested him for the murders of Sergeant Burke in Austin and Sheriff Whitney in Ellsworth. Billy was taken to Austin and jailed. After several attempts by Ben to have him released through legal maneuvers, Captain Sparks and two rangers took him back to Kansas by train. Once back in Kansas, Billy was moved several times to avoid his being strung up by lynch mobs. Finally, on September 5, 1877, Billy's trial began in Ellsworth.

Ben did not go to Kansas but rather sent his brother-in-law, Robert Gill, to arrange for J.D. Mohler, A.H. Case and Phil Pendleton to represent Billy at the trial. Ben stayed in Austin, where he could finance his brother's defense through his gambling. Business was good, and he soon had a sizable bankroll to provide for his family and take care of Billy's legal costs.

Before long, Ben had legal problems of his own in Austin as a result of a shoot-out with Mark Wilson, the owner of the Senate Saloon and the Capital Theater. Shortly before Christmas in 1876, James Burditt, the man who loaned his horse to Billy for his getaway from Ellsworth, had been arrested for a disturbance in the Capital Theater. A running feud developed between Burditt and the owner, Mark Wilson. On Christmas Eve night, Thompson was in the Capital Theater watching a performance when someone in the audience lit a string of firecrackers. Everyone roared and laughed at the disturbance, which brought the performance to a halt. Mark Wilson stepped out into the audience and, seeing Burditt, accused him of creating the disturbance. He then ordered a private duty policeman named Allen to arrest Burditt and take him to jail. At this point, Thompson stepped in and offered to escort Burditt out of the theatre, promising to have his friend at city hall on the following morning to face charges. Walton, in his book, quotes Wilson as saying, "Who is running this house, you or I, Mr. Thompson? You attend to your business and I will attend to mine." Thompson replied, "I am attending to my business, and that in this instance is keeping a friend from going to the lock-up, when there is no necessity for it."

Wilson, being a hotheaded Irishman, let out a tirade of abuse on Thompson, calling him the instigator of the disturbance. Thompson

denied any involvement, and when Wilson called him a liar, he slapped the man's face, cutting him with the heavy ring that he wore. With blood streaming down his face, Wilson raced to the bar, grabbed a double-barreled shotgun and fired one barrel at Thompson. The blast tore a hole in the rear wall but missed Thompson. At the same time, the bartender leveled a Winchester at Thompson and got off a single shot. The bullet cut a hole through Thompson's coat but did not cause an injury. Wilson was cocking the hammer on the other barrel of his shotgun when Thompson sent three bullets into him, killing him instantly. The bartender got off two more shots at Thompson before dodging behind the bar. Uninjured, Thompson estimated the bartender's position behind the wooden bar, leveled his pistol and pulled the trigger. The bullet hit the man in the mouth, knocking out most of his jaw teeth and lodging in his neck. He died a few weeks later.

Thompson held his ground, watching to see if anyone else would be shooting at him. After a moment of silence, he backed his way out of the

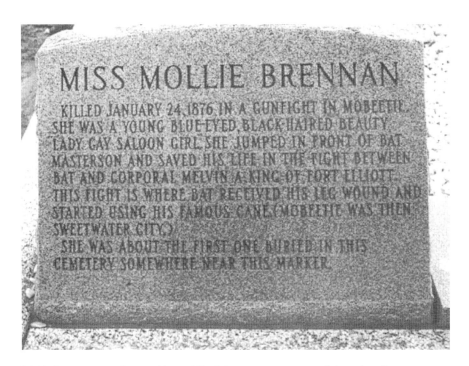

Mollie Brennan's tombstone. She and Bat Masterson were gunned down in a Sweetwater, Texas saloon. Ben Thompson was said to have saved Bat's life after the shooting. *Courtesy O.T.T. Collection.*

smoke-filled theatre and walked to the sheriff's office. He surrendered and, knowing that a lynch mob was likely, said:

> *Don't endanger yourself for me, prepare me with a few good pistols, I will defend myself; They will kill me of course, but I will not die like a lamb, there is nothing to justify this outburst of public feeling—life has been taken, but it was justified by every law of self-defense, somebody had to die, the dead men were the aggressors, seeking my life.*

The sheriff locked Thompson in jail, and a few days later at the examining trial, he was charged with murder and not allowed bail. His legal team of Walton, Green and Hill went to the court of appeals in Galveston and won his freedom after posting a $5,000 bond. It was during this time that one of the lawyers, William "Buck" Walton, developed a friendship with Thompson that would continue until Thompson's death and ultimately resulted in Walton writing the gunfighter's biography.

Ben Thompson and James Burditt were tried at the May term of the district court in Austin. By now, things had cooled down, and Thompson's lawyers presented a convincing case for self-defense. At the end of the trial, the jury found Burditt guilty of simple assault, and he was fined twelve dollars. After a few minutes of discussion, the jury returned with a not guilty verdict for Thompson.

Shortly after he was acquitted in the Mark Wilson killing, Ben Thompson was said to have been part of the last major Indian conflict. In his book, Walton says that Thompson told him that he rode with Captain Edward Burleson's company of rangers to rid west Texas of the Indians who were raiding ranches and settlements. In his book, Streeter repeats the story, listing Walton's book as the only source. In reading the account, it sounds more like the melodrama of a dime novel than an actual event.

According to Thompson's story, they had been out on the trail of the Indians for forty days without finding them and decided to pitch camp north of the headwaters of the North Concho River. On the third day of their bivouac, Captain Burleson sent Ben and a friend named "Buckskin" Sam out to scout for Indian raiders. As they made their way down a grassy slope, a charging herd of buffaloes thundered after them. A large party of Indians was chasing the animals, and when they spotted the two men, they broke off and went after them. Ben and Sam high-tailed it in the direction

of Burleson's camp, with the warriors in hot pursuit. Firing at the Indians as best they could, they managed to kill a few of the lead riders, but eventually Ben's horse went down. Freeing himself from the dead animal, he crouched behind the horse and kept firing at the approaching Indians. Sam joined him, and the two were on their last rounds of ammunition when Captain Burleson and his men came charging over a hill. After a brief skirmish, the Indians gave up on the white men and returned to their pursuit of the buffaloes.

Historical research can not confirm this story. As to riding with Burleson's rangers, it would have to have been before 1877, when he died in Austin. George W. Baylor and his rangers did chase Apaches in far west Texas in 1879 and eventually fought the last Indian battle at Eagle Springs in January 29, 1881, but Thompson was not part of this company.

Meanwhile, back in Ellsworth, Billy was facing his own trial for the murder of Sheriff Whitney, with Ben sending money for his defense. The trial lasted ten days, and after one hour of deliberation, the jury announced a verdict of not guilty. The people of Ellsworth were shocked at the verdict. They expected a minimum of twenty years in prison and could not understand the jury's stance that the shooting was accidental. As we think back to Ben Thompson's complaints about being badgered by a lawyer seeking money to bribe the judge and state attorney in his own Ellsworth trial, we might suppose that he used his resources to "fix" the trial for his brother. It is a distinct possibility, but there is no surviving evidence to prove that the trial was rigged.

In the spring of 1877, the Thompson brothers traveled to Dodge City, the next major cattle town in Kansas. A.A. Robinson, the chief engineer for the Atchison, Topeka & Santa Fe line, had laid out the railhead town. They named it Dodge City after Colonel Richard I. Dodge, the commander of the post at Fort Dodge. Because of its wild and woolly reputation, it had a number of other choice names. The story goes that a cowboy, deep in his cups, flagged down a train at a way station. After he stumbled on board, the conductor asked him where he was headed so he could sell him a ticket. The cowboy fumbled in his pockets and produced a handful of money. Then with a heavy, drunken slur, he said, "I wannta go to hell." The conductor was quick in responding. "Get off at Dodge. That'll be a dollar, please."

Dodge's famous Front Street became the focus of the town's businesses, which included a large number of saloons, dance halls and gambling rooms. Saloons with names such as the Long Branch, the Alamo and the Lone Star catered to the cowboys and cattle buyers, providing the finest

brandies, liqueurs and ice-cold beer. Most of the saloons offered musical entertainment—a piano, hurdy-gurdy or banjo player kept it lively. The Long Branch Saloon even sported a five-piece orchestra. Buffalo hunters, railroad workers and soldiers mixed in with the cowboys, drifters, card sharks and painted dance hall girls. The times were wild, and the law was slow in developing. Fights, shoot-outs, robberies and general hell-raising was the norm, with many of the participants winding up at the infamous "Boot Hill Cemetery"—being buried with their boots on.

Law and order finally arrived in the form of W.B. "Bat" Masterson, who had the ominous task of corralling the wild bunch south of the railroad tracks. No guns were allowed north of the tracks, where respectable people conducted business and lived. Bat had been a successful buffalo hunter, and as that trade started to fold, he turned his talent with firearms into enforcing the law in Dodge.

Once again setting up operations at gambling tables in saloons, the Thompson brothers plied their trade with all comers and were very successful at raking in the money. Fortunately, Dodge City proved to be less violent for the pair, as they managed to avoid killing anyone. Ben did run afoul of the law in an incident that occurred in the Comique, a theatre on Front Street in Dodge. Ben had been drinking, and he found one of the performers, Eddie Foy, sitting at a table behind the stage. Thinking that he would have some fun at the comedian's expense, Ben told the man to move so he could shoot out a lamp behind the man. When the man did not budge, Ben threatened to shoot the man to hit the lamp. There was a dangerous moment of silent standoff. Then Masterson rushed in and grabbed Thompson's pistol. After some coaxing, Ben was ushered out of the Comique, and no charges were made against him.

According to Wyatt Earp's account in his memoirs, this was the second encounter between Masterson and Thompson—the first being in Sweetwater when Thompson held off a room full of soldiers hell-bent on killing Masterson, who lay wounded on the saloon floor. If this is true, then there was an established friendship between the two men, enabling Masterson to convince Thompson into backing down from his threats to Foy. The entertainer went on to finish his tour of the western frontier and would later relish in telling a breathless account of his narrow escape from the famous gunman Ben Thompson.

Did Ben really intend to shoot Foy? He probably didn't. More than likely, it was a drunken prank played on a dude from back east meant to

Billboard for Eddie Foy, the famous touring comedian. Bat Masterson is credited with preventing a drunken Ben Thompson from shooting him in Dodge City, Kansas. *Courtesy National Archives and Records Administration.*

be entertaining to those watching the encounter. The episode did mark a turning point for Ben in that his drinking was starting to progressively increase, and periodically he would go on drunken binges very much like his father and brother. Sober, he was friendly and congenial, but when on a bender he was aggressive and mean-spirited. This particular episode served as a harbinger for his eventual showdown with destiny seven years later.

Chapter 6
Leadville and the Royal Gorge War

The Atchison, Topeka, and Santa Fe have about 150 men under arms and the sheriff 100. A collision is imminent.
—*Telegram to Colorado governor F.W. Pitkin*

Following the cattle season in Dodge City, the Thompsons returned to Austin and continued their practice of staying well heeled from the profits of their gambling. Then, in the spring of 1879, Ben left with a friend named Frank Cotton for the Colorado mining town of Leadville.

Silver had been discovered in 1876 on the Arkansas River near Leadville. Thousands of prospectors flooded the area, and fortunes were made daily. One of the local merchants, Horace Tabor, grubstaked two German shoemakers with two picks, two shovels, enough food for a week and a jug of whiskey—coming to the grand total of thirty-seven dollars. A short time later, they hit the mother lode, and the Little Pittsburgh Silver Mine was started, making all three men millionaires. Tabor went on to buy the Matchless Mine, which produced $2,000 per day in high-quality silver ore.

Shortly after becoming one of the richest of the Colorado "Silver Kings," Tabor divorced his wife and married a trollop named Elizabeth McCourt Doe, or as she was known, "Baby Doe." Bedazzled by her beauty and eager to impress his new love, Tabor escorted her to the opulent Tabor Opera House that he had built on Harrison Avenue. It was billed as the finest theatre between St. Louis and San Francisco. At one time or another, all of

the great performers of day played at the Tabor Opera House, including John Philip Sousa, Anna Held and Oscar Wilde.

When Ben Thompson and Frank Cotton strolled past the opera house on Harrison, they found the Clarendon Hotel, which had also been built by Tabor. This fancy hotel had an elevated walkway to the third floor of the opera house next door. A little farther on, they passed the Quality Liquors building that housed the Joslin and Park Jewelers, touted as having the most complete stock of diamonds, jewelry, watches, chains and clocks in all of the western frontier. Jewelers were always a necessity for gamblers in evaluating rings, watches, stickpins and other articles offered as collateral in games of chance.

Also on Harrison Avenue, Thompson had his choice of a large selection of saloons. The Board of Trade Saloon opened in the Clipper Building, while Adolf Newsitz opened his saloon farther down the street. Around the corner on State Street sat the Pastime Bar, followed by another long row of saloons and dives. Thompson could hear the tinkling of whiskey glasses, the rattle of dice and the soft slap of cards on felt-topped tables as he passed each saloon. He and Frank were in familiar surroundings. Yes sir, there was money to be made in Leadville, Colorado.

Unfortunately, Ben quickly found out that a Leadville gambling operation would be vastly different from setting up in the cattle towns of Kansas and Texas. He was used to paying a small weekly rent or a percentage to the saloon in which he practiced his trade as a dealer at the monte or faro tables. This was not so in the Colorado mining town, where the price of everything was heavily inflated. In a column that appeared in the *Austin Daily Statesman* dated March 6, 1879, Ben was quoted as describing the difficulties of trying to run an honest gambling table in Leadville:

> *It is impossible for me to describe this city fully. It is a city of ten or fifteen thousand inhabitants, of which about twenty-five hundred are ladies. Leadville has a water works and is soon to have gas, and a street railroad…One variety man pays for his house seventeen hundred dollars per month rent and at least two thousand a week for performers. He takes in about six or seven hundred a night for drinks at five dollars a bottle in the conversation parlors, where visitors are entertained by the lady performers… Houses for sporting and saloon business rent for five to ten hundred per month, which shuts out all legitimate business…Bedrooms, ten by twelve in size, scantily furnished, rent readily for sixty dollars a month.*

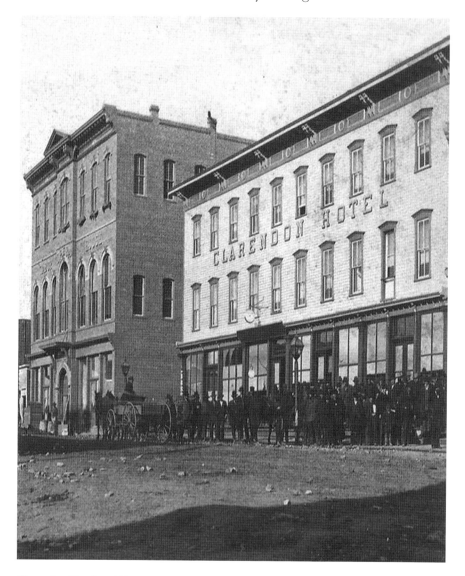

Clarendon Hotel and Tabor Opera House in Leadville, Colorado. Oscar Wilde called Leadville "the richest city in the world." He entertained silver miners at the Tabor Opera House. *Courtesy Ted Kierscey Collection.*

Faced with the fact that he could not afford the prevailing rental rates of the saloons and sporting houses, Ben decided to take on the established gambling tables as a player. Figuring that he would take his chances, he went up against the faro dealers and eventually wound up losing more than

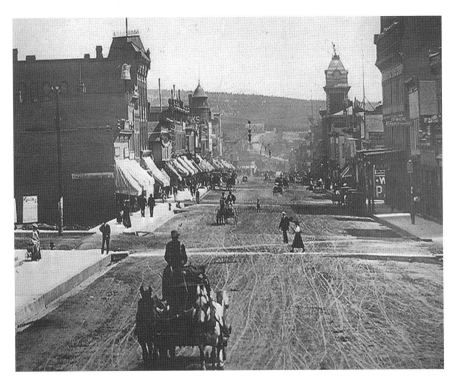

Leadville, Colorado, during its heyday as a silver mining town. The *New York Times* reported Leadville as having an abundance of "saloons, gambling halls, variety theaters, and dance-houses." *Courtesy Ted Kierscey Collection.*

$3,000 in money and hocked jewelry. He said that the tables were crooked and that the dealers had fleeced him.

Rising from his chair, he pulled his pistol and declared that he would not stand for gamblers who cheated. His pistol roared, and saloon lights began to shatter, sending the saloon crowd scrambling out the windows and doors. When the room was cleared, Ben calmly holstered his gun and walked across the street to another saloon. Ordering a drink, he remarked that there appeared to be some kind of commotion going on across the street. A short time later, the city marshal pushed through the saloon doors and told Ben that he was under arrest. Ben had had his fun, and he knew that he would have to pay for the damage, so he quietly followed the officer to the jail. He paid his bail and then pleaded guilty at a hearing the next morning. After paying for the broken lights, he decided that it was time to head back to Austin, where he was among friends.

Leadville and the Royal Gorge War

Once back in Austin, Ben decided that he would not let the Leadville crowd get the best of him, so in May 1879 he organized a group of his gambling friends and headed back to Colorado. As an Austin paper reported it, they were going to "shuffle" things up in Leadville.

Ben and the Texans did just that, quickly setting up a profitable gambling operation in Leadville. A short time later, Thompson, satisfied with their moneymaking enterprises, answered the call to take part in a small but significant melodrama in Colorado history. Called the "Royal Gorge War," the incident took place in the Arkansas Canyon during the years 1878 and 1880.

The stage was set in 1872 when the Denver and Rio Grande (D&RG) Railroad Company built a narrow-gage rail line from Denver to Pueblo. Next it opened a line from Pueblo to Canon Coal Mines thirty-seven miles to the west of Pueblo. Then, building south of Pueblo, it ran a line through the mountains of southern Colorado and into the San Luis Valley until it reached El Moro in 1876. It extended the rail line to Fort Garland in 1877 and finally to Alamosa in June 1878.

About same time, the Atchison, Topeka & Santa Fe (AT&SF) Railroad Company was building west of Kansas City. The AT&SF reached the Colorado line by 1872 but, due to delays, did not reach Pueblo until 1876. During that same year, Leadville was booming as a center for the silver mines, and a great deal of money was to be made freighting goods into and out of the city. Realizing this potential, the AT&SF decided to run a rail line from Pueblo to Leadville. This required the line to pass through the Royal Gorge of the Arkansas River, which was situated fifty miles west of Pueblo. The narrow pass would allow only one rail line to be constructed. This was the crux of the conflict; the D&RG wanted the same thing.

By 1878, both railroad companies had rushed men and equipment to the area hoping to secure the right-of-way through the gorge while the company attorneys battled for court rulings in their favor. In April of that year, the AT&SF had stationed more than three hundred men in the canyon to secure its line construction sites. The D&RG matched that number but had trouble keeping the men hired because its rival paid higher wages.

The AT&SF attorneys got a local court to issue a temporary injunction against the D&RG, halting any further work in the canyon. But before the AT&SF could take advantage of this opportunity, the D&RG got *its* court order, blocking the Kansas company from doing any further work on the line. With both companies at a standstill, men were placed at critical spots

Narrow-gauge train in the Royal Gorge in Colorado—scene of the railroad feud over the rail rights to the canyon called the "Royal Gorge War." Ben Thompson and Bat Masterson were paid handsomely for their actions in the episode. *Courtesy National Archives and Records Administration.*

in the canyon to ensure that they had control of the line and the equipment. The D&RG built several stone forts under direction of its chief engineer, a man by the name of James R. DeRemer, who had served in the Civil War and knew how to construct the rock breastwork needed for fighting a battle. These dry-laid masonry "DeRemer Forts" built at Texas Creek and Spikebuck featured gun ports and a commanding view of the track below.

Fortunately, for both sides, the rock forts were never used for ambushing each other. By November 1878, the D&RG had run out of money and was forced to make a pact with its archrival. On December 1 of that year, it issued a thirty-year lease to the AT&SF that gave it the use of all of the rail lines and all equipment—including the rolling stock.

Once the AT&SF had control of all the tracks and trains, it quickly started squeezing in more business for Kansas City and less for Denver. Realizing its mistake, the D&RG started legal action to break the lease. Finally, in the early part of 1879, the case was brought before the Supreme Court in Washington. Anticipating a violent response regardless of the court ruling, each company sent in armed men to defend its rights and property. The AT&SF hired Bat Masterson and a posse of thirty-three men who were recruited in Dodge City to set up a camp in the canyon to defend its construction men and the company property. They arrived on a special train, and after setting up the camp, dubbed "Dodge City," Bat returned to Kansas.

On April 21, the Supreme Court ruled that the D&RG had the prior right to the canyon but did not have the exclusive rights. The decision, diluted as it was, did not please either party. In the latter part of May, the Colorado attorney general entered a suit in the state court to halt the AT&SF from operating railroads within the state. Then on June 10, State Judge Thomas M. Bowen issued a writ stopping the AT&SF from using or operating any of the D&RG buildings, equipment or rolling stock—essentially nullifying its lease. With Judge Bowen's writ in hand, the officers of the D&RG went to the sheriffs of each county traversed by the railroad lines to take possession of all of their property.

Before the writs could be delivered to the county sheriffs, the AT&SF instructed Bat Masterson to return to Colorado and concentrate its forces in Pueblo. He quickly recruited fifty armed men—including Ben Thompson and a dozen of his fellow Texans—and brought them in on a special train.

Initially, when approached with the offer, Ben was reluctant to sign on, fearing that if violence broke out he would be accused of murder. Finally, he agreed to hold the stone roundhouse at Pueblo until officers of the law presented him with legal papers to take possession. According to Walton's book, Thompson agreed to do the work for $5,000 and was approached by the D&RG to surrender the roundhouse for $25,000. Ben turned down the offer, saying, "I will die here, unless the law relieves me."

On June 11, the sheriff of Denver and his posse of D&RG men seized the AT&SF office and roundhouse in Denver. Then a train load of D&RG agents headed south to take possession of the property along the way. At the same time, the ex-governor of Colorado, A.C. Hunt, raised a posse of two hundred men, captured a train and headed north, seizing all the small stations and taking the agents as prisoners. At Cucharas, Hunt's forces shot it out with twelve AT&SF men—killing a Mexican and wounding an Irishman named Dan Sullivan.

At Pueblo, Sheriff Henly R. Price backed two officials from the D&RG—J.A. McMurtie and R.F. Weitbrec—while they served copies of Judge Bowen's writ to all of the AT&SF workers at dawn. After serving the writs, Sheriff Price and his posse marched down to the office of the train dispatcher at 8:30 a.m. The dispatcher refused to let him take possession of the building, and the sheriff told him that he had thirty minutes to think it over. At 9:00 a.m., Price returned and found the office filled with several dozen armed AT&SF men, who refused to budge. Rebuffed, the sheriff trekked back to the Grand Central Hotel and recruited an additional one hundred deputies—all heavily armed and primed with plenty of free liquor.

Returning to the depot at noon, Sheriff Price and his army of deputies demanded that those in the depot surrender. They refused, and the posse moved on to the roundhouse, where Ben Thompson and the Texans were waiting. Confronted by the sheriff, Ben said that he had been placed in charge of the company's property and that he could not give it up without being authorized to do so. The sheriff then stated that he had come to disperse an armed mob. Ben replied that there was no armed mob in the roundhouse, only men from the construction crew who had been sent to guard the company's property. Saying that some of the men did have arms, Ben invited the sheriff to step inside the roundhouse and look over the men to see if any of them were guilty of violations of the law. Price was allowed to enter the roundhouse alone, and after a brief search he left without making any arrests.

Faced with a powder keg of a standoff, Sheriff Price withdrew his men and sought the advice of the local attorneys. After reviewing the judge's writ, he was advised that he was not authorized to use force to take over the AT&SF property. He chewed on this until about 3:00 p.m. and then decided that it was time to take action regardless of the legalities of the writ.

He and fifty of his liquor-lubricated deputies met in front of the Victoria Hotel, where they were supplied with rifles equipped with bayonets and a heavy ration of ammunition, courtesy of the D&RG. Marching down to the depot, they formed a skirmish line in front of the building. About that time, a cattleman by the name of W.F. Chumside staggered out of the ticket office. He was said to have been "a little under the influence of liquor" and wanted to argue the case for those inside the depot. He was quickly struck down by one of the deputies and kicked in the head.

The posse then headed to the telegraph office, and shooting started as they were battering down the door. Most of the men inside the office quickly escaped through the back doors and made it to safety. Unfortunately, Harry Jenkins fell as he was running away and was shot through the chest; the bullet lodged in his spine. The posse pitched the wounded man in an express wagon and sent him for medical attention. He died a short time later.

After storming the telegraph office, the posse raced over to the roundhouse, the last stronghold of the AT&SF defenders. Thompson met them outside the roundhouse, yelling, "Come on you son of a bitches; if you want a fight you can have one." Before he could back up his challenge, he was overpowered by a dozen of the deputies and thrown in jail. Without their leader, those inside wanted to parley. A short time later, they surrendered the building without firing a shot. All of them were disarmed and herded down the street to join Thompson in the crowded little jail on West Fifth Street.

Late that evening, ex-governor Hunt and his party arrived by train from the south and then continued on up the Arkansas River to Canon City. By midnight, the entire railroad had been captured. Sometime during the night, Bat Masterson, Ben Thompson and the others hired by the AT&SF were released from jail and put on a special train bound for Dodge City. Arriving the following morning, Ben collected his money from the AT&SF and headed for Texas by way of Kansas City and St. Louis.

The Royal Gorge affair did not end on June 11 but rather continued on in the courts for several more months. Finally, the "robber baron" Jay Gould bought 50 percent of the stock in the D&RG and settled the litigation out of court. On March 27, 1880, both railroads agreed to sign the "Treaty of Boston," which returned the railroad and property back to the D&RG. The AT&SF was paid $1.8 million for the rail line that it had built through the pass, and the Royal Gorge War was finally over.

Chapter 7
Ben Thompson
Austin City Marshal

Mr. Ben Thompson announces himself a candidate for city marshal in this morning's issue. He is well and favorably known to everyone in the city, and is in every way worthy the confidence and support of the people.
 –Austin Daily Statesman

Ben Thompson arrived in Austin flush with the money he had received from his role in the Royal Gorge War. He bought a fine home at 2009 University Avenue just across the street from the newly constructed University of Texas campus and took on the airs of a well-to-do businessman. Dressing the part, he often wore fashionable clothes of the day, frequently wearing a frock coat over a fine linen shirt with a stylish cravat and diamond stickpin. It was common for him to round out his wardrobe with a top hat and stylish walking cane. He and his family rode around Austin in an expensive carriage, and he became known for owning fine horses and a collection of guns. Yes sir, Ben and his family had come a long way from their small house on Willow Street near the river.

He also used the railroad money to buy interest in a number of gambling rooms around town, eventually becoming the sole owner of the faro tables above the Iron Front Saloon on Sixth Street just off Congress Avenue.

At one point, he had a partner in the Iron Front gambling tables, a man by the name of Loraine. Shortly after Loraine took over managing the tables, Ben, who had been drinking with friends, stopped by the Iron Front one evening to look over the action. His partner was dealing faro. After several

players dropped out of the game due to losses, Ben approached the table. He motioned for all to move away from the table and, pulling his revolver, shot every stack of chips on the table, blew the dealer's box to pieces and then shot out the chandelier over the table. Everybody in the room ducked or dived for cover except Loraine, who calmly sat still during the shooting. When someone asked what he was doing, Ben responded, "I don't think that set of tools is altogether honest, and I want to help Mr. Loraine buy another." He then turned to his partner and said, "You can buy another set of tools and charge them to me. I don't like the ones you had."

Reloading his pistol and downing a few more drinks at the bar, Ben went next door to the keno hall owned by a man named Solomon Simon. Without saying a word to Simon, he pulled his revolver and shot up the keno "goose," which contained the ivory balls used in the game. He then shot out all of the lights in the room, scattering the crowd amid the flying glass and ricocheting keno balls. Leaving Simon's place, he wandered down to the red-light district, where he shot out streetlights and fired at some of the window lamps in the whorehouses. He then headed up another street, where he spotted a man asleep in a chair in front of the Raymond House. Sneaking up to the man, Ben put his gun close to the man's head and fired two rapid shots into the air. The poor man jumped up from his chair and ran down the street yelling, "Murder!" Two blocks later, the frightened man was arrested by the police for disturbing the peace. Laughing at the mayhem he had caused, Ben shot out a few more streetlamps and then called it a night. The next morning, he promptly reported to the mayor's office to plead guilty to all charges and paid the fines he owed.

Shortly after his death, an Austin weekly newspaper, *Texas Siftings*, speculated that Ben was involved in some type of protection racket:

> *The question is often asked: "How did Ben Thompson succeed in having so much money?" The mystery is capable of an easy solution. He was not a successful gambler, but he owned a third interest in all the gambling establishments in Austin. His income from this source often aggregated thousands of dollars a week. In consideration of this third interest in the profits of these establishments, he protected them from any possible interference on the part of the police, and also from any outside competition.*

Was the newspaper's supposition based on hard evidence, or was it merely reporting rumors? Research has not shown any reports to support

the accusation. In contrast, Ben's reputation was such that he was sought out and encouraged to run for the office of Austin city marshal when the office became available.

In October 1880, the Democratic Party met and chose Ben Thompson as the candidate for the office of city marshal. At the time, Ben was thirty-six years old and had been married for sixteen years to his wife Katherine. They had two children: Benjamin Jr., who was ten years old, and Katie, who was eight. In addition to his wife and children, Ben also cared for his elderly mother, who lived with them until her death. Impeccably dressed and generous in his relations with many of the leading citizens in the community, Ben enjoyed a reputation of being loyal to his friends and a man of his word. His rip-roaring background and his fame as pistol fighter made him one of the best-known men in Texas, so the Democrats knew he could make a good run for the office.

Ben was running against the incumbent, a former saloon owner by the name of Edward Creary. Marshal Creary was a very popular lawman who had held the office since he was first elected in 1875. When the votes were counted in the November election, Thompson tallied an impressive 774 votes, but this was not enough to unseat Creary, who garnered 1,174 votes. Ben took the defeat in stride and continued his gambling business without regrets, knowing that he had a solid base of voters willing to support him in next election.

Later that summer, while he was plying his trade as a gambler in Dodge City, Ben had to call on his old friend Bat Masterson to extricate his brother Billy from Ogallala, Nebraska. Ben said that he knew that the men who ran Ogallala would kill him if he went to get his brother. He had received a wire that noted that Billy had been shot up and was awaiting trial in Ogallala, with a good possibility of being lynched. Bat agreed to help and left immediately. Traveling by train and stagecoach, Masterson finally arrived in the Nebraska cow town, which at the time consisted of little more than a few dozen buildings huddled round the Union Pacific line on the north bank of the South Platte River.

Billy was being held prisoner at the only hotel in town, the Ogallala House. He had been shot up by a saloon owner by the name of Bill Tucker over the affections of a local whore with the curious name of Big Alice. The word was out that Tucker and some of his friends were planning a necktie party as soon as Tucker could recover from his wounds. Tucker had lost his thumb

and three fingers on his left hand in the gunfight but had still managed to fill Thompson's backside with a load of buckshot from a sawed-off shotgun. Bat told Billy to pretend to be much too weak to try an escape, while he figured out a way to get him out of town. Knowing that Billy could not ride a horse and that a buggy was out of the question, Bat figured their best bet was the train that pulled into Ogallala about midnight. Biding his time, Bat became friends with the young deputy guarding Billy.

Finally, Bat's chance came on a Sunday night when most of the town was attending a dance at the schoolhouse on the edge of town. The sheriff was the best fiddle player in the area, and he was keeping the crowd on the dance floor with "Turkey in the Straw." The Ogallala House was empty that night with the exception of the prisoner, his guard, Bat and the bartender, Jim Dunn. In exchange for a few dollars, the bartender agreed to slip a Mickey Finn (chloral hydrate) in one of the whiskey sours he delivered to Masterson and the deputy. The guard downed his doctored drink, and Bat ordered another round. Not long after drinking his second whiskey sour, the guard slumped to the floor and was out like a light. Bat quickly dressed Thompson, rolled him up in a carpet, hoisted him over his shoulder and carried him to the depot. They arrived just as the train pulled into the station, and soon the two were quietly on their way to North Platte, some fifty miles east of Ogallala.

When they arrived at two o'clock in the morning, the only thing open in North Platte was Dave Perry's saloon. Carrying Thompson over his shoulder, Bat headed for the lights of the saloon. Pushing through the swinging doors, he found Bill Cody telling stories to his drinking buddies. When Bat explained the situation, Buffalo Bill agreed to offer protection and a means for the men to get back to Dodge City. Cody let them borrow his wife's horse and new carriage and then invited them to tag along with a caravan he was leading to Keith's ranch, which was about twenty-five miles to the south. The caravan consisted of foreign dignitaries who had asked Cody to show them some of the Wild West that they had read about in the newspapers. After traveling a short distance, Cody stopped for rest and refreshments. Cody's idea of refreshments was several tall shots of whiskey or brandy at each stop. Before long, all in the caravan were having a grand time but were also having trouble staying in the saddle or upright in a wagon.

After having a wagon roll over with a passed-out Cody in the bed, the drunken group finally made it to Keith's ranch. The next morning, Masterson and Billy left in Mrs. Cody's phaeton and headed for Dodge

City. Not long after they left the ranch, the pair ran into a heavy rain that continued to inundate them through most of their two-hundred-mile trek to Dodge. Rain-soaked and shivering, they finally rolled into town, looking for a hot bath and a decent meal laced with some mighty stiff drinks, but not before Billy made a stop at the telegraph office. He could not resist sending a wire to the sheriff of Ogallala "notifying him of his safe arrival and inviting him to come and get him in case he still thought he wanted him." Billy had been accused of many things, but never of being very smart.

With Billy back in Austin healing from his buckshot wounds, Ben's popularity took a positive turn when William F. Cody brought his Wild West Show to Austin in the early part of December. Billed as featuring a "mammoth combination of artists performing the popular play, Knight Of The Plains or Buffalo Bill's Best Trail," Cody's show played to packed stands at the Millet Opera House on December 9 and 10. Immediately upon arriving in Austin, Cody sought out Ben and presented him with a buffalo trophy. The newspaper reported the gift by saying: "The head of the largest buffalo ever killed will be on exhibition on the picnic grounds. The buffalo was killed by Grand Duke Alexis, of Russia, and presented to Ben Thompson, of Austin, by Buffalo Bill, of Dakota."

Cody also invited Thompson to join him in some competitive target shooting at the fairgrounds on the outskirts of Austin prior to each night's performance. Both shooters awed the spectators with their prowess using both pistols and rifles. A San Antonio newspaper account noted that Thompson showed that he was a crack shot and proved that he was one of the best pistoleers in the country.

When Cody and his troupe ended their Austin performances, they moved on to a scheduled engagement in Galveston, where Thompson's shooting was heralded as some of the best in the United States. With this kind of promotion and his increased popularity, Thompson got another chance to run for city marshal in September 1880. Marshal Creary had decided to run for the office of Travis County sheriff, and an election was held to fill the vacancy. Thompson and the Democratic Party quickly filed for the spot in the coming election. Gaining the support of the *Austin Statesman*, the newspaper described Thompson's candidacy:

> *Mr. Thompson is well-known to the people of Austin. He is known especially as a man without fear, and there are very many here who regard*

him as the proper sort of person to be marshal of a city like this one. They say his life may appear as a reckless one, but that his disposition is and always has been to act honorably to all men and that they would pledge themselves that he would make a model peace officer. Mr. Thompson has lately bought a most beautiful home in the northern portion of the city, and he expresses a desire to serve the public in an honorable capacity, and says he will do so if elected, and it is known that his word is an excellent bond.

On election day, December 17, Thompson also used the newspaper to publish several small notices asking for the support of voters, saying, "If you elect me city marshal today I promise that by no action of mine shall you ever regret your choice." Apparently, he got the message across to the voters, who cast 56 percent of the vote in favor of Thompson, who was declared the winner on the following day. That night, bands from the Hope Hook and Ladder Fire Company and the Manning Rifles gathered at his home to celebrate his victory. A large crowd of supporters brought food and drinks, making it a jolly good party—so much so that the newspaper reported that

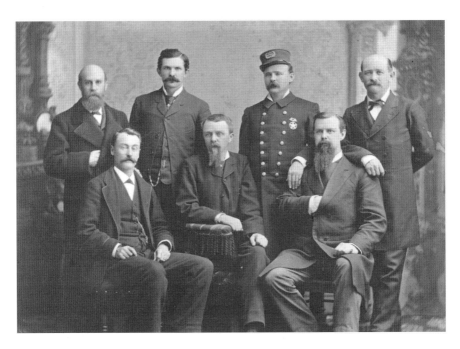

Ben Thomson and the Austin City Council on the day he was sworn in as the city marshal. *Courtesy Texas State Library Archives.*

94

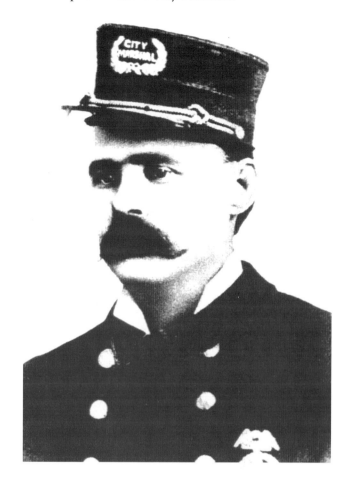

Ben Thompson was elected Austin city marshal in 1881.
Courtesy Texas State Library Archives.

the following day Ben was suffering from a bout with "illness"—no doubt the effects of a long night of celebration.

When he had fully recovered from his "illness," Ben pinned on the law badge and took control of the Austin police. At the time, the city had grown to a population of eleven thousand people, which swelled to several thousand more when Congress was in session. Austin boasted two major railroads serving the city, an extensive system of gaslights lighting the main streets and water mains and fire hydrants for each of the ten wards; some of the newer homes even had indoor plumbing. It was one of the first Texas cities to have a telephone service, with a line running from Thompson's house to the police station. It had a first-class opera house and a well-attended horse track on the edge of town.

At the same time, Austin had a number of saloons, dance halls and brothels located in the first ward. The most well-known whorehouses took on the names of their owners, so that cowboys, drummers and legislators headed to the residences of Fanny Kelly, Sallie Daggett and Blanch Dumont for "sporting fun." An Italian by the confusing nickname of "Mexican Charlie" held nightly fandangos in his saloon and grocery store located in the first ward. Most of the women were offering more than a simple spin around the dance floor, which made it a very popular spot in the evenings.

Laws and regulations meant to control prostitution and fandangos were passed by the city, but due to the fact that most of the city officials owned rental property in the first ward, enforcement was usually held to a minimum. Ben took his job seriously and, with the noted exceptions made to the first ward, was very effective in controlling crime within the city. Newspaper accounts lauded his efforts, noting, "The city was never more orderly at this season of the year." The *Daily Statesman* went on to report that "one of the dullest months in police circles for a long time was that of January just past. The total number of arrests reached only seventy-seven. It is, however, a good showing for the orderly conduct of the city and worthy tribute to the efficiency of captain Ben Thompson and his officers and men."

Ben ran a police force of seven men headed by Sergeant John Chenneville. During his term as marshal, violent crime dropped to an all-time low. Most arrests were for vagrancy, intoxication, being asleep in a public place, simple assault, discharging firearms and disturbing the peace.

After about two months on the job, Ben was invited to join a goodwill tour to San Antonio that was organized by the Austin city officials and the state legislators. The train pulled into San Antonio on the afternoon of February 21, 1881. While the others toured the famous spots in San Antonio, Ben headed to the faro tables of the Vaudeville Theater. Located on the corner of Soledad and Commerce Streets, the theatre sported a saloon and gambling hall. Jack "Pegleg" Harris, a prominent saloon owner and political boss, owned the Vaudeville plus a number of other businesses in San Antonio.

Playing against a faro dealer named Joe Foster, Ben lost a great deal of money and some of his jewelry that he had put up as collateral. With each lost wager, Ben continued to boil until he finally called the dealer a cheat. Foster reacted by reaching for his pistol, but not before Thompson had his .45 pointed directly at the dealer's head. After a momentary pause, the dealer shoved his gun back in his coat and calmly watched as Thompson

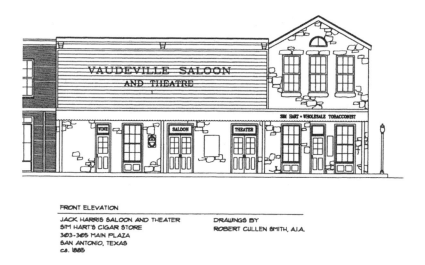

FRONT ELEVATION

JACK HARRIS SALOON AND THEATER
SIM HART'S CIGAR STORE
303-305 MAIN PLAZA
SAN ANTONIO, TEXAS
ca. 1885

DRAWINGS BY
ROBERT CULLEN SMITH, A.I.A.

Historically accurate drawing of the front elevation to the Vaudeville Theater, located on Main Plaza in San Antonio, Texas. *Courtesy Robert Cullen Smith.*

scooped up his cash and jewelry. Declaring that the theatre was a robber's den, Ben pocketed the money and with his gun trained on the crowd backed his way out of the building, vowing to have the legislature close the business.

Jack Harris was not in the theatre at the time of the incident, but when he got word of what had happened, he immediately made it known that Thompson was not to set foot in his place of business again. The ultimatum finally reached Ben the next evening, and he confronted the saloon owner. The two exchanged angry words and threats until they had to be separated by some bystanders. This was the start of a feud that continued to fester over the next two years.

On May 1, 1881, Thompson arrested the notorious gunfighter John Ringo, who had been a major player in the bloody Mason County War. Ringo had spent the night in the first ward and, about 4:00 a.m., noticed that he was missing money from his wallet in one of the bordellos. Storming out into the hall, he found several Austin men and pulled his revolver, demanding that they throw up their hands and be searched for his money. When he did not find his property, he returned to his room and locked the door. The men left the bordello and headed straight for the police station, where they reported the incident to Thompson. He calmly went down to the house and demanded that Ringo open his door. When the gunman

"Buffalo Bill" Cody in a buggy with Ben Thompson, from when the two men put on shooting exhibitions at the fairgrounds in Austin, Texas, in 1880. *Courtesy National Archives and Records Administration.*

refused, Thompson pulled his pistol and kicked in the door. He disarmed Ringo and arrested him on the spot. Returning to the station, he turned the prisoner over to Officer Chenneville and told him to lock him up. The following day, Ringo was fined thirty dollars for carrying a pistol and disturbing the peace. Considering himself lucky to still be alive after being confronted by Ben Thompson with a gun, Ringo paid his fine, retrieved his revolver and then quietly left Austin. It was reported that Ringo never returned to the city again.

One month after the arrest of John Ringo, a package from Buffalo Bill Cody arrived at Thompson's office. Inside was a letter congratulating him for winning the election and a finely engraved pistol. The *Austin Statesman* reported:

> *Yesterday morning Marshal Thompson received a very handsome present from Buffalo Bill. It is a handsome and costly target pistol, manufactured by Stevens & Co., Chicopee Falls, Massachusetts. The mountings are of gold, handle beautifully tinted pearl, while the glittering steel barrel is most artistically and beautifully carved. It is engraved on the handle: "From Buffalo Bill to Ben Thompson." It is the only pistol in the city, and is a marvel of skilled workmanship.*

At the time, Joshua Stevens's single-shot target pistol was highly prized by the eastern sportsmen for its craftsmanship and superior accuracy. The gun

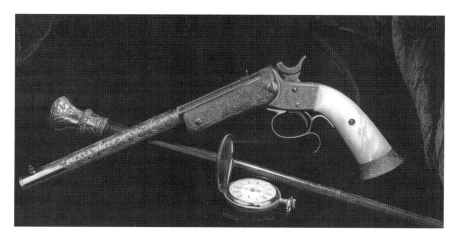

"Buffalo Bill" Cody presented Ben Thompson with a fine Stevens-Lord target pistol after Thomson was elected the city marshal of Austin, Texas. *Courtesy www.knottingly.org*

was a Stevens-Lord model no. 36 with a ten-inch barrel and chambered to fire a .32-caliber Colt center-fire cartridge. The nickel-plated frame and the blued barrel were heavily engraved with artwork and bore the serial number of thirty-two (only six hundred of the pistols were manufactured between 1880 and 1886). The pistol was finished off with mother-of-pearl grips and presented in a fine walnut case. Thompson added it to his collection of guns that he kept in his office and took great pride in showing it to visitors.

On July 21, Ben Thompson made his most sensational arrest when he arrested a woman traveling with the Lee County sheriff, James Brown. The sheriff was returning from Louisiana with a woman by the name of Mrs. Amelia Schooman. He had gone to Louisiana to hunt for a fugitive wanted for murder in his county, and Amelia had accompanied him on the trip to help him identify the wanted man. As it turned out, the woman was notorious for hustling lust for money in Austin and did not even know the fugitive. With his prisoner in tow, Brown and Amelia stopped in Austin to change trains. Amelia was dressed in men's clothes and toting a holstered pistol on her hips, which was strictly outlawed in Austin—that is, wearing clothes of the opposite gender. Thompson took all three—the red-faced sheriff, the woman and the prisoner—down to the city hall. The mayor fined her twenty-five dollars and, after she agreed to change into a dress, released her. City hall was abuzz with excitement over the scandalous affair in which the embarrassed sheriff, who was married, had to endure the repeated

questions of the local reporters. Amelia was described as having "sharp blue eyes, a small mouth, retrousse nose and a naiveté manner, which made her quite attractive." That evening, the ignominious Brown, his prisoner and his "companion" boarded a train to return to Lee County to face his constituents and his wife.

Sheriff Brown returned to Austin on August 23 with three racehorses to run in the races at the fairgrounds. The *Austin Statesman* reported his arrival in the city, and soon tongues were wagging about a possible showdown between him and Thompson. Things remained quiet until September 3, when Ben got word that some of Brown's friends from Lee County had arrived in town with the intent of creating a disturbance out at the racetrack, to draw Thompson into an ambush to settle the score with the sheriff. Undeterred, Ben went straight to the racetrack at the fairgrounds. The newspapers reported that Thompson "met Brown at the fair grounds, and approaching him informed him of what he had heard, and said, if it was true, now was the time to settle the trouble, like men. Brown, flatly denied the report, and matters were amicably settled."

With the affair defused, Sheriff Brown returned to his home in Lee County. A few days later, he received word through a mutual friend that Jack Harris in San Antonio wanted him to leave Thompson alone: "[H]e's mine...I had it fixed for him once...but he slipped through by mere accident. Sooner or later...I'll get my work in." Apparently, Harris had plotted to seek retribution after his altercation with Thompson, though historical accounts cannot confirm the basis for his cryptic message to Sheriff Brown. Regardless, the stage was set for an eventual showdown between the two gamblers who had once been good friends but now were locked in a blood feud that had to be settled with gun smoke and lead.

Chapter 8
Jack Harris Killing

When sober and sane he was a suave and polished man of the world, who gave but little, if any intimation of the murderous malevolence that controlled him when deep in his cups.

—San Antonio Times, *on Ben Thompson*

In October 1881, Ben Thompson again filed as the Democratic candidate for city marshal, with full support of the gaming, sporting and saloon contingent of the city—which was a sizable chunk of the voting citizens. His opponent, Jack P. Kirk, also had the support of a large amount of voters and was praised by the *Statesman*: "Mr. Jack P. Kirk is known to every man in the city as a gentleman of undoubted integrity and sterling worth. As a deputy sheriff of this county for years, he made a most careful and efficient officer, and no man is better qualified in every respect to fill the office he now aspires." Two weeks later, Thompson published his request for continuing his job as marshal with a lengthy statement of his accomplishments since he took over the remainder of Creary's tenure. Then, as the election drew near, he sensed that it would be a close race and that he would need to square off with his opponent in a public meeting. On November 3, he attended a meeting of candidates held on the corner of Congress Avenue and Ash Street, located between the Palace and Club House Saloons. Ben was the last to speak at the podium:

> *I am not a public speaker. This is the first speech I have ever made in my life. My opponent, Mr. Kirk, has not assailed…my record. I have tried*

to do my duty while I have been in office, and, although there were many people who voted against me…I have treated all alike, and if I am elected again, which I expect to be, I intend to act the same toward those who vote against me as to those who vote for me. I have tried during the past to befriend all who were in need of aid, and I intend in the future to help everybody that I can, whether I am elected or not…but I say to you now, if anyone can justly charge me with having neglected to do my duty at any time, of failing to befriend anyone when it was in my power to do so…vote against me. I want your vote, but if I am not worthy of it don't give it to me. That is all I have to say.

It is hard to imagine a present-day politician being that candid in his public speaking, but his speech captured the interest of the audience, and they loudly applauded Thompson as he stepped down from the podium. They all wanted to shake his hand and wish him well in the coming election.

The next day, at another campaign meeting, Ben had to break away from the speakers and stop a knife fight between two men, one of whom had been stabbed during the fracas. Arresting the man who had the knife, Ben quickly

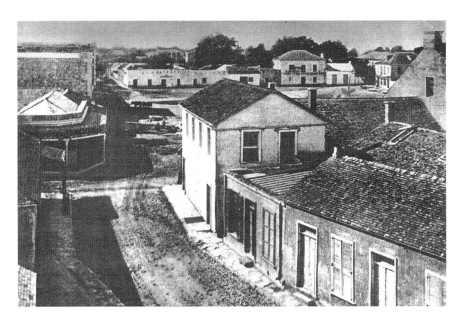

The Vaudeville Theater, located at the corner of Soledad and Commerce Streets in San Antonio, Texas. *Courtesy O.T.T. Collection.*

ushered him down to jail while the meeting continued. Apparently, this demonstration of swift action and the public's enthusiasm for his speech the night before was just what he needed to carry the majority of seven of the ten wards. He garnered 1,173 votes, while Kirk mustered a close 933 votes.

Austin was fairly quiet for Ben during the rest of 1881, but things started to change in the early part of 1882, when he once again accompanied local and state dignitaries on a trip to Laredo. When the train pulled into San Antonio, the excursion group unloaded for an overnight stop. Later that evening, Thompson received word that Jack Harris was on the street with a double-barreled shotgun, looking for him. Thompson's friends managed to keep him from going out to search for Harris and kept him occupied for the night. Meanwhile, Harris had holed up in his Vaudeville Theater, where he was prepared for a shoot-out with Thompson. About midnight, Harris sent a policeman to Sheriff T.P. McCall's house to tell him that he needed him at the theatre. When the sheriff arrived at the theatre, he found Harris with a shotgun, saying that Ben Thompson was in town and that there was going to be trouble. Harris instructed the sheriff to get several other lawmen and post a guard at the theatre. So while Ben was comfortably asleep in the Menger Hotel, the sheriff and his men stood around waiting for trouble that never materialized. Finally, at three o'clock, everyone went home to bed.

The next morning, Thompson felt that it was his duty to find Harris and confront him with the report of the previous evening. He found him at the Green Front Saloon and said, "Hello, Jack! I understand you were on the hunt for me last night with your shotgun. Is that so?"

"No," said Harris. "I was not hunting for you, but I was waiting for you, and if you had come about my place, I would have filled you full of shot."

At this point, a deputy sheriff by the name of Penolosa stepped in to keep the two from drawing their pistols. He quickly ushered Harris out the door to safety, while Ben issued his own ultimatum: "I understand you and your crew are forted for me and intend to shoot me, if you can get the advantage—now let me tell you, go and get your crew of assassins; arm them with shot-guns and Winchester rifles, and come out on the Main Plaza, and I will run you all to your holes; come out and fight like men."

Returning to Austin, Ben continued to hear of threats and warnings issued by Jack Harris but did little to respond until July 10, when he traveled back to San Antonio. He had promised his two children that he would take them to see friends in San Antonio, and as it happened, he

had received word that a fugitive from the law was recently seen in the Vaudeville Theater. Aiming to fulfill his promise to his children while at the same time pocketing the $1,000 reward for the wanted man's capture, Ben and his kids boarded the train and headed for San Antonio. The fact that the fugitive had been seen in Jack Harris's place also probably played into his decision to go after the man. What better place to capture a criminal than in the haunts of his bitter enemy who had warned him to never set foot in his saloon and theatre again?

Apparently, Ben Thompson did not fear the power that Jack Harris wielded in San Antonio. At the time, Harris was considered the most powerful man in the city, with most of the elected officials obligated to him for winning elections. He was the unofficial leader of the gambling, sporting

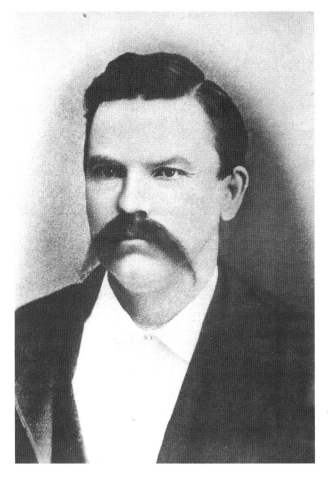

Jack "Pegleg" Harris, owner of the Vaudeville Theater in San Antonio. *Courtesy N.H. Rose Collection.*

and saloon community, as well as the political boss of the Democratic Party in San Antonio. The county sheriff and the city police chief were at his beck and call whenever he needed something from them. He had been a member of the police force before he and another policeman named Penezola opened a saloon on Market Street in 1868. Then, in 1872, he sold his interest to Penezola and opened up a saloon at the corner of Soledad Street and West Commerce Street, calling it the Jack Harris Saloon. In 1874, he added a theatre and changed the name to Jack Harris Vaudeville Theater and Saloon. Eventually, he opened a gambling hall upstairs, the 101 Club, and was partners with Sim Hart in his tobacco shop on the corner portion of the theatre building. It quickly became known as the most lavish and gaudy saloon, whorehouse, gambling hall and variety house in all of San Antonio. Yes sir, old Jack had a bunch of irons in the fire and a pack of politicians in his pocket—definitely a man to reckon with. It seems that Ben Thompson was not swayed by all of Jack's power and influence, thinking that he could match wits with the best of the power brokers and come out on top.

The minute Ben and his children stepped down from the train at the station, word quickly got to Jack Harris and Billy Simms that Thompson was back in San Antonio. Ben took his little boy and girl to stay with some friends and then he went downtown to the Vaudeville Theater. Seeking out an old friend, a dealer in the 101 Club by the name of "Bones," Thompson was alarmed by his reception. Bones appeared to have exhibited a great deal of excitement when he saw the Austin marshal enter the gaming hall. Ben pressed him for the reason, but the frightened man would not say why he was afraid. Looking around, he could not see Harris or Simms, which led him to believe that an ambush might be imminent. Thompson quickly left the establishment and did not return that night.

The next morning, Simms carried two loaded pistols to the theatre and placed them on a table in his private office in the 101 Club. He talked with Harris, and then they loaded Harris's double-barrel shotgun. At four o'clock, Harris went home for his afternoon rest, instructing his men to notify him if Thompson came into the building looking for trouble. It had been his custom to sleep in the afternoons, returning to the theatre at about eleven o'clock at night to lock up the money from the theatre ticket sales.

Due to the abundance of eyewitnesses, what happened next was probably one of the best-chronicled shoot-outs in the history of the Wild West. About three o'clock, Ben had a drink with a gun dealer and bought some centerfire

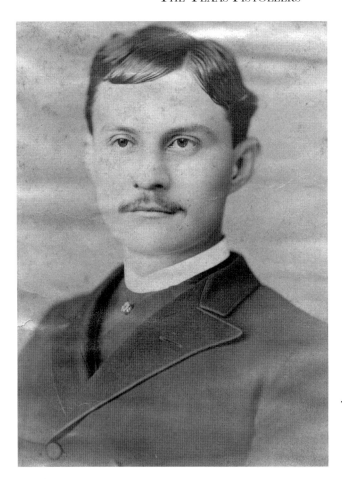

Billy Simms, along with Joe Foster, took over the Vaudeville Theater in San Antonio, Texas, after Jack Harris was killed in 1882. They vowed to kill Ben Thompson if he returned to the saloon. *Courtesy Robert McCubbin Collection.*

.44 Winchester cartridges for his nickel-plated Colt revolver. At 6:30 p.m., he walked toward the Vaudeville Theater, where he stopped to talk with Charlie Bennett and Dick Strayhorn. The three decided to step into the Vaudeville for a drink. After the drinks came, Ben surveyed the saloon and, not seeing Harris or Simms, asked the bartender, Barney Mitchell, "Where is that shot-gun brigade that is on the hunt for me?" When Mitchell said there was no one with a shotgun looking for him, Thompson responded by saying, "I'm going to close this damned whorehouse. You tell Joe Foster he is a thief, and tell Jack Harris he is living off the produce of their whores." Mitchell gamely shot back that Thompson could tell it to Harris and Simms himself when they were in the house. Still bristling, Ben backed out of the saloon and in the process collided with a musician who was walking into the

theatre. Thompson roared, "Who the hell are you?" Then, seeing that the man was carrying a coronet instead of a gun, he apologized. "Oh! I thought you were one of those shotgun men."

Outside, Ben questioned a policeman named Jacob Ripps about how many patrolmen were on duty that night. When the lawman responded that only a few were in the area, Thompson told him that he had better go find the city marshal, Phil Shardein, and get more men because there was going to be trouble. Ben then asked him why the police had not closed "this damned whorehouse." When told that there was no cause, Ben exploded: "If you San Antonio policemen are afraid to close this house I'll close it for you. I'm barred from this house. I want you to protect me." Then he added, "I am going in there and if you interfere with me I'd just as soon shoot you as anyone else."

At this point, Leon Rouvant, a jeweler, walked up and kidded Thompson, saying, "Well, you are making a lot of noise." Thompson wheeled around and growled, "You mind to your business and I will mind to mine." Taken back by Ben's attitude, the jeweler reminded him that they were friends and invited him into the bar for a drink. Gaining his composure and smiling, Ben agreed and the two entered the saloon.

When Thompson and Rouvant stepped up to the bar, an employee named Biencourt rushed out the west door to warn Harris, whose home was a few blocks up Soledad Street. Simms, who had been upstairs in the 101 Club, came downstairs; when he saw Ben standing at the bar, he immediately went to meet Harris. He found him returning with Biencourt and handed him one of his pistols. They both arrived at the theatre as Thompson stood talking to a man just outside the front of the Vaudeville. Eying Thompson, Harris went to the ticket office and pulled out his shotgun. Muttering, "I will shoot the head off the son of a bitch," Harris stood waiting in an alcove that was difficult to see from the street.

Simms went out to the street and tried to talk Thompson out of going into the theatre. Ben ended the conversation by telling Simms, "Billy, there is going to be hell here tonight. There's no use in talking to me. I'm going to close this damn place up." Parting, Thompson walked a few steps to Sim Hart's cigar store, while Simms went inside. He then went upstairs, cocked his pistol and positioned himself for Thompson's return.

A few minutes later, Thompson left Hart's and stood out on the street talking to E.A. Hicks. At this point, dusk was settling into night, and the

electric lights were on in the saloon, making it easier to see inside. Suddenly, Ben spotted Harris standing behind a screen in the saloon and told Hicks to stand aside because there was going to be trouble. Then, putting his hand on his pistol, he called out to Harris: "Jack Harris, what are you doing with that gun?" Cradling the shotgun on his crippled left wrist, Harris responded, "To shoot you, you damned son of a bitch!"

At this point, there was a wild scramble for cover as the crowd ducked or ran out of the saloon. In the confusion, it was not clear if Harris had his double-barrel shotgun lifted into firing position, but Thompson pulled his gun and fired a quick shot that caught Harris in the chest near the heart. The wounded man staggered from the force of the bullet, and Thompson fired a second shot that hit Harris in the shoulder. He slammed into the wall behind him and then managed to collect himself and stumble up the stairs to the balcony still holding his scattergun. He made it a short way down one of the aisles and collapsed.

Three of the actresses who had been working the crowd in the balcony, the Mauri sisters and Miss Marshall, rushed to Harris. The most that they could do was to place a pillow under the bleeding man's head and offer sympathy. Another employee, a bartender named Johnny Dyer, dashed over to Schasse Drug Store looking for a doctor. A short while later, he returned with two doctors—Adolph Herff and Thomas R. Chew. They propped up Harris on a cot and, after an examination, took him to his house, where he died later that night. Shortly before he died, Harris whispered to Dr. Chew, "He took advantage of me and shot me from the dark." Apparently, Harris could not clearly see Thompson, who was standing outside in the dim light, while he was well lit by the saloon lights.

After firing the second shot, Thompson stepped out into the street and fired a third shot to warn others to stay out of the fight. He then crossed the street to some hacks that were parked on the plaza. He turned back to the saloon and pointed his pistol at the band that had been playing in the balcony, still wary of the "shotgun men" who he had thought were stationed somewhere in the saloon. The musicians scattered like a covey of quail, and Thompson took off down the street. He ducked into George Horner's saloon and ordered a drink at the bar. As he downed the shot, he assured Horner that the man had nothing to fear and that he intended to give himself up to Marshal Shardien. Before anyone could talk with Thompson, he left the bar and walked out the back door. From there, he quickly made his way to the Menger Hotel, where

he spent the night. The next morning, he sent word to Sheriff T.P. McCall and Marshal Shardien to come to the Menger so he could surrender to the proper authorities without being shot by one of Harris's crowd.

Ben was locked up in the "Bat Cave," as it was known around town, which served as the city and county jail. A coroner's inquest was held on July 12, at which the two bartenders Barney Mitchell and Johnny Dyer, Billy Simms and Doc Herff testified. Then, on the following afternoon, an examining trial was held before Justice of the Peace Anton Adams. Due to the large crowd of spectators, the examining trial was held in the district courtroom. The room was packed with people when Thompson took his seat at ten o'clock in the morning. After a short legal sparring between Thompson's lawyers and the judge, Ben was sent back to jail to await the grand jury in September; his appeal for posting bail was denied. On the September 6, the grand jury formally indicted Ben for the murder of Jack Harris, and he remained in jail until his trial in January 1883.

Thompson hired the best legal staff possible: Walton and Hill, Seeks and Sneed and Wooten and Pendexter of Austin; J.A. Green, N.O. Green and John A. Green Jr.; and J. Minor of San Antonio. They were up against a cadre of seasoned lawyers for the prosecution that included Major T.T. Teel; Tarleton and Boone; Anderson and Anderson; Fred Cocke, the county attorney for Bexar County; the prosecuting attorney from the adjoining district, named Wallace; and Judge Thomas J. Devine. Thompson spent his time in his cell conferring with his legal staff, reading newspapers and picking at a banjo.

In the early part of August, he decided that he should resign from his position as city marshal, and he sent the following letter to the city council: "Gentlemen, I hereby tender to you my resignation as marshal and chief of police of the city of Austin, to take effect on the first day of September next ensuing, or before that date if my successor should sooner qualify. Very respectfully your obedient servant, Ben Thompson." The letter of resignation was presented at the city council meeting on August 7, but the council refused to accept his resignation. Instead, it passed a motion by unanimous vote "that Marshal Thompson be granted a leave of absence for sixty days and that action on his resignation be deferred for that length of time."

Ben's trial finally took place on January 16 in the old courthouse, just up Soledad Street from the Vaudeville Theater and Saloon. The trial drew the

attention of all of the major Texas newspapers and was billed as a classic battle between legal titans, with Judge George H. Noonan presiding. Over the next five days, witnesses for the prosecution and the defense offered their versions of the killing.

Barney Mitchell, who worked the bar the night of the shooting, testified:

> *Jack Harris came in upstairs and went to the ticket office. He came out and he had a shotgun, holding it downward under his bad arm. Thompson walked out and I heard him talking aloud to Billy Simms. Thompson then saw Harris and he said, "What are you doing with that shotgun, you damned S.O.B." and Harris said, "Kiss my ass you damned S.O.B." Harris was still holding the shotgun pointing down under his arm when he was shot.*

Billy Simms gave a long testimony, in which he stated on the witness stand:

> *I knew Ben Thompson, and when he cursed Joe Foster and Jack Harris about the way they lived off the proceeds of those women, he said, "Billy, I am going to close this house tonight." I told Ben, "Don't get into trouble, it is not necessary." At about that time Terry O'Neal came up and began talking to him and took him by the arm and I went upstairs and two shots were fired and I was told Jack Harris was shot. When I saw Harris he was laying in the hall of the show house. Dr. Chew I think was there and others. I got the gun [the shotgun] after the killing from Frank Sparrow.*

A. Hicks told a slightly different version of what Simms had to say. He claimed he was in the saloon that night:

> *He was coming down the stairs from the gambling room and saw Ben Thompson step out the east door of Jack Harris' Saloon onto the pavement. I saw Jack Harris at the same time step in at the far door of the saloon. Mr. Simms was standing in the door as Mr. Thompson stepped out. I think they were conversing when I passed them. I heard Thompson tell Simms: "Billy, there is going to be hell here tonight. I am going to close this place up." After a few minutes Simms went upstairs and Thompson walked down towards Sim Hart's. As Thompson walked up I asked him to go over to the Revolving Light [a saloon] and he refused and crossed his arms over his chest standing there and suddenly he placed his hand on his pistol and*

said: "What are you doing with that shotgun you S.O.B.?" I do not think he drew his pistol before he made the remark. I think it was afterward. A few seconds elapsed and he fired a shot and a few seconds more elapsed and Thompson fired a second shot…I was standing six or seven feet from the saloon door and when Thompson fired his second shot he had one foot on the pavement and the other in the gutter.

The jury heard testimony from many other witnesses, who told some slight variation of the central story. One witness gave a peculiar twist to the deadly drama. Henry Ansell, who was the theatre ticket agent and bookkeeper, reported the following:

The night Jack Harris was killed I had a double-barreled English shotgun in the office. It had been there a year and I had charge of the gun. I can't tell whether the gun was loaded or not. It was a breach-loading gun, No. 12 center fire. There were several paper cartridges and they were loaded with shot No. 7 or 8. This is birdshot. A person by getting behind the ticket office cannot be seen from the front at all…The last time I saw the gun was at 11:00 o'clock that day in the ticket office. I was not there when Harris came into the ticket office and got the gun just before he was shot.

If there really was birdshot loaded in the shotgun, it would have been worthless in a gunfight at that distance; Harris never would have stood a chance. Since the ticket agent last saw the gun at eleven o'clock that morning, Harris may have changed the load to buckshot before he left that afternoon at four o'clock. This will probably remain a mystery, since no one testified to seeing Harris loading the shotgun.

Finally, after five grueling days of testimony and lawyers arguing points of law, "Buck" Walton closed for the defense, and T.T. Teel gave the final closing remarks for the prosecution. Judge Noonan handed the judgment over to the jury at nightfall. The jury left the courtroom and ate supper before considering the evidence. Nine of the jurors were for acquittal and three were for conviction, so they went home to sleep on the matter. They continued their deliberations the next morning at the courthouse. Shortly after eight o'clock, they returned to the courtroom with a verdict of "not guilty." A wild round of applause rang out in the spectators' gallery as newspaper reporters rushed to wire the results to their editors. Though Ben

Thompson had been vindicated in the court, there were still many in San Antonio who felt like there had been a miscarriage of justice.

Late the next day Ben, his wife and his daughter arrived back in Austin on the afternoon train. It was sundown, and the station was packed with well-wishers welcoming the return of their maligned marshal. There were state and local dignitaries, a brass band and a mass of the city's finest citizens, as well as a sizable number of characters from the underbelly of the city. As Ben emerged from the train, he was given a wild ovation. Then, as he and his family stepped into their waiting carriage, the crowd insisted on detaching the horses and pulling his carriage triumphantly up Congress Avenue themselves. Ben, their prodigal son, had returned safely and vindicated, but there were those in the crowd who wondered for how long. Jack Harris's friends had failed to convict him for murder, but the feud was far from over.

Chapter 9
King Fisher
The Early Years

J. King Fisher was one of the most colorful characters of the Texas frontier. He was as handsome a figure as ever stepped out of the pages of a dime novel.
—Glamorous Days, *Frank H. Bushick*

In the years following the Civil War, the strip of land lying between the Nueces River and the Rio Grande was a lawless no man's land of stock thieves and border bandits. The "Nueces Strip," as it was called, was a remnant of the bitter battles fought by the early Texans to gain their independence from Mexico. Shortly after the surrender of Santa Anna at the Battle of San Jacinto in 1836, the government of Mexico reneged on the treaty, saying that the Nueces River, and not the Rio Grande, was the boundary line between the two republics. Skirmishes and battles raged in the disputed strip until Texas was admitted into the United States in 1845 and General Zachary Taylor defeated the Mexicans in the war with Mexico. This rough strip of the border then became a haven for outlaws and raiders on both sides of the Rio Grande.

Located in the center of the Nueces Strip was Dimmitt County, where John King Fisher reigned as the acknowledged leader of a large band of outlaws and stock thieves. From his stronghold on the Pendencia Creek, he ran a loosely organized gang that took the art of changing brands with a running iron to new heights. When asked, most people who lived in the area would be quick to say that it was "King Fisher's land" and that he controlled everything that went on there. At the same time, most would say that he was

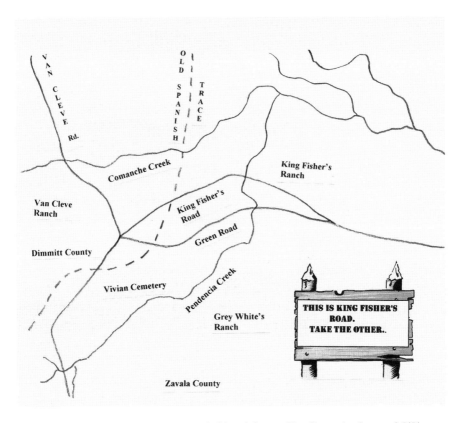

Map showing King Fisher's ranch stronghold and the road leading to it. *Courtesy O.T.T. Collection.*

"a pretty good ol' boy." Feared by some, hated by a few, Fisher generally had a reputation of being friendly with most people as long as you were not facing him with a gun.

John King Fisher was not a native son of the Nueces Strip; he was born in 1854 in Collin County. His father, Jobe, and his mother, Lucinda, had one other son named Jasper. King's mother died from complications at Jasper's birth, leaving his father to take care of the two young boys. Jobe quickly found a second wife, but Lucinda's brother, Cam Warren, thought that she was not up to rearing and educating the youngsters. At the time, he was a storekeeper in McKinney, Texas, and felt that his family could do a better job with King and Jasper. He offered to take the boys, but Jobe would not hear of it. He and his new wife, Minerva, would manage just fine.

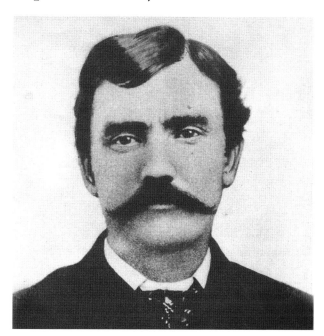

John King Fisher, outlaw
folk hero of the rough
border area known as
the "Nueces Strip."
Courtesy Lawrence Vivian.

Shortly before the War Between the States broke out, Jobe and his family moved to Williamson County. Then, in October 1861, he joined Captain J.L. Whittenberg's infantry company from Williamson County. This was a part of the Twenty-seventh Brigade, under General E.S.C. Roberton's command. A few years later, he was part of a mounted company with the Twenty-first Brigade under the command of General William Hudson, who was in charge of the Texas State Troops. He was eventually transferred to the Confederate States Army (CSA), in which he served until he was mustered out in February 1864.

When war ended, Jobe Fisher returned to his wife and found Minerva in poor health, barely able to tend to the children. He decided that the mineral springs in Lampasas was what she needed to regain her health; in 1865, then, he moved the family and several hundred head of cattle to Lampasas. After a few months, Minerva's health continued to falter. Finally, after consultation with a physician, it was decided that she needed a better climate, closer to the Gulf of Mexico coast. Once again, Jobe packed up the family and moved to Goliad, where he built a home and started a thriving cattle business. In addition, he set up a freighting business that ran wagons from an old boat landing south of Goliad up into central Texas.

At thirteen, King, as he was now called, was responsible for tending to the cattle and the other children—Minerva had a son and a daughter by Jobe before she died and left the rearing up to her husband. King was an expert horseman at this early age and yearned for more excitement than playing nursemaid to his siblings and a heard of cattle. In 1869, when a local frontiersman named Grey "Doc" White pulled up stakes and headed a wagon train of settlers to the brush country of the Mexican border, King pleaded with his father to let him go with the group. Jobe would not hear of it and sent him to Florence, Texas, to live with relatives and attend school.

The young Fisher was described as a handsome young man and a good student but rather quiet and mild-mannered. At fifteen years of age, he was also a scrapper and won most of the fistfights that cropped up now and then. In one fight, he gave a thrashing to a boy who was seeing his cousin Annie. When her boyfriend arrived at a dance with head and face injuries, King said that his horse had run under a tree limb with him in the saddle. Annie later found out that King and her boyfriend, Ed Burns, had been racing horses and that Ed refused to pay for the wager on the race. King, an excellent rider, expected payment for racing wagers and usually got it one way or the other.

King quickly gained the reputation of being one of the top bronc riders in Florence. He bought and broke the wildest and most spirited horses and then traded or swapped for other horses. Wrangling horses came easy to the young man, but it eventually led to his first scrape with the law.

One day, after working stock for several days straight, King unsaddled his horse and took a nap under the shade of a large oak tree. While he was asleep, the horse pulled away and left him stranded. Disgusted, King saddled up a neighbor's stallion and went to look for his stray horse. When he found his horse, he transferred his saddle from the stallion and then returned the borrowed horse to the owner's pasture. Being friends with the neighbor's sons, Hugh and Bill Turnbow, he did not think it was important to tell them what had happened. As it turned out, it did matter to old man Turnbow. When it was reported that King had been spotted riding the stallion, he filed a complaint against King for "borrowing" his stallion without permission.

A few days later, when Fisher found out he was "wanted" by the constable, he figured it was time to get out of town. At dusk, he rode up to his Aunt Nancy's house and asked for supper. He said that since school was out, he was riding back to Goliad. The aunt was very fond of King and felt that his stepmother

had mistreated him when he was a young child. While they were eating supper, several riders were seen approaching the house. King gulped down the last of his food and sailed out the back of the house to his horse. He took off in a full gallop but was later captured when he stopped to rest the next morning.

King soon appeared before a justice of the peace, who instructed him to go with Constable Ike Barber and Mr. Turnbow for a hearing in Georgetown, the county seat. While on the fifteen-mile ride, Turnbow's conscience got to bothering him about the horse-stealing charge that would be levied on the youth. He slipped a pocketknife to Fisher, and while they were stopped at a house to get a drink of water, King cut the lead rope to Barber's horse and thundered off to Goliad. King returned to his father's place without telling him about his scrape with the law in Florence.

Goliad at the time was a booming town due to the upswing in the cattle business. King's father was beginning to prosper with his cattle and freighting business. This meant that he and Jasper were frequently away from home, leaving King to tend to the cattle while Jobe's mother, Anna, took care of the children and the house. With his father gone, King soon started spending time with some of the rough element of the community. He became friends with some of the Bruton boys, who had frequent brushes with the law. Under their influence and that of other undesirables, he became involved in a series of petty crimes. Finally, in October 1870, he and Willis Fulcord were jailed on housebreaking charges in Goliad. At the time, there was a community-wide movement to rid the area of the lawless element, and the sixteen-year-old King was found guilty of the charges. He was sentenced to two years in the penitentiary in Huntsville.

When he arrived at the prison, the records described him as being five feet nine inches tall and weighing 135 pounds with a fair complexion and brown hair. He was thrown in with some of the worst criminals in the state, which caused his father to fear for his life. Jobe used every influence he could muster to free his son. Finally, in February 1871, he managed to get the governor to grant a full pardon because of his age.

Returning to Goliad, King found that people were not as friendly as they were before he was sent to prison. In addition, his old cronies the Bruton boys had pulled up stakes and headed for the rough brush country of what would later become Dimmitt County, a section of Maverick County. Charles Bruton left with warrants for his arrest on charges of using an unrecorded brand, for violating the stray law and also for seduction and rape.

A short time later, Doc White sent word that he could use King on his ranch in Maverick County. At seventeen, Fisher figured that he was ready to make it on his own, so he and another youngster saddled up their horses and headed to the land on the Pendencia Creek. His father pleaded with him to stay away from the rough bunch that had migrated to the border country. Headstrong and defiant, King refused to listen to his father and headed for a new life in the wild brasada of south Texas. Apparently, his father died a short time later, still grieving over the path that his son had chosen.

Chapter 10
Nueces Strip Renegades

I am willing to take a good many chances, but I certainly would not live on a stock ranch west of the Nueces River...the risk is too great.
—Texas Ranger Captain L.H. McNelly

John King Fisher and Bud Thompson (no relation to Ben Thompson) crossed the Nueces River and rode into the wild and untamed Nueces Strip. They traveled through a stretch of arid, cactus-filled flat land until they reached the lush grasslands of Dimmitt County, where artesian wells were plentiful and everything they saw looked to be a paradise for ranching. Finally, they reached Grey "Doc" White's settlement of sod houses and mesquite corrals. Doc, who got his moniker for being an expert amateur veterinarian, had led the wagon train of settlers from Goliad, Atascosa and Frio Counties four years earlier. King Fisher knew a number of people from Goliad: the Whites, the Vivians, the Englishes, French Struther, John Gibson and the Bruton boys. One of the Vivians, Sarah, held a particular interest to King. The two were childhood sweethearts in Goliad, and King was pleased to be near her again.

Doc White and his wagon train of settlers had arrived at Pendencia Creek on Christmas Day 1867. Since that time, they had built *jacales*, or houses, in the fashion of the Mexican huts prevalent in the area. Jacales had walls of straight posts or pickets of mesquite or elm that were plentiful in the area. The posts were set in the ground and tied together using rawhide; then split pickets or small tree limbs were wedged between the posts. A plaster of

caliche and sand was used to cover the walls inside and out. On top of this was a low thatched roof of *sacahuisto* (salt grass), a water-repellent grass that kept the rain out but provided ventilation in the heat of summer. The floors were of hard, packed caliche. Windows and doors were little more than openings covered by deerskins. Primitive by any stretch of the imagination, these jacales were the best that could be built with existing supplies. By the time Fisher arrived, some of the settlers were working on new, more substantial homes made of rock.

When Fisher had last seen Doc White, before the wagon train left for the "Pendench," as it was called by the settlers, he had bragged, "If you run into anything over there you can't handle, just send for me." At the time, Doc had simply smiled and said that he would keep him in mind. Now, four years later, he really did need the young wrangler, who knew his horses and could work cattle. Also, since there was no protection from the continuing threat of Indian raids, cattle thieves and Mexican bandits, Doc needed an extra gun working for him. Young King Fisher fit the bill perfectly.

Doc White insisted that King join his family for supper that night, and after they had finished eating, he laid out the situation that they faced in the Nueces Strip. Mexican bandits and Indian raiders accounted for a continual decline in the branded herds of stock and horses. At the same time, there was an influx of bandits, thieves and other hard cases drifting into the area from up north. Dubbed GTTs ("Gone to Texas"), these were mostly wanted men who camped in the brush, some rounding up strays but most stealing from the settlers. Even the Mexican Army did not hesitate to take the Texans' stock, as mentioned by Jake English when he later wrote about the 1869 attack on Jim Roberts:

> *Jim Roberts owned a ranch five miles above Carrizo Springs on Carrizo Creek, at what was known as Fort Ewell Crossing. He had a large herd of cattle and horses pastured in the vicinity of his herd pens on San Roque Creek, 30 miles south of Carrizo Springs. It was at a distance of about 3 miles from his pen that he was attacked by Mexican raiders and killed. At the camp with him were his brother Caldwell Roberts, and John Gardner, Bob Lemmons, Jose Flores, and another Mexican called Anisetta. Jim Roberts was out rounding up cattle when he discovered agents of the Mexican Army rustling a large number of steers and horses. When he protested, he was shot down and left in a dying condition, and all of the*

livestock in the vicinity were herded across the Rio Grande by his slayers. It was later found that the stolen livestock had been turned over for the use of Mexican troops.

Doc White said that they needed someone to stop this wholesale rustling of livestock and rid the area of the hard cases. After talking with the other families, King agreed to go to work for the settlement. He quickly became a fearless, hard-riding "stock marshal" who made the rules as he went along. Outfitted with a pair of revolvers and a rifle, he soon mastered the art of quick draw and steady aim. He practiced daily until he could plug a target using either hand or the two simultaneously. Those watching him practice knew that they had hired a true pistoleer.

Not long after he started work for the stockmen, he broke some of the best stray horses in the area and finally picked one for his own mount. He called the horse Yaller Lightnin and bragged that Old Yaller could "pace a mile a minute." Often working in the shadows of night, King astride Old Yaller chased Mexican bandits back to the border, recovering stolen horses and cattle. Before long, the stockmen developed a real respect for the remarkable young cowboy and his relentless pursuit of rustlers. As long as he was protecting their interests, they cared little about his methods or the men who eventually rode with him. Word quickly spread that if you had any intentions of rustling livestock, you had better steer clear of the Pendencia area, where King Fisher was the law and dealt justice with a six-shooter.

John Leakey, who wrote *The West that Was*, describes an episode in which the young gunfighter teamed up with Joel Fenley and his son, George, to track down some Mexican rustlers who had stolen cattle from Fenley. They caught up with the gang before they could reach the Rio Grande. Boldly riding into their camp at noon while the Mexicans were eating, King and Joel introduced themselves and stated that they were going to cut out all of Fenley's stock from the herd. Realizing who they were dealing with, the Mexicans did not offer resistance and said it was fine with them. Then, with George standing guard, his rifle across his saddle bow, King and the elder Fenley went through the herd retrieving the stolen cattle. Fenley got his cattle back, and the Mexicans returned to Mexico with a few stays—and their lives. Fisher's reputation quickly started taking on mythological proportions. The young pistoleer had worked miracles in protecting the settlement's livestock, and the community felt fortunate to have him working for them.

After a few years, King had developed into a handsome young man with a smooth, friendly approach to those he met. Most of the settlers liked his calm, easygoing nature, but some felt that there was an element below the surface of his smile that was as deadly as the rattlers of the brush country. He was well received by the community but was still viewed as a dangerous man with a gun and someone you did not want to cross. Various accounts have him standing about six feet tall and weighing about 180 pounds with thick black hair and dark eyes. When he was not tracking rustlers, he liked to dress in fine clothes that included black broad-cloth suits with fine white linen shirts. He usually wore the big wide-brimmed Mexican sombreros and black patent leather boots with fancy trimming. Projecting an image of self-confidence mixed with a dash of swagger, King became the topic of conversations in the Pendencia settlement, as well as at the saloons of Eagle Pass, located about thirty-five miles to the west. When he walked into a bar, all heads turned in his direction, following his every move. Savoring this attention, he did little to discourage the growing stories of his escapades on the Pendencia, which were often embellished and sometimes fabricated. He seemed to enjoy his growing reputation and the effect it had on those who knew him, as well as those who feared him.

Finally, after a few years of working for the ranchers in Dimmitt County, King decided that he would work for himself and begin his own herd of cattle. He located a ranch on the Pendencia in the northwestern part of Zavala County. Then, after building a house and corrals, he started rounding up unbranded livestock. He broke wild mustangs and in a short time amassed a sizable remuda of tough horses to work his cattle. Soon he was delivering small herds of longhorns to drovers, clearing a nice profit from his efforts.

It is at this time that the stories of King Fisher start to take on a dark and ominous tone. When, where or if he had killed someone prior to this time is open to speculation, but there are many stories circulating that he had killed a few of the Mexican rustlers. It is a fact that he started letting drifters and other hard-luck cowboys help him with his cattle operation. Some of these men were wanted by the law and knew that King would harbor them without fear of being turned over to the law in Eagle Pass. It was not long before stories started to make the rounds that he and his men were dealing in stolen cattle. Next came the accounts of King using his pistols in gunfights.

Frank Bushick, editor of the *San Antonio Express* in the 1890s, wrote an account of Fisher's feud with a man by the name of Donophan. The man

owned a ranch south of Eagle Pass and about thirty miles from Fisher's place on the Pendencia. Bushick said that Donophan accused Fisher and his men of killing some of his cattle and one of his cowboys by the name of Porter. After a few more killings, it became a full-blown feud. According to Bushick, a sheep rancher named C.S. Brodbent owned a small spread between the two warring groups. As he was herding his sheep to a watering hole, a Mexican suddenly appeared out of the brush and said that he was camped with some others down by the water hole. He followed the Mexican to their camp and found that it was King Fisher's men. Each man was armed with a Winchester, a pistol, a knife and two cartridge belts. The Mexican politely asked the man if they could buy two of his sheep for food. The man agreed, and the sheep were slaughtered and put on the fire to roast. King, who had not been at the camp at the time of Brodbent's arrival, rode up and asked, "Is that your camp down the valley?" Brodbent nodded, and Fisher said that some of them had been down to the camp and had baked some cornbread. Apologizing, Fisher said, "I'll pay for them. We were hungry."

Brodbent refused to be paid for the pones of cornbread but did accept Fisher's invitation to join them for dinner. After the meal, the men asked if he had seen anything of the Donophan outfit. The sheep man said that he had seen some of Donophan's men a few days earlier but did not relay the fact that they had been asking about Fisher's men. Brodbent figured that big trouble was brewing and that it was best to stay out of the melee. He thanked them for the supper and then left to look after his sheep. Sometime later that night, Donophan's ranch house mysteriously burned down.

A few days after losing his house, Donophan rode into Brodbent's camp late in the evening. After eating with the sheep man, he stated that he had found several of his cattle shot. He said that he thought it was the work of the King Fisher bunch and was riding down to the Pendencia to confront Fisher. Brodbent diplomatically cautioned him about going down there, saying that it might be dangerous, particularly if he went alone. Donophan looked at the herder and said, "I'm not afraid of them; if they shoot me they'll have to be mighty quick about it." Realizing that Donophan had his mind set on the showdown, Brodbent responded, "Well, if they want to kill you they will not be very ceremonious about it."

Apparently, the sheep man was correct in his warning. After spending the night, Donophan finished his morning cup of coffee, thanked Brodbent for his hospitality and then rode off toward Fisher's ranch. That was the

last time that anyone saw him alive. His body was found in the road a short time later (where he had been shot and killed). Though other accounts of Donophan's death describe King Fisher as the killer, Frank Bushick wrote that it was never clearly determined exactly who killed the rancher or the circumstances of the shooting. According to Bushick, there were many who speculated on the killing, but there were no eyewitness accounts documented.

Major T.T. Teel, a noted criminal lawyer who represented King Fisher on several occasions, later told of Fisher's fight with three Mexican vaqueros who were trying to take a horse from his corral. The riders claimed that the horse belonged to them, and one of them pulled a pistol and fired at Fisher. The shot missed its mark, and King jumped the man, taking his pistol. The other Mexicans had their guns out, but Fisher's rapid fire managed to kill all three of the vaqueros. Teel later successfully defended Fisher when he was tried for the killings.

Teel also described what was later to be called the "Comanche Cattle Fight," in which King was accused of killing several Mexicans over a dispute of some stolen cattle. According to the lawyer, King only acted in self-defense when Mexican riders attacked him. The May 31, 1876 *San Antonio Daily Express* ran this front-page account:

> *EAGLE PASS, MAY 30, 1876.*
> *A bloody fight occurred on Comanche Creek, about twenty-five miles below here yesterday morning at ten o'clock. Alejo Gonzales of Rio Grande City, with three others, were killed, and five persons wounded. Gonzales was pursued by cattle thieves, who made the attack upon his party. The authorities of Maverick County will visit the scene, and care for the dead and wounded.*

At the same time, another San Antonio paper, the *Herald*, reported that Gonzales and eight of his men followed about thirty cattle thieves and "found them to be white men." The account continues saying that the gun battle lasted from nine o'clock in the morning until four o'clock that afternoon, with Gonzales and four of his men being killed. The report says that five of the cattle thieves were killed in the fight.

Teel's version of the story has it very different. According to him, Gonzales had followed a herd of stolen cattle to Fisher's ranch. King had a legal bill of sale for the livestock, which he had purchased from a Mexican drover. Without conferring with Fisher, Gonzales and his men rounded up the stolen

stock, as well as some other cattle from one of King's pastures, and headed them back to Mexico. King and his men went after them in hot pursuit, catching them at Comanche Creek. A gun battle took place, and King killed three of the Mexicans and wounded several others.

Apparently, the trouble between King Fisher and Alejo Gonzales had begun a year earlier, when the June 8, 1875 issue of the *San Antonio Herald* reported:

> *A man who calls himself King Fisher has been arrested on the Salado, and placed in the Bexar County Jail, on the affidavit of Alejo Gonzales, the arrest being made yesterday by Deputy Sheriff Dashiell for stealing cattle. The accused claimed a herd of cattle as his own which is made up of a great many different brands, and has other indications that create the impression the owners of the cattle have not been consulted in the matter.*

King made bail and returned to his ranch, forfeiting the money by not appearing for his trial. So, a year later, Gonzales thought he had to handle the affair with his own two hands rather than trying to rely on the law. Gonzales, who had grown up in San Antonio, was a well-known young man who operated a very successful mercantile business in Piedras Negras, Mexico, as well as his cattle operations in Rio Grande City, Texas.

As it turned out, Gonzales was not killed in the gunfight. In an article entitled "Let Justice Be Done Our Western Citizens," printed in August 28, 1877, the *San Antonio Daily Express* purported to tell the "real story" of the Comanche Cattle Fight. The subtitle read, "The Mexicans, and not King Fisher, the Robbers in the Comanche Cattle Fight." Testimony from several of the participants in the fight that appeared in a hearing in Castroville described the details that led up to the gun battle. In the latter part of May 1876, Frank Porter sold King Fisher 150 head of cattle that were branded with five different Spanish brands and several American brands. Fisher then applied his "KP" brand over the top of the other brands and moved the cattle to pens located near Comanche Creek.

Charley Bruton, who owned a nearby ranch, had witnessed the cattle transfer to King. When fourteen Mexican horsemen arrived at his ranch two days later, the leader told Bruton that they were tracking eighty head of stolen cattle and asked if there had been any livestock moving in the vicinity. Charley eyed the vaqueros, who were heavily armed with pistols and Winchesters. Seeing that they meant business, he answered truthfully that

King Fisher had a herd penned in a camp near Comanche Creek. Vowing to have those cattle or "follow them to hell," Gonzales and his men thundered off in the direction of the cattle pens.

Bruton, who was an old friend of Fisher's, quickly sent George Claunch on a fast ride to King's camp to warn him of the approaching Mexicans. King was outnumbered, but he was determined to stop Gonzales from taking his livestock. He ordered his men to scatter the cattle into the dense brush to make forming the herd more difficult for the vaqueros. This bought Fisher some time to marshal his forces. He rode into Charley Bruton's place that night and from there sent word to the neighboring ranchers that he needed help. By morning, enough riders had arrived for King to carry out his plan to hunt down his cattle and the thieves with the intent of killing the thieves and recovering the livestock.

At daybreak on May 29, King Fisher and a dozen men left Charley Bruton's place and headed for Fisher's pens, located about eight miles east. Riding with Fisher, the *Daily Express* reported, were Frank Porter, Nick Reynolds, Williams C. Bruton, John H. Culp, John Hudgins, Ed Calvin, Bob Lewis, Dick Horn and a man named Gildea (probably Gus Gildea, who was well known in the area). Strangely enough, Charley Bruton did not ride with Fisher, choosing to ride out to his own cattle camp instead.

By this time, Alejo Gonzales and his vaqueros had managed to gather up more than two hundred head of cattle and were hard at work on the rest of Fisher's herd when Fisher and his men rode up. It was ten o'clock in the morning, and the cattle were moving up Comanche Creek. Some of the Texans raced ahead of the others. When they were within a hundred yards of the vaqueros, they pulled up, dismounted and opened up with their Winchesters. W.C. Bruton was the first to fire and caught one of the Mexicans who was trying to dismount and return fire. Then as the other stockmen arrived, all hell broke loose in a roar of gunfire. Alejo Gonzales was hit three times before he fell seriously wounded. Nick Reynolds downed a Mexican with a shot to the man's head. The rest of the Texans kept up the firefight until several others were wounded. Then, with their leader and several others severely shot up, the remaining Mexicans had had enough and took off for the border. Some of the Texans wanted to go after them, but Fisher decided to let them go. He had his cattle back and the fight was over.

Charley Bruton heard the shooting but did not take part in the fight. He estimated that he heard more than one hundred shots fired and that the fight

was over in a hurry. Two hours later, he rode over to inspect the carnage. He spotted Alejo Gonzales's hat lying in the dirt and then saw a dead Mexican who had been shot "through the head from ear to ear." The court testimony of Charley and the others confirm that King was not credited with killing any of the Mexicans, but circulating stories had raised Fisher's reputation another notch by saying that he had personally killed three of the Mexicans.

John Leakey, in his book, told of another shooting involving King Fisher as described by one of Fisher's most trusted employees, a man named Pancho. According to Pancho, King had a disagreement with four other Mexicans who worked for him. They were not satisfied with the way they were going to be paid for bringing in a herd of cattle from Mexico.

King saw that they were planning to kill him. He didn't let on. He went right on branding and watching. Out to one side, Pancho was tending the branding irons. One Mexican was working with King and three sat on the fence. King always wore his six-shooter, according to Pancho's version; the men, who had too often seen the results of Fisher's aim, were not anxious to start anything.

One of the three men on the fence wore a gun, too, and he was the one King watched the closest. But it was the one helping with the branding who started the argument and then tried to put up a fight. King saw his first move and brained him with a branding iron. In a flash, the armed Mexican jumped into the pen, his hand on his gun. King drew and shot him before he could draw the gun and then whirled and killed the two on the fence.

Pancho helped bury the dead men behind the branding pen and later placed markers on their graves. He hated to see the men killed but remained loyal to Fisher. According to Leakey, he was very clear that even though many people repeated the rumor that Fisher had killed eight men, in reality there were only four killed that day.

"Pest House" Pete was another man who claimed to have worked for Fisher. He told Judge W.A. Bonnett that he was with King when he rode into Mexico in hot pursuit of some Mexican bandits. It is not recorded how or why the man got tagged with the odd nickname, which refers to a sanatorium for contagious diseases such as leprosy. According to Pete, they overtook the riders, and King killed three of them. Pete was then ordered to tie a rope to the dead men and drag them back across to the Texas side of the river. Pete said that on a separate occasion they chased another Mexican across the

border, and after King killed the man, Pete was instructed to drag him back across the river.

Another account carried by the January 14, 1876 issue of the *San Antonio Express* describes yet another shooting incident as related by an unidentified source:

> *We had a short conversation yesterday with a stockman, just arrived from the vicinity of Brownsville. He says that we do not hear half the troubles Texans have on the river* [Rio Grande]. *He was near where King Fisher had his recent fight, and says that it was a terrible affair. King was riding a horse, which some Mexican, who stopped him, claimed, and insisted that he should give up. After some words, one of the Mexicans rode up beside King, cut the girdle of his saddle and pushed him off the horse, when the other two drew their revolvers and dared King to budge. But his ire was aroused, and no threats from the bandits would avail anything; so he pulled his pistol and fired, shooting the man who cut the girdle through the head, killing him instantly. He was then fired upon by the other two, and slightly wounded, but two further discharges from King's pistol sent these, too, to their "happy hunting grounds." He then re-saddled his horse and started home, having slain all of his opposers, but was chased by another gang of six Mexicans for some distance, who shot at him with Winchesters, but without effect.*

Because so many stories were embellished, exaggerated or sometimes outright fabricated, it is hard to tell just how many men Fisher killed during his days on the Pendencia. Only those who were there at the time of the shootings were in a position to set the record straight, but even those accounts might have been "improved upon" in the storytelling.

Chapter 11
Other Side of the Coin

King Fisher was very well known around here for not standing for any foolishness.
Some called him a desperado, but I do not think he was as bad as pictured.
—Judge W.A. Bonnett, Eagle Pass, Texas

By the year 1875, King Fisher had become notorious for shootings, cattle rustling and controlling a large portion of the ranching operations of Dimmitt, Maverick and Zavala Counties. Stories about his pistol fighting circulated in the saloons of the border, usually with additional embellishments, fanning the fires of his growing reputation.

Regardless of the number of men or the actual circumstances of the killings, King Fisher did dispatch a number of men to an early grave. Since most of those he is credited with killing were Mexicans, it might be easy to assume that he had little regard for Mexicans on either side of the Rio Grande. Accounts by some tell a different story. He had a number of Mexicans working for him on his ranch as related earlier, and in the community of Eagle Pass, several prominent men of Mexican blood counted him as a friend.

Trinidad San Miguel, a highly respected man in Eagle Pass, was a close friend of Fisher's. He served as the tax collector and in other public offices in Maverick County during his seventy-nine years in Eagle Pass. He revealed a completely different view of the outlaw when others were circulating stories of lawlessness and death. His son, Refugio, related this story about Fisher:

One time my mother purchased a Spanish pony from the other side of the river. It disappeared, and it was believed some of King Fisher's men had taken it in their roundups. My mother was very unhappy about this loss because she valued the horse very highly. My father took this up with King, described the horse, and asked him to help locate it. The very next day the horse was returned to our house.

Another story told by Refugio concerned two of Fisher's men who shot a Mexican wood hauler's team of oxen. One of the men had wagered with the other over their pistol shooting abilities, saying, "I'll take the brindle ox and you take the other. If I fail to kill mine I'll give you five dollars. If you miss, you give me fifteen dollars."

The other man accepted the bet, and they both drew and fired at the team. Both oxen dropped where they stood, in the middle of Main Street. Prajedes, the wood hauler, thought that he was the next to be shot, so he took off for the safety of his adobe hut. A few minutes later, King Fisher was riding down Main Street when he spotted Trinidad San Miguel looking over the dead animals. When Trinidad told him who had killed the team, Fisher asked him to take him to the owner of the oxen. The two men found the poor frightened man under a bed in his hut. With a little coaxing, they got him to come out from under the bed and tell them the value of the oxen. Relieved that he was not going to be killed himself, he said that twenty-five dollars would cover the damage. King and Trinidad returned to town, where they located the two men who had killed the animals. Fisher demanded an explanation. After they explained the wager, Fisher told them that since the oxen were killed simultaneously, it was a draw, so both lost their wager and each owed fifteen dollars regardless, according to King. Both men knew that it would be futile to argue with their boss, so they coughed up the thirty dollars and handed it over to Fisher. Fisher returned to Prajedes and gave him the money.

Refugio San Miguel said that his father always defended King Fisher, saying that "King Fisher was a 'muy bueno hombre,' and that regardless of what was said about him, he meant well."

In another story illustrating King's disposition toward Mexicans, he spoke up on behalf of a poor Mexican who was on trial for putting his brand on a maverick that was claimed by an Anglo rancher. The Mexican stood before the judge pleading his case with his two small children by his side. Fisher,

who happened to be in the courtroom at the time, asked the judge if he could speak. The judge nodded approval, and Fisher asked the man where the children's mother was while he was in court. The man replied that his wife was dead and that he did not have anyone to look after the children. King turned to the judge and presented an argument that the man needed to care for his children more than the state needed to send the man to the penitentiary. The judge agreed and the charges were dismissed.

King Fisher also enjoyed the friendship of Porfirio Díaz, the Mexican revolutionary leader who would later become the president of Mexico. A few years before he became the president, Díaz lived in Piedras Negras, across the river from Eagle Pass. Apparently the two men conducted a series of cattle transactions—more than likely stolen cattle. As a token of his friendship, General Díaz invited Fisher to be his guest at balls and celebrations in Piedras Negras. The general made it a practice to send bodyguards to escort Fisher across the Rio Grande because of threats by some Mexicans who said they would kill the Texan if he entered their country. At one of these celebrations, Díaz presented a beautifully crafted pistol to King. The gun was a .45 Colt with a black gutta-percha handle and a blue-bronzed steel cylinder and barrel.

In addition to Fisher's popularity with some sections of the Mexican population on both sides of the border, he also had a number of prominent Anglo friends who defended him and his actions. Though most agreed that he was a very dangerous man with a gun and had men of questionable backgrounds working for him, they did not see him as all that bad.

Tom Sullivan, who was a deputy sheriff in Medina County, got to know King Fisher while he was incarcerated in the Castroville jail for killing some Mexican cattle thieves. He also knew Ben Thompson and considered him a friend. In a November 1935 article that appeared in *Frontier Times*, Tom described them, saying, "They called King Fisher and Ben Thompson bad men, but they wasn't bad men; they just wouldn't stand for no foolishness, and they never killed any one unless they bothered them." This was the prevailing opinion of a number of people at that time, regardless of what appeared in the newspapers.

As mentioned earlier, Judge W.A. Bonnett had been a prominent citizen in Eagle Pass for decades. As a young boy, he got to know King Fisher and often visited with the notorious figure. "When I came to Eagle Pass as a boy in 1878," he later related, "King Fisher was very well known around here

for not standing for any foolishness. Some called him a desperado, but I do not think he was as bad as pictured." Judge Bonnett, who was working in a store across from the Old Blue Saloon, told of a shooting that occurred at the watering hole. According to Bonnett, a Seminole government guide walked into the saloon and ordered a drink. When it came time to pay for his libations, the Indian became enraged and started shooting. King Fisher happened to be in the saloon at the time and had tried to avoid having a fracas with the Seminole. Finally, when the smoke cleared, Fisher walked out of the saloon with a scalp wound and the Indian guide was left nursing a stomach wound. "It all happened so quick that no one could tell how it had happened," Bonnett later recalled.

Bonnett, who wrote about his knowledge of Fisher, summed it up by saying, "Please do not think from what I have said that King Fisher was a bad man, as men were here then. There were many like him, only worse…it took men like this to make the frontier fit for us to live in today."

John Leakey also knew King Fisher as a young boy and described him as "a handsome man with black eyes and black hair and mustache, noted for his fine bearings and appearance as he rode through the towns and bottoms of southwest Texas, followed by his flashy vaqueros. He always rode beautiful horses and dressed well." This seemed to be a recurring sentiment held by many in the community, where the handsome young rancher had a way of dispelling the uneasiness that was often felt when he was first introduced to those who knew him only by this reputation.

Mrs. Albert Maverick Sr. remembered meeting King Fisher when she was a young woman and having a very pleasant conversation with the soft-spoken rancher, not knowing what kind of a reputation he carried. "To my inexperienced eye, he was a very innocent looking cow boy, tall and thin and dark." Later, she was shocked to learn that she had been speaking with one of the state's most notorious pistoleers.

E.H. Schmidt, a prominent banker in Eagle Pass, told of his mother's impression of King when he attended the community dances. "He danced with every woman present, according to my mother. He was very popular and acted the part of a perfect gentleman."

Another prominent pioneer rancher, F.W. Pulliam, backs up this account by saying that his mother remembered meeting King Fisher at a dance. She said that he danced with her and the other ladies, stating, "He always behaved like a perfect gentleman."

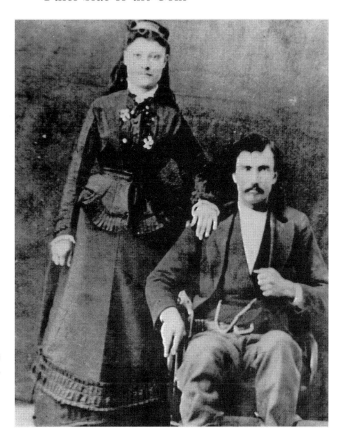

King Fisher and his wife Sarah posed for this photograph at the time of their wedding. Note the pearl handle of his pistol in the picture. *Courtesy Lawrence Vivian.*

One of the young ladies who whirled around the dance floor with Fisher was his childhood sweetheart, Sarah Vivian, the daughter of John and Jane O'Neel Vivian. Sally, as she was called, was a nineteen-year-old beauty of Irish blood with sparkling eyes and a vibrant personality. King was a handsome young man of twenty-two years of age and at his peak of power and influence in the community. On April 6, 1876, the couple stood before Doc White, presiding as the justice of the peace for the Pendencia precinct. They looked into each other's eyes and recited their wedding vows that included the pledge that they would love each other "until death do us part." The wedding took place in Eagle Pass, and afterward the newlyweds moved into King's ranch house on the Pendencia.

Chapter 12
Captain McNelly's Raid

...right there, facing each other at not more than five paces, were by long odds, the two best pistol fighters in Texas, before and since.

—George Durham, Texas Ranger

King Fisher's road sign—which read, "THIS IS KING FISHER'S ROAD—
TAKE THE OTHER ONE"—did not intimidate Captain Leander H.
McNelly and his Texas Rangers. They had warrants for his arrest, as well
as for some of those who rode for him. Come hell or high water, they were
going to capture the legendary border boss and lock him up for trial in
Eagle Pass.

It was June 3, 1876, when the much feared ranger captain and his men
set up the attack on King's ranch stronghold, just a few months after Fisher's
wedding in Eagle Pass. Captain McNelly was adamant that they were going
to take this outlaw down and make him pay for all of his crimes.

In his mid-thirties, lean, hard-bitten and battling bouts of consumption
(tuberculosis), McNelly was the epitome of the classic fearless Texas Ranger.
He had led the fight to clean up the Sutton-Taylor blood feud in DeWitt
County in 1874. Now, after battling Mexican cattle thieves on the border at
Las Cuevas and Palo Alto, the men of the Seventh Company of the Frontier
Battalion were seasoned fighters whom McNelly ruled with an iron fist. In
an interview with a *San Antonio Express* reporter, he described the handpicked
men under his command:

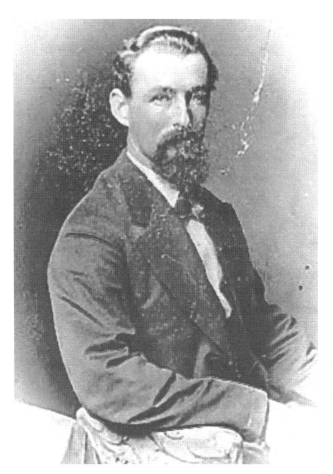

Texas Ranger captain Leander McNelly was sent into the "Nueces Strip" to arrest King Fisher and his gang. *Center for American History, University of Texas.*

My men are mostly from the interior of the State, many of them from Washington County, near my home. I prefer men from the interior, because of their greater steadiness. I find that they can ride longer, stand more hardships, eat less, and are most obedient to my commands. I enforce the very strictest discipline, and would not hesitate to compare my company with a similar number of men anywhere, in any respect, regarding their qualifications as soldiers. I allow no whiskey in camp—there has not been a drop of liquor in my camp for many months. No man that wears a Mexican hat with snakes around it can belong to my company. I allow no obscene language to be used by my men. When any of them violate these rules they are dismissed.

Captain McNelly's Raid

Before they had arrived in King Fisher's territory, Captain McNelly had signed on a new recruit, A.L. Parrott, who had been an itinerant photographer specializing in pictures of people and frontier cattle camps. He reported to McNelly, "I joined up with them [Fisher's gang] at Espantosa Lake. I went from one camp to another and sold them lots of pictures. The main settlement where King lives on the Pendencia is a right nice layout." Using Parrott's information, the captain sent a report to Adjutant General Steele describing the situation in Dimmitt County:

> *It is a reign of terror from the men who infest this region. This county is unorganized and attached to Maverick County for judicial purposes. The white citizens are all friends of King Fisher. There is a regularly organized band of desperadoes from Goliad to the headwaters of the Nueces. This band is made up of men who have committed crimes in other states and fled for refuge here, where they go to robbing for a living. They are organized into parties of twenty-five to forty men each and form camps in counties, in touch with each other. They pass stolen horses along this line and sell them up north.*

After filing his report, McNelly led his men into Carrizo Springs, where he was briefed on King Fisher's whereabouts by a storekeeper named Levi English. Parrott suggested that they hire a local boy by the name of Drew Taylor to serve as their guide. McNelly agreed, and the detachment of twenty-five men headed to the Pendencia.

Among the small army of rangers were two privates, George Durham and N.A. Jennings. Both later wrote about the raid on Fisher's stronghold, providing an insight into the events that unfolded on that Saturday, June 3. Durham's book was entitled *Taming the Nueces Strip*, while Jennings penned his book under the title *A Texas Ranger*. According to them, Captain McNelly divided his men into two squads about two miles apart and riding parallel to each other. Scouts were sent out a mile in front of the two bands of rangers, looking for Fisher or his men. They managed to get within a quarter-mile of the ranch compound without being discovered. The ranch house was situated in a small grove of cottonwood trees, and it had a lean-to that ran out from the north. Near the front were a saddle shed and a picket fence. Inside the shed were a few of Fisher's men playing cards.

At this point, McNelly gathered all of his men around him and quietly ordered one of the squads to ride through the chaparral to the other side of the house, while he and the others approached from the front. At an agreed signal, both bands of rangers charged full speed toward the bandit's stronghold, catching Fisher and his men completely off guard. With every ranger leveling a pistol at the ranch house, McNelly issued an ultimatum—surrender or all would be killed.

Frank Porter, one of the gang, spotted Parrott and shouted, "It's that damn picture man!" He leveled his rifle on the ranger who held a pistol on him.

"We're McNelly's Rangers," hollered Parrott, with Porter firmly in his gun sight. For a long, tense moment, it looked like a bloody firefight was imminent; then Fisher stepped out onto the front porch with his hands raised.

"I'm Ranger Lee McNelly," the captain stated. "Lock your hands behind your head and come out."

According to Durham, "right there, facing each other at not more than five paces, were by long odds, the two best pistol fighters in Texas, before and since." King did as he was told and walked out into the yard. When McNelly instructed him to hand over his pistols, King obeyed, pulling two of the fanciest pistols the rangers had ever seen from his holsters and presenting them to the lawmen. Durham described the pistols as having gold streaks on the grips and that the "hammers and barrels shined like glass."

King smiled as he handed over his guns. This evoked a smile from the captain, who said, "We had you."

"Yes, you had me," Fisher replied, "Pretty neat."

At this point, Sarah ran out onto the porch and demanded, "What are you going to do with my husband?" McNelly explained the warrants for his arrest, and Sarah demanded to know what her husband was accused of doing. McNelly calmly answered, "Plenty," and that was the end of the conversation.

Apparently, the surprise raid had caught the Fishers preparing to attend a Saturday night dance. Jennings described seeing King for the first time:

> *Fisher was…the most perfect specimen of a frontier dandy and desperado I ever met. He was tall, beautifully proportioned, and exceedingly handsome. He wore the finest of clothing procurable, but all of the picturesque, border, dime-novel kind. His broad-brimmed white Mexican sombrero was profusely ornamented with gold and silver lace and had a golden snake for a*

band. His fine buckskin Mexican short jacket was heavily embroidered with gold. His shirt was of the finest and thinnest linen and open at the throat, with a silk handkerchief knotted loosely about the wide collar. A brilliant crimson sash was wound about his waist, and his legs were hidden by a wonderful pair of chaparejos, or chaps as cowboys called them—leather breeches, to protect the legs while riding through to brush.

Jennings said that he was told that the chaps were made from the skin of a royal Bengal tiger and ornamented down the seams with gold and buckskin fringe. He said that the tiger had come from a circus, leading us to believe that the outlaw's band had been responsible for killing the animal.

In addition, Jennings said that King was fitted with a cartridge-filled belt housing two ivory-handled, silver-plated revolvers. He wore black patent leather boots with silver spurs that were ornamented with little silver bells. If this report by Jennings is accurate, the capture of such a colorfully dressed outlaw must have been quite a sight to the rough-and-tumble rangers, who were used to tracking down very seedy-looking characters.

Captain Leander McNelly was not impressed by Fisher's outfit and ordered all of the prisoners to be handcuffed and tied to their saddles for the trip to Eagle Pass, about thirty-five miles away. As he was leaving, he told King's wife that they were going to be jailed in Eagle Pass and that any attempt to free them before they reached jail would result in deaths of all the captives. McNelly was a firm believer in the Mexican custom of *la ley de fuga*, which meant the shooting of all prisoners if they tried to escape.

Sarah's eyes flashed, and she shot back, "That's your law. We've heard you make your own law. No rescue will be attempted. My husband has done nothing and you can't keep him in jail."

Captain McNelly then turned the prisoners over to Lieutenant Wright and six other rangers to deliver them to the county jail. He then instructed the rest of his rangers to round up the stolen stock and await a cattle inspector to sort out the brands. By this time, due to his health condition, he could hardly mount a horse, so he rode with his wife in his hack to Eagle Pass. They arrived the following day at noon. King Fisher's lawyer was waiting at the jail, where he was ready to take on the rangers with legal papers instead of pistols.

The lawyer patiently waited for Captain McNelly to turn over the nine prisoners to Deputy Sheriff Vale and then asked to see the warrants for their arrest. After studying the documents that McNelly gave to the deputy,

Fisher's lawyer vehemently argued that there were no new charges against Fisher, except suspicion. He said that if the men were to be held, they had to be charged with specific crimes that could be backed up with witnesses. Too weak to effectively rebut the lawyer, McNelly feebly tried to make a case for the incarceration of his captives. The lawyer knew he had the upper hand, and he lectured the rangers on conformity with the written code and not the "jungle law," as he described McNelly's actions.

At this point, Ranger Durham could see that "the Captain was whipped" by the lawyer. Enraged, he grabbed the barrister by the shirt and soundly slapped him. McNelly mustered up the strength to intercede and ordered the private outside. Once things had calmed down, Captain McNelly told the deputy that Kansas had felony warrants for the two of the prisoners—Frank Porter and Wes Bruton. In addition, Missouri had warrants out for three of the others. He admitted that he did not have any warrants—only their names and descriptions that were recorded in the Crime Book, issued to all rangers. He argued that this served to provide him with a blanket warrant.

The lawyer said that this was far from a valid warrant and challenged them to review the matter with a judge. Then Deputy Vale chimed in by saying that he wanted assurance that the other states that held the warrants on the men would pay for the expense of holding them and that they would come to Eagle Pass to pick up the prisoners.

Defeated by the legalities and roadblocks, McNelly gave up the fight, turned to Lieutenant Wright and angrily ordered, "Give these men back their guns and release them!"

As the released men filed out of the jail and were issued their firearms, McNelly drew King Fisher aside and warned:

> *You've won. You're a young man, King. You've won every bout with the law up to now. You might just be lucky and win some more, but finally you'll lose one and that one will be for keeps. At least it will be if you lose to the Rangers. We don't fight draw or dogfalls. When we lose, we lose. When we win, we win. And when we win once, that's enough. The law might lose now and then. We just did. But the law always wins the last round. We'll win. We represent the law.*

King Fisher acknowledged what the ranger had said but insisted he was a law-abiding citizen. McNelly coldly stared at him for a moment and then said:

Make sure you stay law-abiding, King. You've got a nice wife. You could make a good citizen. You'd also make a nice corpse. All outlaws look good dead. I only aimed to tell you to get out of this outlaw business. The next time the Rangers come after you we just might leave you where we overhaul you—and you could make a better life for yourself. But it's up to you.

King Fisher thanked the ranger captain for his advice and then watched him slowly make his way to the telegraph office to file a report to his commander in Austin. The report read: "Have arrested King Fisher and nine of his gang and turned them over to sheriff. Will camp at Fort Ewell and scout country between here and Oakville until otherwise instructed. Country in most deplorable condition. All civil officers helpless."

Captain McNelly then sent word to the rangers holding the stolen cattle to turn them loose—the local cattle inspector had refused to go out and examine the brands. Finally, he climbed into his hack, and Jim Wofford drove him to the ranger camp at Carrizo Springs. Wofford reported to the others that the captain was coughing up blood. After resting a night in camp, McNelly had enough strength to write his superior a more detailed account of the Pendencia raid:

> *You can scarcely realize the true conditions of the section. The country is under a perfect reign of terror…About one-half of the white citizens of Eagle Pass are friends of King Fisher's gang. The remainder of the citizens are too much afraid of the desperadoes to give any assistance in even keeping them secure after they have been placed in jail, and they would never think of helping to arrest any of them….No witnesses can be found who will dare testify against the desperadoes and I am told by the Circuit Judge that he is convinced no jury in three counties—Dimmitt, Maverick, and Live Oak—can be found to convict them.*

That morning, McNelly handed the report to Lieutenant Robinson and turned the command over to him. He ordered the rangers to move their camp to Oakville and await further orders. Then he climbed into his hack and with his wife at the reins drove off toward San Antonio for medical attention. Gravely ill and morally defeated, he had gone up against King Fisher and lost. It must have been painful for his men to watch their fearless leader leave the Nueces Strip a broken man, headed for an early death at age thirty-three.

Chapter 13
Fight at Espantosa Lake

Boys, we are going to capture those thieves or kill them…If they only fire at us,
we can rush in on them and kill them all.
—Sergeant J.B. Armstrong, Texas Ranger

Before the rest of McNelly's Rangers left Carrizo Springs, they saw
the bandit chieftain ride in from the Pendencia to attend a grand
baile (dance) being held in town. This was a countywide social event
that drew people from all parts to dance and celebrate in the Mexican
tradition of *fiesta*.

George Durham was among the rangers who watched as King Fisher
arrived for the dance: "He rode a deep-chested dapple gray gelding that
would heft around twelve hundred pounds, a lively prancing piece of
horseflesh that had plenty of Kentucky breeding in him. His only blemish
was burned brand that ended up as a 7D." In addition to the obviously stolen
horse, Durham described the saddle as being carved out of flank leather and
was adorned with about "ten pounds of beat silver." He went on to describe
King Fisher:

> *He was the most commanding picture I had ever seen. He stood six foot,*
> *and weighed, I judge 180 pounds. He had black, wavy hair; and while*
> *he was just turning twenty-one years of age, he was growing one of them*
> *mustaches that he trained down his cheek.* [Durham got Fisher's age
> wrong—at the time he was twenty-two.]

He wore a tres piedras sombrero, with a solid gold coiled rattler, for band; and gold tassels. His shirt was of that heavy Mexico City silk, opened at the throat; and a silk, red bandanna was knotted around his neck.

Durham left with the other rangers, wondering if anyone could tame this section of Texas. Since Fisher did not have to worry about facing a jury of his friends, he would not hesitate to turn over his guns when approached by the law. According to Durham, "He'd give up to a Mexican burro if it had a Ranger badge." Thinking that all of their efforts to jail the outlaw had been futile, he said, "All the good I could see come of it was to give some Rangers the chance to tell their young'uns they'd arrested King Fisher."

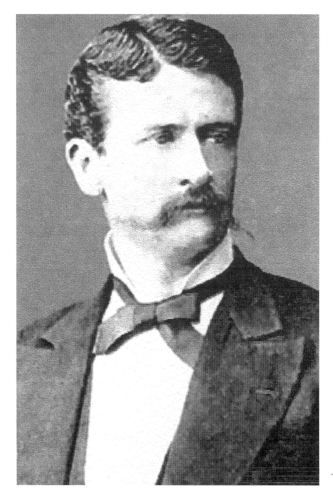

Texas Ranger lieutenant Lee Hall led the nighttime raid on King Fisher's gang at Espantosa Lake. *Center for American History, University of Texas.*

From his sickbed in San Antonio, Captain McNelly ordered Sergeant John B. Armstrong to take a squad of twenty-five men back to King Fisher's country and make the charges stick this time—or kill all of the outlaws they could track down. Armstrong had gained the reputation of being "McNelly's bulldog" and was well versed in the techniques of dealing with the hard cases of the border.

In September 1876, Sergeant Armstrong and his rangers made the one-hundred-mile ride from Oakville to Carrizo Springs at lightning-fast speed, arriving by night. The surprise maneuver was meant to catch not only King Fisher and his men but also some bank robbers from Goliad who were thought to be hiding in Fisher's territory. Armstrong ordered the rangers to

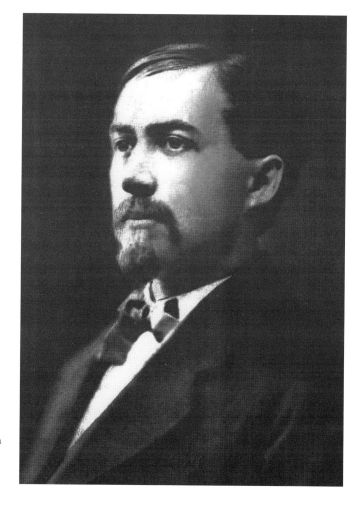

Texas Ranger lieutenant John Armstrong, known as "McNelly's bulldog." *Courtesy Chuck Parsons.*

arrest anyone they found. By sunup the next morning, they had captured five men. One of the men was Noley Key, whom they roped around the neck and hoisted a few feet in the air while they grilled him. Fearing that he would be hanged, Key agreed to guide them to a camp on the west bed of Espantosa Lake. He said that there was a herd of east Texas horses being held there for delivery a few days later to a group on Devil's River.

Espantosa Lake was a legendary haunted lake, long known for its eerie shallows where man-eating alligators lay in wait. The word "Espantosa" has been loosely translated to mean "frightful" or "ghostly," and all who lived in the area called it haunted. Travelers on El Camino Real, the main trail from Mexico to Louisiana, had camped on the banks of Espantosa for more than a century, and by this time stories of apparitions, death and devil-alligators had made the small lake notorious.

Key, still rubbing the rope burn on his neck, informed them that King Fisher had left a few days earlier with a herd of 150 steers to be sold in west Texas. The rangers were not sure they could believe him about Fisher but pressed him to lead the way to the horse camp. Splitting into two groups, Armstrong sent Sergeant Wright and his men to scout out the lower end of the lake, while he and six other rangers followed Key.

According to Durham, who was with Armstrong, they managed to get within a quarter-mile of the camp without being detected by the outlaws. Armstrong told his men to dismount and, leaving Key and the horses with two of the rangers, follow him to the camp at the edge of the ghost lake:

> *Boys, we are going to capture those thieves or kill them. The reason I did not bring more men along was because I was afraid that these fellows wouldn't resist if we were so many. Key tells me that they stood off the sheriff and his posse a few nights ago, and so they'll be looking for officers and be prepared to fight. That's just what we want. If they only fire at us, we can rush in on them and kill them all.*

Using the light of a half-moon, they quietly worked their way to within fifty yards of the camp before a sentry emerged from out of the shadows and fired at the leader, missing him by a few inches. What happened next became known as the Fight at Espantosa Lake, during which the rangers took on the bandits in a heated battle with guns and knives. Sergeant Armstrong lined up the sentry in his rifle sights and fired a quick shot, killing him. Then

the night exploded, with all seven of the outlaws blazing away at the five approaching rangers. By the time the rangers made it to the campfire, only three of the outlaws were still standing, though all had been wounded.

Ranger Jennings wrote that as he approached the camp he had a shoot-out with one of the bandits named Jim McAllister, who was blasting away with his pistol and hurling every curse word he could muster at the rangers. Jennings dropped the outlaw with a rifle shot to the head that tore off part of his jaw and effectively ended the tirade of cussing.

At the same time, one of the rangers by the name of Boyd fought it out with a bandit named John Martin—or, as the rangers had him down in the Crime Book, "One-Eyed John." He had a gouged-out left eye and was known to ride with Burd Obenchain. Martin, a giant of a man with a bullet wound in his right hip, emptied his pistol at Boyd. Pitching the useless gun aside, Martin pulled his Bowie knife and backed toward the brush. Boyd's Winchester jammed, and Martin lunged at him with his knife. Pitching his rifle aside, Boyd dodged Martin's blade and drew his own knife. Each man slashed at the other several times, and Boyd was left bleeding from a chest wound. Being quicker than the big man, Boyd managed to come up behind Martin on his literal blind side and sink his knife into the bandit. The fight continued on for several minutes, with each man bleeding heavily, until they finally fell into the lake, with Boyd riding Martin's back. After some thrashing in the dark waters of the haunted lake, Boyd stood up and staggered to the bank, leaving a lifeless Martin floating in the shallows.

Sergeant Armstrong ordered Parrott to get Boyd to a doctor while he and the rest tried to identify the seven dead outlaws. It was then that they found out that Jim McAllister was still alive. After finding four of the men in their wanted book, Armstrong told his men to collect the dead men's weapons, load up McAllister and head back to their horses. When they got to the horses, they found Noley Key dead from a gunshot wound to the back. According to Rangers Evans and Devine, their captive had tried to escape when the shooting started. They called for him to stop, but "he kept running and was fired upon and killed." So, with seven dead outlaws and one prisoner heavily wounded, Armstrong and his men located the other unit, which had rounded up seven prisoners. By the time the night was over, they had taken twenty-two captives.

Armstrong paired up the prisoners, tied them together and put them on bareback horses for a grueling thirty-five-mile ride to Eagle Pass. Once

there, none of the outlaws wanted a lawyer; they just wanted to be locked up and far away from McNelly's "bulldog."

Sergeant Armstrong's report pleased the ailing McNelly, but his command of the unit was coming to a close. Lieutenant Lee Hall took over while he was being treated by Dr. Cupples in San Antonio. Then on January 21, 1877, Captain McNelly was declared unfit for duty for the remainder of the winter. General Steele reorganized the Special Force with Lee Hall in charge, citing McNelly's mounting medical bills. "The bills paid on his account were nearly one-third of the whole amount paid for his company. I do not consider that the command of a few men that can be paid from the small remnant of the appropriation for this company as the proper place to put an incompetent man, no matter what his previous service may have been."

So, regardless of the fact that history will place Leander McNelly as one of the greatest Texas Ranger captains to ever pin on the badge, he was unceremoniously booted out of the ranger service. The McNellys had no choice but to return to their farm at Burton. Defeated, defamed and gravely ill, he finally succumbed to tuberculosis on September 4, 1877. He was buried in Washington County, where the cattle baron Richard King erected a tall gravestone to commemorate his service to Texas.

Chapter 14
For the Love of a Good Woman

As for being a desperado, all I can say is that I have never killed a man unless it was in self-defense or in defense of my property, and I have very little respect for anyone who would not do the same.

—King Fisher, 1879

Jesse Leigh Hall took command of the Special Forces of the Texas Rangers as a first lieutenant in January 1877. Known as Lee or "Red Lee" because of his bright red hair, he vowed to finish the job of cleaning up the border that Captain McNelly had started. He and his rangers would take the fight to King Fisher and the other outlaws of south Texas until they were all in jail or dead.

In February, Lee Hall and J.B. Armstrong, his second lieutenant, took the company of rangers into the rough border area where stock rustling and bandit raids from Mexico were rampant. Between the incursions by General Díaz's revolutionary forces and the depredations of the King Fisher's gang, it was critical that they bring law and order to the border. Armstrong sent a dispatch to General Steele from Eagle Pass on February 13, 1877, that stated that he had stopped Charles Bruton at Fort Clark for rustled stock. He also reported that King Fisher was back on the Pendencia and was "gathering a crowd around him again." In the report, he described the large number of horses hobbled around the rustlers' camps and his difficulty in finding witnesses that were willing to testify against Fisher "or any of his clan."

Lee Hall, on the other hand, had been quietly contacting a number of citizens to serve on a special grand jury at the upcoming court session scheduled on May 15, 1877. In a dispatch to Steele dated May 18, Hall reported:

> *We were warmly received by the people in this country, who looked upon our arrival as truly a godsend just at this time, as in no section of the state have the good people and the law been worse trampled by desperadoes and thieves than in this County and Dimmitt which is attached...Three months since I scoured the list of Grand Jurors for the Company and have endeavored to impress each of them previous to assembling of the Court that they would be amply protected against the numerous outlaws and desperadoes who for a long while have had full sway in this community.*

He reported that as a result of his efforts, the grand juries handed down a number of indictments against King Fisher and his men who "have gone scot free heretofore, though several Grand Juries have been held here since and they have been found guilty of the most heinous crimes known to the law, committed even in the presence of officers of the law." Hall gave credit to Judge Thomas Paschal and the district attorney, John Sullivan, for their cooperation in getting the indictments, which covered twenty-one arrests. He concluded the report by saying, "I think there will be a change of venue in King Fisher's cases, of whose arrest I telegraphed you. My men are now engaged in guarding the jail, bringing in witnesses and protecting them in appearing before the Grand Jury."

Lee Hall and his rangers had arrested King Fisher on May 16 and over the course of the next few months would repeat the procedure several more times. Each arrest was made without resistance from Fisher—he would simply hand over his pistols and accompany the rangers to jail, where he would make bond and then be released. Apparently, he had remembered Captain McNelly's warning that the rangers, if given the chance, would kill him if they arrested him again.

At the end of July 1877, Hall and his rangers staged another raid on Fisher's operation, arresting King and more of his men on a number of charges. Fisher was accused of killing two Mexican men, one named Estanislado and the other named Pancho. The men had worked as vaqueros for Alexander Zimmerman, a rancher in Dimmitt County. The charges noted that Fisher had killed the two Mexicans on November 10, 1875.

Later, on November 19, 1877, King Fisher was charged with killing a Mexican by the name of Severin Flores. This time, Lee Hall used a different approach: jailing Fisher in the Bexar County jail to get him away from his friends and influence. The old jail, or "Bat Cave" as it was called in San Antonio, had been built in 1850 and served as jail, city hall and courthouse. The nickname came about from the fact that bats hid out on the second floor, where district court was held. It became a ritual each time court was in session to chase out the bats and clean up the droppings. Undoubtedly due to the lingering stench of bat guano, cases were rapidly heard and dispatched with utmost speed.

At the rear of the Bat Cave was the jail, surrounded by a high wall and topped with broken glass to prevent escape. King Fisher spent his days locked up in this jail until he was finally released to the sheriff of Medina County for a habeas corpus hearing before Judge Paschal in Castroville on April 11, 1878. At the hearing, Fisher's bail was fixed at $25,000. The bail bond was quickly signed by prominent ranchmen of the area: George Whaley, B.C. Flowers, C.L. Fielder, Jose Angel Oliva, Francisco Zertouche and the brothers LaFayette and Charles Vivian. In addition, King made bond on the rest of the charges at $2,500 each. After five months in jail, he walked out happy to be free at last and met his friends and rode back to the Pendencia.

The spring term of court opened in Eagle Pass on May 13, 1878, with fifteen indictments to be considered against King Fisher. District Attorney Sullivan, as well as County Attorney A.M. Oliphant, prosecuted the cases before Judge Paschal. Backed by an array of other attorneys, T.T. Teel led the defense for Fisher. Travanion Theodore Teel was a Confederate war hero and a brilliant criminal defense lawyer. During his career, he was said to have defended more than seven hundred clients charged with capital crimes and saved them all from the hangman's noose. Due to his penchant for gambling, Teel had to defend himself on several occasions when raids were made on his favorite wagering haunts. He was a member of the law firm Merchant, Teel & Wilcox of San Antonio and was thought to be one of the top criminal lawyers in the state.

The court got off to a wild start on the first day when the district attorney stood up and painfully disclosed that the "indictments and all other papers" in the pending cases were missing. At this point, sworn statements from the new county clerk, Charles Schmidt, and the previous clerk, Albert Turpe, showed that the records had truly vanished. Red-

faced, the district attorney pleaded to "have permission to substitute for the original copies." After some haggling by the defense, the judge agreed and the trial got off to a rocky start. On May 14, King's murder trial for the killing of Estanislado continued under the fractious conditions when the court declared a change of venue:

> *In this case, it appearing to the Court that no attorney can be found in this County to prosecute this cause, in behalf of the State, and therefore no trial can be had and it appearing to the Court that attorneys for defendant and the State (by A.M. Oliphant who represents the State only for the purpose of changing venue), having agree to the change of venue to Uvalde County.*

Over the next two years, Hall stayed on his crusade against King Fisher, arresting him at various times. According to Texas Ranger Durham, at one point Hall sent a ranger by the name of Allen to arrest King, tie him to a mule and jail him in Laredo for stealing horses. "King didn't like this so much," Durham reported, "so down the river a piece, he stampeded the pack animals; and when Allen and his two men run for them, King dived his mule into the river and crossed into Mexico." By this time, Durham had acquired a curious sense of admiration for the outlaw's tenacity and disdain for Hall's continued harassment of the Fisher. As he later recalled in a *Harlingen Valley Morning Star* article:

> *Lee Hall took command; and Lee thought to make a reputation he had to do something to King Fisher. He kept sending over the details to arrest King. Well, damn it, he didn't have a case on King. He stood trial on that Daugherty killing and came clear. They proved that the two men was sworn enemies; that they met on the prairie and it was a swap-out; and King won.*

It is obvious that Durham was referring to the shooting of Donophan rather than the name Daugherty, but it is not clear who made the error—the ranger or the reporter. Durham used the term "swap-out" to mean a face-to-face shoot-out between two men willing to die in the gunfight.

During 1879, Fisher managed to stay out of the courts and public scrutiny until the early part of the summer, when the newspapers made mention of a gunshot wound to his leg. The *Austin Statesman* reported:

For the Love of a Good Woman

King Fisher, the desperado of former years is now a quiet, placable, industrious rancher. He began to feel the devil getting the better of him a few days ago and rather than have any trouble or shoot anybody else, he shot himself through the thigh and is now laying up to cool off. He may be a priest yet. There is nothing like self punishment and "mortification of the spirit," if you don't have to submit to amputation.

Most of the other major newspapers picked up on the story, and some embellished the incident to the point that King Fisher decided he had to defend himself in the press. He wrote a letter to the editors of the *San Antonio Daily Express* dated June 26, 1879, in which he told his version of the story:

In driving cattle up to Parker's and Ladd's ranch, I happened to come across one of your papers in which I saw an article about myself, which being totally false, I hereby take the liberty to correct.

In the first place, I do not live on the Cariza [Carrizo], *but on the Nueces, seventy miles below Uvalde. In the second place, my revolver did not go off while I was fooling with it, as the person who wrote that article would have known had he been better acquainted with me. I am not in the habit of playing with such things.*

Since you have taken the trouble to mention such a small matter in your columns, and it being so far from the true statement of the case, I think it no more than right in me to restate it in the way it took place. I laid my revolver down previous to going out hunting, and somebody picked it up and didn't put it back as they found it. Not thinking anything was wrong, I got on my horse and started after a cow, but in chasing her my hat came off and I threw myself back in the saddle to catch it, when my revolver struck the saddle and went off, the ball passing through the fleshy part of the leg.

As for being a desperado, all I can say is that I have never killed a man unless it was in self-defense or in defense of my property, and I have very little respect for anyone who would not do the same, especially in certain parts of the state where there are so many horse thieves, etc.

I hope you will excuse me for having taken up so much of your time.
Yours, respectfully,
King Fisher

Fisher's response seems very plausible, but there are some who speculate that he might have been covering up the fact that the accident happened in an entirely different way—much more embarrassing to him. His wife's family stories describe a swivel holster rig that he had made that enabled him to fire from the hip without having to pull the gun from holster. If this were the case, it seems possible that he might have been working with the swivel rig and shot himself in the thigh.

In 1880, Lee Hall left the Texas Rangers to marry Miss Bessie Weidman and become the manager of the 250,000-acre Dull Ranch in LaSalle and McMullen Counties. He turned the command of the company over to Lieutenant T.L. Oglesby. From that point on, the Texas Rangers stopped their intense operations in the Nueces Strip. They had accomplished what Captain McNelly had started. Now it was up to the local lawmen and courts to prosecute the outlaws.

On April 21, 1881, King Fisher was brought to trial in Uvalde County for the murder of the two Mexicans who had worked for Alexander Zimmerman. The rancher was to be the star witness for the prosecution, but the Frio County sheriff sent a report to the court, saying, "I hereby return attachment for A. Zimmerman. I have been to his home several times, but he is on the dodge and hard to get hold of. I will try to get service by the time your District Court meets."

Zimmerman never showed up for the trial, and Fisher was found not guilty of the murder charges. Over the course of the next several months, various other charges were dismissed due to lack of evidence. King traveled to Laredo on July 14 to stand trial for the six remaining indictments for horse stealing. He was acquitted in three of the cases, and the rest were dismissed. So after being indicted in twenty-one cases that included capital murder and rustling, King Fisher and his lawyer T.T. Teel won six acquittals. The rest of the indictments were dismissed when the state had to admit that its evidence was not sufficient to justify holding a trial. Undoubtedly, one of the most notorious and legendary figures in the history of southwest Texas, King Fisher had lost some battles with the Texas Rangers, but ultimately he won the war.

Finally cleared of all charges against him, Fisher broke his ties with his old cronies and started a new life as an "honest stockman." When his first child, Florence, was born on the Pendencia ranch, he seems to have been convinced that he needed more stability in his life for the sake of his wife

and daughter. To further distance himself from his old haunts and habits, he moved into a house in Eagle Pass. He soon owned a financial interest in the Old Blue Saloon and was a partner with B.A. Bates in a livery stable business.

Later Fisher's second daughter, Eugenia (called "Ninnie" by the family), was born in Eagle Pass. Family stories say that he then decided to sell his interest in the saloon because "it was certainly no credit to the two daughters for it to be known that their father was in the saloon business."

In 1881, King Fisher, Sarah and the girls moved to Uvalde, where they bought a comfortable home on Mesquite Street. At this point, Fisher was managing two ranches—one on the Pendencia and the other a ranch that he bought from his brother-in-law, James Vivian. Before he could look at other ranches to increase his holdings, J.B. Boatright, the sheriff of Uvalde County, approached him with an offer to become his deputy. At first, he was amused at the thought of being asked to be a lawman in the county in which he had been tried for murder and declined the offer. Boatright was persistent; he persuaded G.K. Chinn, a Texas Ranger, to encourage Fisher to take the job. After visiting with Chinn, Fisher decided that he would take the offer, but with one condition—he would be running for the office of sheriff in the 1884 election. Sheriff Boatright agreed to the condition and King was sworn in as his deputy. Oddly enough, Boatright himself later switched sides of the law badge by absconding with some of the county funds and heading to California.

Shortly after Fisher had come full circle from lawman to outlaw and back to lawman, his third daughter was born on November 25, 1881. Unfortunately, the little infant girl died on January 2 of the following year. They buried her at the private Vivian cemetery above the banks of the Pendencia.

Saddened by the loss of his daughter but determined to start a new life for himself and his family in Uvalde, Fisher threw himself into his new responsibility with all the fervor that he used in the early days in Dimmitt County as a "stock marshal." He quickly became known as a fearless, resourceful peace officer who knew how to handle and manage people—both good and bad. Citizens of Uvalde saw him as a friendly, amiable man who was very willing to treat people in a kind and courteous manner—unless they were criminals.

Chief among the criminal element in the county was the notorious Hannahan family. Thomas Hannahan, his wife Mary and their brood of hell-bent sons had an assortment of indictments pending against them

at the time. James and his mother were indicted for murder on April 13, 1880, while at the same time John had been indicted for cattle rustling. Old Thomas had been indicted in seven cases involving theft. It is safe to say that the Hannahans were not what you would call the pillars of the community.

Shortly after Fisher signed on as deputy sheriff, the Hannahan gang held up the San Antonio–El Paso stagecoach and got away with a strongbox full of money. King and another lawman followed their tracks to the Hannahan ranch on the Leona River. When the lawmen arrived at the ranch house, there was an all-out barrage of bullets coming from the Hannahans, until King finally killed John and wounded Jim. After a brief search, King found the strongbox, secured it to a pack mule and, with the wounded bandit in tow, returned to the county jail in Uvalde. The confrontation and capture of the terrible Hannahans was the talk of the community. The people knew that they had the right man for the job of deputy sheriff, and though he may have had a checkered past, they were mighty glad that he was working for them.

Not only was King Fisher effective with a pistol, he also possessed the ability to press the law with friendly persuasion. In his book, John Leakey wrote about an encounter Fisher had with some of his relatives who showed up in Uvalde "on the dodge" from indictments for stealing in Llano County. The two men found Fisher and asked him to help them get away. King shook his head and told them they were on the wrong course. Unless they were willing to return to Llano and surrender to the law, he would have to arrest them. After some further discussion, the two men agreed to ride back to Llano and turn themselves in to the authorities. Satisfied with their promise, King watched them saddle up and ride away. They did not let him down and did as they had agreed.

Fisher and his wife were accepted into the community and were invited to most social occasions without reservations about his past. It is important to point out that Sarah played a key role in King's reformation. She was loving and devoted to him, but at the same time she was instrumental in getting him to change his ways from those that had led him to become an outlaw.

Part of Sarah's reformation efforts involved attending church services when they could. In his book *Springs from the Parched Ground*, Reverend Bruce Roberts told of a discussion with Dr. O.C. Pope, an early Baptist missionary preacher. Dr. Pope said that while he was in Carrizo Springs in July 1882, he preached a Sunday sermon on "the peril of drifting—drifting into bad

company, drifting into lawlessness, drifting into the current that bears one on to destruction." King Fisher and his wife attended that service. After the service, a picnic dinner was served to all who had attended the preacher's sermon. Following the dinner, King asked Dr. Pope if he could have a word with him in private. Everyone held their breath, thinking that Fisher had taken exception to what the preacher had said. The two men walked off in conversation, and everyone gave a collective sigh when it looked like the discussion was not hostile.

Years later, Dr. Pope related their conversation to Reverend Roberts in ministerial confidence, but Roberts thought it was important to let people know what the notorious pistoleer had to say on that Sunday:

> *Dr. Pope, I want to bear testimony to the truth of what you said today. I know how easy it is to drift. I was just a boy, away from home, with poor advantages, but still I had pretty good ideas of what I wanted to be. Then I drifted into bad company, and there didn't seem to be anything much to hold me back from doing wrong. Some of the older people seemed to like me, but it seems they didn't know how to tell me how to go straight. Of course they thought I wouldn't pay any attention to anything they'd say, but I wish they'd tried me out a little more.*
>
> *Captain McNelly and his Rangers came and took me and some other fellows in. But Captain McNelly gave me some mighty good talk. I've heard that he always carried a little Bible with him. Anyway, it seemed like the Captain was on the right road...I never saw the Captain anymore. He had a cough at that time that sounded bad to me, and sure enough in a little more than a year he was gone. I wished that I had when we were together that time talked with him about his road, but being a prisoner—you know—well, I didn't.*
>
> *Dr. Pope, I have remembered the Captain's talk, and I am going to remember your talk today. I am trying to shape things up to where I can travel a different road.*

Reverend Roberts went on to say that Dr. Pope asked about his friend King Fisher at the next annual session of the Rio Grande Association of Baptists that met in Leakey, Texas, on July 13, 1883. He was told that Fisher had taken his message to heart and was then the deputy sheriff of Uvalde County.

So, with a deadly warning from Captain McNelly, being thrown in jail several times, spending a large sum of money on lawyers' fees and the sermon of a brush arbor Baptist preacher, King Fisher decided it was time to follow "a different road." He had finally come to the realization that his wife, his family and his good name were more important than being notorious. He was extremely popular, and it was clear that he would be elected to serve as the sheriff and tax collector in the November 1884 elections.

Sometimes fate has a peculiar way of changing the course of events in a man's life. In King Fisher's case, it was the invention of barbed wire. After being introduced to the open ranges of Texas in the 1870s, thousands of miles of barbed wire had been strung to fence in ranchers' livestock. The days of the free open range were nearing an end, while the era of fence cutting by rustlers and cowboys on legitimate cattle drives was just beginning. By the early 1880s, fence cutting was rampant in Uvalde and surrounding counties. Finally, at the request of Governor John Ireland, the legislature passed a tough law making fence cutting a felony offense.

Early on March 11, 1884, King Fisher boarded the Southern Pacific train to get specific information on the new fence cutting law and how it was to be applied in his county. Along the way, he stopped in San Antonio for quick bit of business in the federal court. Then, after looking into some personal business for a friend who had sold a herd of cattle below San Antonio, he caught the next train to Austin. After arriving in Austin, he proceeded to the capitol, for a briefing on the fence cutting law. That afternoon, when he was finished with his work at the capitol, he headed down Congress Avenue to look up Ben Thompson. Though they were not close friends, they were on friendly terms following a short period of animosity in the past. It is not known exactly what the conflict had been between them, but apparently they had resolved the issue and were willing to socialize with each other. In Ben Thompson's case, socializing meant standing for a stiff drink at the bar in the nearest saloon.

Chapter 15
Fatal Trip to San Antonio

Beware the Ides of March.

—Shakespeare, Julius Caesar

At the same time that King Fisher had reformed and pinned on a deputy marshal badge, Ben Thompson declined the offer to be reinstated as city marshal when he returned to Austin. Though his popularity was at an all-time high after being acquitted for the killing of Jack Harris, Thompson had soured on the justice system and he wanted no part of it.

After his long confinement in the San Antonio jail, what he really wanted was a long excursion to clear his head and revive his spirits. He spent a few days at home with his family and then, with his close friend Monroe Miller, left the Capital City on a train trip that took him back to San Antonio. They spent a few days there and then continued on a trip that took them to the Rio Grande and eventually down to the Texas gulf coast. Before he left Galveston, Thompson received word that his good friend Samuel Slater had died in New Orleans. The death of Slater, who was the closest person Ben had to a father, came as a shock to Thompson. He and Miller went on to New Orleans to offer condolences to the bookbinder's family.

Upon his return to Austin, Ben Thompson found his own mother gravely ill. Eventually, with Ben at her side, Mary Thompson passed away in the family home. The untimely deaths of his mother and Slater weighed heavily on Ben, making him despondent and given to bouts of melancholy. Then, to add more stress to his life, his brother Billy was thrown in jail in Refugio

County on a charge of murder. Ben got his lawyer to sue for habeas corpus, and Billy was released after Ben posted a $5,000 bail. Next, he got the trial moved from Refugio to DeWitt County, where the jury returned a not guilty verdict without leaving the jury box.

It is at this point that Ben started having reoccurring bouts of insomnia and brief episodes of paranoia, largely brought on by a worsening drinking problem. Alcohol started to play a major role in his everyday affairs, often resulting in belligerent confrontations and gunfire. Once, while on a drunken binge, he stormed into a saloon and ordered the owner to serve a number of black men at his bar. When the barman refused, Thompson pulled his pistol and demanded that they be served or he would start shooting. Fortunately, his friends intervened and hustled him out of the saloon before he starting using his Colt. Later, when he sobered up, he returned and apologized for his drunken tantrum.

A short time later, while meandering down the street in another drunken foray, he encountered an Italian organ grinder who, for some reason, caused Ben to lambaste him with a caustic string of profanities. At the same time, he pulled his revolver and shot six rounds into the terrified man's music box. The next morning, after sleeping off his binge, he found the Italian; after apologizing profusely, he paid for the damages to his organ. A week later, Ben swung into the *Daily Statesman*'s office, wild-eyed and reeking of whiskey. The newspaper had written a number of

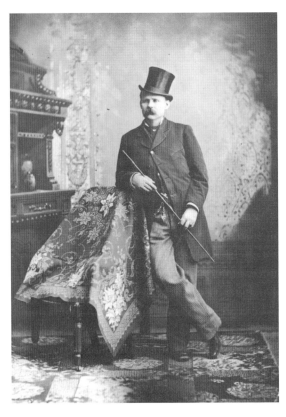

Ben Thompson, the successful gambler in Austin, Texas. He often wore a stylish frock coat with a top hat and gold-tipped cane. *Courtesy Texas State Library Archives.*

unfavorable articles describing his drunken sprees, and Ben was there to take issue. After castigating the frightened printers, he emphasized his point by thrashing their print type boxes, scattering type in all directions. Satisfied with his performance, he sauntered out of the newspaper office, only to return a few days later and apologize. This led the *Albany Echo* to write:

> *Ben Thompson is a great curse to Texas. It would seem from recent dispatches that he has the whole southern part of the state buffaloed. Recently he broke up a cattleman's banquet, licked a man twice in the courtroom while the court was in session, and only a few days ago went into the* Austin Statesman*'s office, drove all the printers and editors out, and plied its forms. What kind of meat does he eat that he is getting so bad?*

The cattleman's banquet ruckus mentioned in the *Albany Echo* article is one of the most frequently told stories about Ben's drunken tirades. The story has many variations, but all agree that it took place at Simon's Café on Congress Avenue. The Texas Livestock Association was in town and having a banquet dinner at the restaurant. A feast of roasted turkey with plenty of spirits, champagne and liquors filled the long banquet table. After knocking down a quantity of libations, various men stood and spoke to the group. About this time, according to Texas Ranger Captain J.B. Gillette, "a little shyster lawyer, by the name of Edwards passing by, saw the banquet and entered the dinning room to see what it was all about." Apparently, Edwards tried to join in on the celebration, and the cattlemen threw him out of the restaurant. The miffed lawyer hustled down to Thompson's gambling house and told him what had happened. Ben put on his coat and a brace of pistols and then followed Edwards to Simon's.

As they reached the restaurant, the banquet was in full swing, with Shanghai Pierce stumbling down the center of the long dinner table in his bare feet, intent on getting another serving of roast turkey. Known as a hell-raising trail driver, Shanghai had a reputation as a fearless fighter in barroom brawls and gunplay. Suddenly, Thompson burst into the room brandishing a pistol and yelling, "Show me the damned rascal that don't like L.E. Edwards!" According to Captain Gillette, total pandemonium broke out in the dinning room, with cattlemen stampeding for the exits. Shanghai Pierce dived through the nearest window, taking the sash as he went. The rest of the cattlemen, realizing who was waving a cocked pistol at them, had

scrambled out every available exit from the restaurant until there were only a few people left staring at the stampede. Satisfied that he had made his point, Thompson holstered his gun and sauntered out of the café.

Captain James E. Lucy, another noted lawman, told the story differently. According to him, he was an eyewitness to the ruckus, and it was ex-Texas Ranger Lee Hall who was addressing the crowd while squatting on a chair back. When Thompson entered the room with a cocked pistol, the cattlemen made a mass exodus from the dinning room, leaving Hall to face Thompson alone. Lucy said he knew that Thompson did not like Hall and would not hesitate to shoot him, so he drew his own revolver and leveled it at the gunman. Thompson never wavered, keeping his pistol aimed at Hall, and said, "Captain, this is not your fight. You have no business in it. It does not concern you." For a few moments, it was a silent standoff; then an unarmed congressman by the name of William Henry Crane rushed in between the men and demanded their guns. Strangely enough, Thompson quietly handed his pistol to Crane, and Lucy followed suit. After securing both men's pistols, Crane quickly left the restaurant. Thompson then yelled for his driver, a black man named Mack. Moments later, Mack entered the dinning room and handed Ben another revolver. When Lucy asked him what he planned to do, Thompson handed his pistol to Lucy and replied, "There are bad men outside. You must protect me. Here is my gun. Are you ready to go? If you are, there is a horse and a cart on the avenue in this same block."

According to Captain Lucy, the two men then went out the main entrance, with Lucy carrying Thompson's pistol. They passed some dangerous-looking men standing outside the restaurant and quickly boarded the horse-drawn cart. They then rode to a house, where Thompson got off the cart and spent the night. A man at the house drove Lucy back to the restaurant without any further trouble occurring. A day later, Lucy met Thompson and they walked to the G.B. Bahan and Company jewelry store, where Ben ordered a pair of English sovereign cuff buttons for Lucy. Then, at Ben's insistence, they went into a clothing store, where he bought Lucy a five-gallon Stetson hat. Thompson told Lucy that without his help the night before, he was sure that he would have been dead before the next day.

Which lawman's version was a true description of the events of that evening in Simon's is hard to ascertain. The story has been told and retold so many times that it is impossible to say with any certainty what really happened at the cattlemen's banquet.

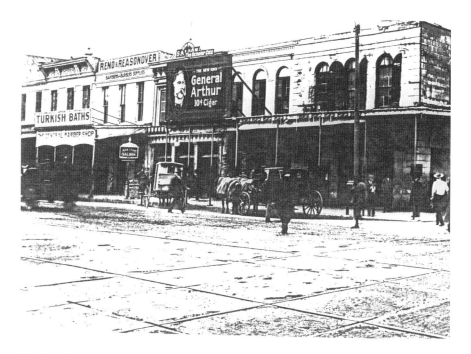

The Iron Front Saloon (beneath the cigar sign), located on the corner of Sixth Street and Congress Avenue in Austin, Texas. Ben Thompson ran the gambling concession located on the second floor. *Courtesy O.T.T. Collection.*

Sometime in early 1884, Ben Thompson had an ominous foreboding of his demise in March. According to Jim Long, a friend of Thompson's, a tombstone peddler named Luke Watts arrived at Ben's gambling table with a pocket full of money. During the game, Watts remarked, "Ben, you will be took off sudden one of these days and I may not be around just at the time to sell a tombstone to ornament your grave. You better order one from me now."

Thompson scoffed at the notion and said that all he would need would be wooden board. The game continued until about midnight, when Watts stood up from the table and declared that he was "cleaned out."

"Hold on there. How much are them tombstones of yours worth?" Thompson asked.

"It depends on what kind of stone it is."

"I don't want no cheap monument," Ben declared. "Have you got any that is made of marble?"

"I have got as fine a marble slab down there in my wagon as you can find south of St. Louis," Watts responded.

"How much is it worth?"

Watts sat back down at the table. "Not a cent less than $200, which is cheap, considering that it is a long ways from the quarries."

Ben looked at the peddler and smiled. "Put that tombstone in a pot against my $200 and I will play you to win or lose." When Watts agreed, Ben asked him to bring the gravestone up to the gambling room so he could see it before the game.

Watts went down to the wagon yard and drove his wagon to the front of the saloon. After he and several porters carried the heavy slab up the stairs, they set it down beside Thompson. Satisfied that the stone was worth $200, Ben started a new game at two o'clock in the morning. A short time later, he won the pot that included the tombstone.

The peddler took the loss in stride. "Better let me carve the inscription on it now."

Ben's apparently ironic answer turned out to be very prophetic, given the events that would play out a short time later. "No you can wait until I have done something that will give you the subject for a befitting epitaph."

For amusement, Ben kept the tombstone on display in the gambling hall for a few days, and then it was moved to the basement for storage. By the time King Fisher came for a visit on March 11, the stone had been forgotten and Thompson was in fine spirits. After a second round of drinks, Ben gave Fisher a picture of himself that had been taken a few weeks before. King stuffed the picture in his coat pocket and pulled out his watch to check the time. His train for San Antonio would leave at four o'clock in the afternoon. King suggested that Thompson accompany him back to San Antonio to make the rounds of their favorite haunts.

At first, Thompson did not want to go. Just a week earlier, he had received a note from Joe Foster inviting him to visit the Vaudeville Theater. Thompson was reported to have said, "They do not catch me in that trap. I know if I were to go into that place it would be my grave yard." But after a few more drinks, he agreed to ride with Fisher to a point about fifteen miles out of Austin where the north and south bound trains met. He planned to board the northbound train and be back in Austin that evening. By the time the two men arrived at the station, the train was pulling out, so they quickly found a carriage that would rush them to the spot where the train slowed

The state capitol building in Austin, Texas. Deputy King Fisher consulted with other lawmen on the new fence-cutting laws before he sought out Ben Thompson to end the blood feud in San Antonio. *From an old postcard.*

down to cross the bridge over the Colorado River. There they flagged down the train and stepped on board the excursion car.

By the time the train met the northbound run, Thompson had decided that he would accompany Fisher to San Antonio. He wanted to see a performance of *East Lynne*, which would be playing in Austin a few days later. Both men were feeling the effects of the numerous drinks they had downed in Austin, but Thompson was decidedly inebriated, or as the Mexicans would say, "muy boracho." He spotted a German who had a bottle of whiskey and promptly confiscated it for his own use. Then he ordered a black porter to do something for him. When the porter did not act as fast as he wanted, he struck the man across the head with the bottle. At this point, Fisher told him to stop abusing the porter and calm down. Thompson let the man go and staggered back to his seat. Checking his hat, he found that it was stained with blood from the porter's wound. He then took out a knife and cut the stained crown out of the hat.

When they arrived in San Antonio at eight o'clock that night, Thompson staggered off the train, still wearing his butchered hat. They stepped across

the street for a quick drink at Gallager Brothers International Saloon, where Thompson told those at the bar about the circumstances of his hat losing its crown. Then leaving the hat in the saloon, the two men boarded a hack and proceeded to Turner Hall Opera House at the corner of Houston and St. Mary's Streets. Before they entered the opera house, Thompson ducked into a nearby clothing store and bought a new hat.

During this time, United States marshal Hal Gosling, who had been a passenger on the same train to San Antonio, hurried over to the Vaudeville Theater to warn the private duty policeman Jacobo Coy. He reported on Thompson's arrival in town and his liquored-up condition. Earlier, Billy Simms, who was now running the Vaudeville Theater, had received a wire saying that Thompson was on the way to San Antonio and was sure to head for the Vaudeville Theater. Simms contacted Marshal Shardein and was told that nothing could be done until Ben made his play. Next, the saloon man rushed to a local judge for some kind of legal action that he could take to protect himself. The judge's advice was to buy a shotgun— which he did. He then had a council with his partner, Joe Foster, and their policeman Coy. Exactly what they decided to do is not known, but later rumors say that they planned for an attack on Thompson if he made an appearance at the saloon.

Thompson and Fisher arrived at Turner Hall just as the curtain was rising for the performance. The celebrated Ada Gray had the leading role and the house was packed. Fisher was seated first on a front row seat on the left side of the hall. A few moments later, Thompson, wearing his new hat, was ushered in for a seat beside Fisher. Tom Howard, the impresario, knew both men and their deadly reputations. When he spotted Fisher's pistol, he figured that Thompson must also be armed and that this could spell trouble. Howard never took his eyes off the two gunmen throughout the performance, but as it turned out, they behaved themselves. Other than visiting the bar during intermissions, they quietly enjoyed the play with the rest of the patrons. A few minutes before the final curtain, Fisher and Thompson quietly slipped out of the opera house, and Howard heaved a sigh of relief.

Once outside the hall, the two men took a hack over to the Vaudeville Theater. Just whose idea it was to return to the saloon at which Thompson had killed the previous owner is not known. King Fisher was a good friend of both Joe Foster and Billy Simms. A few years before, while Fisher was being held in the Bexar County jail, Foster had sent him free meals and whatever

else that he needed. It is speculated that Fisher thought that if he could get Thompson to sit down with Simms and Foster, he could persuade them to drop their blood feud. Jim Brent—an ex-sheriff from New Mexico who knew Thompson and talked with him and Fisher that evening—supports this supposition. According to Brent, the two men were in the best of spirits, and Thompson gave no indication that he was in town to force a showdown with the saloon owners. Patrons of the bar said the same thing—when Thompson and Fisher pushed though the saloon doors of the Vaudeville Theater, they were in a jovial mood. Moving to the bar, the two men ordered drinks and greeted friends with cheerful smiles.

Tom T. Vanderhoven, a San Antonio lawyer, met Fisher before he went into the Vaudeville and as a close friend warned him that it would be dangerous to continue the evening with Thompson. He suggested that King let his driver take him away to safety in his hack. Fisher thanked him for his concern but felt that he could control the belligerent Thompson. He was going to negotiate a truce between Ben and the two saloon owners.

A few minutes after Thompson and Fisher stepped up to the bar, Billy Simms walked into the saloon from the Commerce Street entrance. He had left his shotgun on the theatre stairs and had gone for a walk. Simms spotted the two men standing at the bar and greeted them in a friendly manner. Then, as

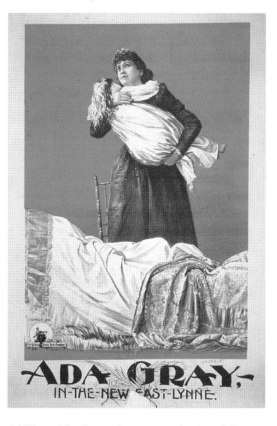

A billboard for the touring stage production of *East Lynne* starring Ada Gray. Thompson and Fisher saw her performance in San Antonio the night they were gunned down. *Courtesy National Archives and Records Administration.*

167

the trio talked, Jacobo Coy appeared and joined in on what seemed to be a pleasant conversation. Eyewitnesses said that it looked like Thompson was in the mood to drop the hostilities of the past and that Simms seemed ready to do the same. Finally, Simms offered them choice seats in the upstairs balcony to view the variety show that was in progress. Simms and Coy stayed at the bar, while Thompson and Fisher filed up the stairs to the balcony.

Once seated in the dress circle, Thompson and Fisher looked down at the stage show below. In *Fabulous San Antonio*, Albert Curtis described the stage action: "[T]he Lillian Russell soubrettes, dressed in glittering green and red Chinese costumes, were executing an exotic oriental dance, while from the orchestra the weird strains of chopstick music seemed destined to provide a macabre setting for the impending tragedy." Coy rejoined them at their table, sitting to the right of Fisher. He greeted them in a friendly manner and joined in on the pleasant conversation as they watched the dancers below. He did not mention that he had contacted Constable Casanovas, telling him to go upstairs, or that he had notified two assistant marshals, Karber and Hughes, that King Fisher was armed.

Simms appeared at the other end of the hall, and Thompson sent a waiter to ask him to join them. Simms nodded approval, walked over and took seat on Thompson's left. Then Fisher asked a waiter to take an order for a whiskey and seltzer, a glass of beer and two cigars. The order arrived, and the conversation continued in a congenial manner until, finally, the subject of the Harris killing was mentioned.

As the conversation started to drift into the bitterness of the past, King Fisher stood up, looked at Thompson and said, "You told me we were to have some fun; never mind talking about past times." Ben responded by saying, "Be easy, we'll get it pretty soon." Fisher then suggested that they all go downstairs to the bar. Thompson agreed, and all of the men started toward the entrance to the stairs.

Just as they neared the door to the stairs Thompson turned around and spotted Joe Foster sitting across the room; he asked Simms, "Billy, ain't that Joe Foster?" When Simms nodded his head, Thompson asked him to go get the card dealer so they could talk. Simms walked over and brought Foster back to Thompson. Ben extended his hand for a handshake and offered to buy Foster a drink. Adjusting his eyeglasses, Foster refused the drink and proffered hand. Angry, Thompson demanded to know why. Foster was calm in his response: "I can't shake hands with you, and all I ask, Ben, is to be let

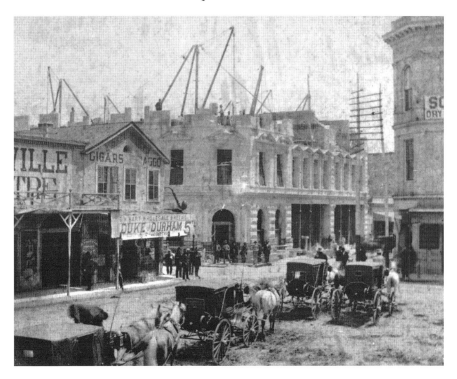

The Vaudeville Theater (far left) at the time of Thompson and Fisher's deaths. The buggies (called hacks) lined up on Main Plaza in front of the saloon served as taxies for visitors. *Courtesy University of Texas Institute of Texan Cultures, University of Texas San Antonio.*

alone, and I told Billy to tell you I never would put a straw in your way. The world is wide enough for both of us, Ben."

It is at this point that Thompson slipped into one of his drunken rages. The conversation turned loud and ugly. As the hot words flew, Thompson and Fisher backed up toward the wall. Then Coy stepped forward and asked Thompson to settle his differences with Foster outside the saloon. Ben shoved him aside and slapped Foster with his left hand while drawing his revolver with his right. He then poked the pistol into Foster's face and cocked the hammer. The dealer took a swing at Thompson and drew his own pistol. As Ben tried to pull the trigger on his Colt, Coy grabbed it by the cylinder rendering it unable to fire. At the same time, the policeman and Thompson scuffled for control of the weapon. Simms had his own revolver out as Foster went at Thompson. This is the split second when the shooting started. There is a debate over whether Thompson fired his pistol, but all accounts agree that Fisher never drew his weapon.

After a volley of gunshots, Thompson and Fisher slumped to the floor, dead. The dying gunmen also dragged Coy to the floor. As the smoke swirled around the lifeless figures on the floor, Coy stood up, nursing a minor wound to the hip. Simms looked over to see about Joe Foster, who was down with a bullet wound to his leg and crying, "Billy, I'm shot all to pieces; help me downstairs." Simms and another man helped Foster to his feet and started down the stairs. Captain Shardein, who had been down at Hart's cigar store, rushed into the theatre and met Foster and Simms coming down the stairs. After they passed him, he bolted into the upstairs room, where he found the two dead gunmen in a pool of blood.

Before he could examine the bodies, word came from downstairs that Ben's brother, Billy, was coming from the White Elephant saloon with a shotgun in his hands. Shardein raced down the stairs and caught Billy Thompson as he entered the west door from Commerce Street. The lawman shoved Billy out the door and into the street, where he searched him for a weapon. Billy was unarmed and, for once, sober.

Back inside the theatre, everything was in a massive state of chaos. At the time that the shooting started, most of the customers in the balcony either bailed out onto the stage below or outside the windows to the street below. According to a *San Antonio Express* article, "[T]he performers on the stage left it as though made to disappear by an illusionist, and that the piano player, while his last note still lingered in the air, beat all world's records for diving sidewise from a piano stool."

Captain Shardein called for the theatre to close its doors, and no one was allowed to enter. Upstairs, still thick with gunpowder smoke, painted dance hall women tracked through the pools of blood trying to get a good look at the dead pistoleers so they could tell all of their friends. A report by the *Austin Daily Statesman* stated: "The dissolute women, with blanched faces, crowded around with exclamations and broken sobs, exclaiming: 'Which is Ben?' 'Show me Ben!' 'Is that him?' and even in his death, amid garish surroundings, the grim reputation of the man stood forth as strong as ever."

As soon as the theatre had been closed to the public, a hastily summoned coroner's jury quickly viewed the bodies. Then the undertakers Carter and Mullaly moved the corpses to the Bat Cave, which served as the police station at the time. The following morning, at ten o'clock, witnesses assembled in Justice Adam's court for an inquest into the shooting. County Constable A. Casanova, Jacobo Coy, a police officer named Chadwell, Marshal Sharedein,

The old courthouse and jail in San Antonio known as the "Bat Cave." The bodies of Ben Thompson and King Fisher were autopsied here on March 12, 1884. *Courtesy Center for American History, University of Texas.*

J.M. Emerson and Billy Simms testified before the court. After taking two long recesses, the verdict was returned at 4:20 p.m.:

> *At the conclusion of the above testimony the jury retired, and after having been out for fifteen minutes, returned the following verdict: That Ben Thompson and J.K. Fisher both came to their deaths on the 11th day of March, A.D. 1884, while at the Vaudeville theater in San Antonio, Texas, from the effects of pistol shot wounds from pistols held and fired from the hands of J.C. Foster and Jacobo S. Coy, and we further find that the said killing was justifiable and done in self defense in the immediate danger of life.*
>
> *The verdict is signed by George Hilgers, H.L. Ansell, J.A. Bennett, E.J. Gaston, J.M. Martin, and R.W. Wallace, who comprised the coroner's jury.*

At noon the next day, Billy Thompson came by the police station and picked up his brother's coffin. He put it on the afternoon train to Austin for burial in the Oakwood Cemetery. King Fisher's body was released to U.S.

deputy marshal Ferd Niggli, who had received a wire from Fisher's widow asking that the body be put on the 6:40 p.m. sunset train to Uvalde.

In most cases, this would have been the end of the story of Ben Thompson and King Fisher, but because of their near folk hero reputations, there was a general outcry for retribution over the injustice of their deaths. Their popularity in Texas and their large number of friends proved that the last chapter of the pistoleers' violent careers was far from over—no sir, not by a long shot.

Chapter 16
Slain Heroes or Final Justice?

The most important service rendered by the press and the magazines is that of educating people to approach printed matter with distrust.

—Samuel Butler

The deaths of Ben Thompson and King Fisher were major news stories in March 1884. All of the leading newspapers in Texas ran front-page accounts of the killings. The shooting even made the front page of the *New York Times*. Then, over the next several weeks, newspaper reports and editorials either hailed the demise of the pistoleers as good riddance or railed about their well-orchestrated assassination.

On March 12, the *San Antonio Express* ran an article with the headline of "Jack Harris Revenged":

> *Ben Thompson, slayer of Jack Harris and various other victims, and King Fisher, the hero of many bloody battles, are no more. They were both shot dead about 11 o'clock last night at the Vaudeville Theater… Thompson and King Fisher were both found dead lying side by side as they had fallen. Thompson had two shots in the head, both just above the left eye. Fisher was shot squarely in the left eye…As everyone knows, bad blood has existed between Thompson and the gaming fraternity here since the killing of Jack Harris, and there were none but who believed it would end in another tragedy. On all hands could be heard last night the expression, "Jack Harris is fully revenged."*

Both were desperate men, feared in the neighborhood in which each resided by the law-abiding element of the State. Both have a record of having taken the life blood of many men in their day, and both were noted for their handsome appearance and gentlemanly disposition when sober. They have died with their boots on, a death which is considered eminently genteel by desperate men...It was a bloody night's work and a most remarkable fact is that two such desperate men, both dead and center shots, could be so riddled with bullets without having victim to add to those whom they have already sent to the happy hunting grounds.

The Austin papers reported a different slant to the killings, reflecting the view that the two men had been set up and assassinated. In a particularly grisly story on March 12, the *Austin Daily Statesman* reported:

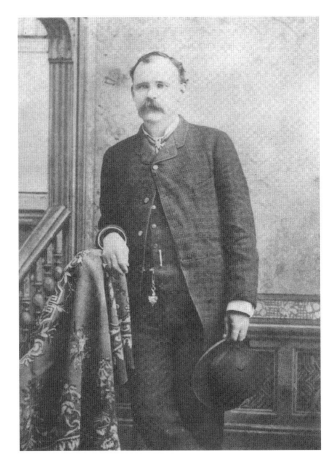

Rare photograph of Ben Thompson taken a few weeks before he was killed. *Courtesy Robert McCubbin Collection.*

Slain Heroes or Final Justice?

San Antonio, March 11 [midnight]—*Ben Thompson was shot and killed to-night in the Vaudeville theater. King Fisher was also killed, and Joe Foster was shot in the leg.*

FULL PARTICULARS—SPECIAL TELEGRAM
Ben Thompson and King Fisher entered the Vaudeville theater about 10:30 P.M. and purchased tickets for the gallery. Shortly after they had taken seats they became rather boisterous in language, and William Simms, manager of the theater, and William Foster an attaché, requested them to desist… It is stated then that Thompson tried to draw his pistol, and Fisher, who was as game a man as ever stepped, followed suit. Thompson's pistol was grasped by Jacob Coy, a special officer attached to the Vaudeville, and then the ball opened. An eye witness states that Thompson went down first, and Fisher next, although on account of the affrighted crowd, the screams of the women and men, the dense smoke, the struggling knot of figures, and rapid successions of reports, it is impossible at this late hour to obtain a lucid and intelligent statement. When your reporter reached the scene the two bodies were weltering in blood, and were laid out side by side, their hair and faces carmined with the life fluid. The stairs leading up to the scene of the horror (Foster having been carried down them), were as slippery as ice, and the walls were stained and the floor tracked with bloody footprints… Thompson was shot twice through the brain, one ball entering squarely in front through the left eyebrow, and the other just above it. Both holes could have been covered with a half dollar. His face wore a stern expression, and the upper lip is drawn tight across the teeth. The brain is visible through the wound in the eyebrow.

Andreas Coy, the brother of the policeman who first grasped Ben's pistol says that he is persuaded that Ben never fired a shot.

Fisher is also shot through the brain, the ball entering the left eye and completely smashing the pupil. He was Deputy Sheriff of Uvalde County, is about twenty-seven years of age, has a wife and family, and was, by all odds, the most noted desperado on the Rio Grande frontier from New Mexico to the gulf.

By March 13, both bodies had reached their hometowns and had been prepared for burial. In Uvalde, it was discovered that King Fisher had thirteen bullet holes in him, with speculation that all of the shots had come

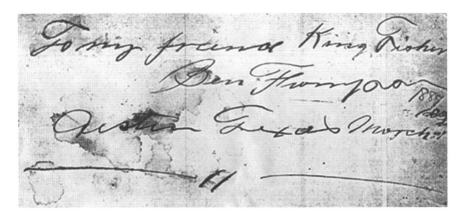

Inscription on the back of the photograph that Ben Thompson gave to King Fisher on the day they were murdered. The photograph was pulled from Deputy Fisher's bloody coat when they were removed from the Vaudeville Theater. *Courtesy Robert McCubbin Collection.*

from his left and from above. In Austin, two physicians examined Thompson and found that he had nine bullet holes in him—all stemming from shots coming from the left side and from above. An Austin ballistics expert, J.C. Petmecky, examined the bullets recovered from the body and declared that they were .44-caliber and fired from a Winchester rifle. Thompson and Fisher had powder burns on their faces, indicating fatal shots fired close to the head. Both communities were enraged with the seemingly blatant fact that it would be impossible for Joe Foster and Jacobo Coy to have fired twenty-two shots from their two six-shooters, as the coroner's jury had concluded at the inquest.

The *Austin Daily Dispatch* on March 13 reported:

> The general verdict in our city is that Thompson was lured into a trap and brutally assassinated, and that the affair was well laid, coolly prepared plan to murder him. The verdict of the coroner's jury is simply prepared to suit the case, and is not sustained by the facts…That Thompson came to his death by shots from the pistols of Foster and officer Coy, is unworthy of belief. Thompson was shot nine times, and any of the eight shots would have proved fatal. Neither Foster or Coy, or both together, shot him that often or at all. In an interview with Billy Thompson, the brother of Ben, he declares that Ben and Fisher were shot by parties in the boxes or behind the scenes, hired to do the shooting, and all the circumstances point to this being

Historically accurate drawing of the floor plan to the Vaudeville Theater—the scene of multiple shootings in San Antonio. Note that Sim Hart's Tobacco Shop occupied the front right corner of the first floor, while the upper floor was used for gambling and balcony seating for the theatre below. *Courtesy Robert Cullen Smith.*

> *the fact…A reputable gentleman, not a resident of Texas, but who was in San Antonio on the night of the shooting, and who saw and conversed with Thompson half an hour before he was shot, says he was informed by a police officer that the police force had orders to kill Thompson on the slightest provocation.*

The assassination theories continued on in the Austin papers with the March 16 *Austin Statesman* giving an account by two out-of-town salesmen who were eyewitnesses to the shooting. The men were identified as Alex T. Raymond out of Chicago and John R. Sublett from Kentucky. According to the article, both Fisher and Thompson were seated when Foster had his confrontation with Ben. When Foster refused to shake hands with Thompson,

> *both Simms and Coy stepped to one side, at least two feet from where Thompson and Fisher were sitting, and Foster was about as far on the*

other side of them. Thompson and Fisher sprang up, neither had a revolver in his hand, and before they got to their feet a volley that sounded as though there were a dozen carbines was fired from a box a little to the left and considerably above the doomed men, and both went down instantly. Neither Thompson nor Fisher drew their pistols, nor did they have time to do so.

The salesmen said that either Simms or Coy rushed up and grabbed Thompson's revolver. Pointing the barrel point blank at Thompson's ear, the man fired one shot and then, thumbing the hammer back, put two more rounds into his head and body. At the same time, the other man shot Fisher in a similar fashion. As to Joe Foster, the men said that he tried to draw his pistol from his waistband and got it caught. Finally jerking it free, Foster's gun discharged and shot him in the leg. The paper ended the article by saying that the account "is no doubt as near the truth as the public will ever get."

Many years later, Frank H. Bushick, who had been the city tax commissioner and was the editor of the *San Antonio Express* between 1892 and 1906, wrote an account of the shooting in his book *Glamorous Days*. Bushick was on good terms with the San Antonio gamblers and other various members of the "sporting" community. He stated that it was a well-circulated fact that Simms and Foster had stationed three men armed with Winchesters in a theatre box with instructions to shoot Thompson if trouble started. Bushick identified the shooters as a bartender named McLaughlin, a gambler by the name of Canada Bill and a Jewish theatrical performer with the stage name of Harry Tremaine. The men were reported to have been paid $200 for the killings and slipped out of the theatre in all of the confusion that ensued that night. All three left town that night and never returned to the city. According to Bushick, the coroner's inquest was a total sham.

There are some interesting unanswered questions that turned up in the testimony during the inquest. As part of his testimony, Jacobo Coy swore that "I never drew my pistol. I think there some twelve or thirteen shots altogether fired, in all. I turned over Thompson's pistol to Marshal Shardein. I am not sure at what time Thompson and Fisher came in. The parties who were shooting were behind us. I do not know whether Fisher had his pistol out or not." When a member of the jury asked about "the parties who were shooting were behind us," Coy declined to answer, and the justice sustained his refusal. In addition, during his testimony, Billy Simms was asked by one

of the jurors as to "who drew a pistol just after Thompson had drawn his?" Simms refused to answer and the justice sustained his objection as well.

Charles M. Barnes, who served as a clerk for the coroner and was a reporter for the *San Antonio Express*, wrote an article that noted that the two dead men had between twenty-two and twenty-four bullet wounds. Some were attributed to buckshot. Yet no one told of hearing a shotgun blast, which has a distinctly different sound when compared to a Winchester rifle shot.

Another interesting discovery was reported at the scene of the shooting. King Fisher's pistol had never been fired. Officer Chadwell testified that he removed the unfired .45 Colt with the black gutta-percha handle and blue-bronze steel barrel from Fisher's body. Later, he turned it over to Marshal Shardein. This was the same pistol that President Porfirio Díaz had presented to King Fisher in Mexico. In contrast, Thompson's pistol was found to contain five empty shells. These reports would tend to bolster the account given by the out-of-town salesmen, Raymond and Sublett.

Joe Foster had not given testimony at the inquest due to his severe leg wound that eventually required amputation above the knee joint. After the operation, he gave a statement to an *Express* reporter, which gave a detailed account of the shooting. His version of the events differs from the other testimonies in a number of particulars, especially as to who did the shooting and the sequence of shots fired during the fracas. He stated that when Coy grabbed Thompson's pistol, he drew his own revolver and shot Thompson in the chest. When Thompson, Fisher and Coy went down in a corner, he said, "I ran up to Thompson, put my pistol to his left eye and turned it loose again. That was my second shot. I was shot next in the leg and fell. I do not know who shot me. As soon as I fell, I caught hold of one of the benches and pulled myself up and fired the four remaining shots in my pistol into the crowd." In reading the recorded account, it is presumed that Foster meant that he fired into the men on the floor when he referred to firing his remaining shots "into the crowd."

Although the autopsy did not show that Thompson had a chest wound, Foster's claim only accounts for a small number of the bullet holes in the dead man. If Coy swore under oath that he never drew his pistol, who else shot Thompson and Fisher? It is obvious that in reading Foster's bedside account and the testimony presented at the inquiry that the stories did not validate the verdict. The inquest was conducted for the sake of a public explanation of a premeditated assassination that was concocted to eliminate

Ben Thompson. Undoubtedly, Billy Simms, Jacobo Coy and Joe Foster all had a hand in the killings, but the eyewitness accounts indicate that there were also other shooters blasting away that March night.

In an ironic twist, Joe Foster was rushed to the same room a short distance down Soledad Street where Jack Harris had died two years earlier. He lingered on for a few weeks until an unexpected aneurysm developed in his amputated stump and he died. It would be poetic justice if the bullet that had "shot him all to pieces" had been fired by Thompson, but there is every indication that he was hit by a .44 slug that came from his own pistol or from the shooters hidden in the theatre box.

Jacobo Coy's minor wound eventually turned out more serious than was originally thought. Evidently, an infection set in on the wound, and he was bedridden for a considerable time. After he finally recovered, he was partially crippled, hindering his ability to work as a saloon policeman. To his credit, Billy Simms provided financial assistance to Coy until his death in 1907. Then again, it might be that he figured he had to pay to keep Coy from telling the "real story" of the shooting.

Unlike the others involved in the shooting, Billy Simms came out of the episode unscathed and continued on in the saloon theatre business in San Antonio. Interestingly enough, Ben Thompson was credited with encouraging the younger Simms to leave the printing trade and take up the gambling business with him. While Thompson was in jail awaiting his trial for the Capitol Theater shootings in Austin, Simms brought him copies of the newspapers and other items.

As a youth, Billy had been in a knife fight at Woodlief's Saloon in Austin, during which he sustained several stab wounds to the ribs and stomach. Four years later, he was involved in the shooting death of a barroom friend by the name of J.V. George. Liquored up and in a rage over the affections of a woman named Annie Woods, George entered the Brown Front on Skiddy Street yelling threats of killing Woods and Simms. He then pulled a knife and stormed down to Miss Woods's room at the Brown Front. Finding the door locked, he proceeded to break it down and charge inside. Simms was with Miss Woods, and he had a pistol trained on George the minute he stepped through the battered doorway. His first shot missed, but his second hit the drunken man squarely in the head. George hit the floor dead as the proverbial doornail. The shooting was ruled as self-defense, and Simms was not charged.

A short time later, Billy had a falling out with Thompson and moved to San Antonio, where he eventually managed the Vaudeville Theater with Jack Harris and Joe Foster. After Harris's death, he took over the dead man's interest in the business, along with Joe Foster as partner. A few days after the Thompson-Fisher shootings, he reopened the Vaudeville Theater as the sole proprietor. But things did not go smoothly for Simms. In the following month, at about six o'clock in the evening, King Fisher's close friend, R.H. Lombard, entered the Vaudeville and threw down a $50 bill on the bar. Lombard, who was an attorney and a former editor of the *Eagle Pass Maverick*, was drunk but still ordered more whiskey. He then proceeded to call King Fisher's killing a cowardly act and nothing short of coldblooded murder. A short while later, he confronted Simms with the same accusations, and both men drew pistols. Lombard got off the first shot but missed Simms. Billy began blazing away with his revolver but did not hit Lombard—who was having trouble firing his double-action pistol. Lombard sloshed out the door of the saloon, but before he could get away, Simms hit him with a bullet to his right arm. Both men were arrested and later fined $100 each.

By this time, Simms was beginning to become paranoid about King Fisher's many friends who, he thought, wanted to settle the score. He told a *San Antonio Express* reporter that even ex-Texas Ranger Captain Joseph Shelly and U.S. deputy marshal F. Niggli were trying to draw him into a fight so they could kill him. After making some quick arrangements, Simms sold the Vaudeville to Mr. John Strappenbeck for $1,753 and left town for Chicago. He checked into the Matteson Hotel with a traveling companion named John Slattery.

The *Chicago News* quickly ran an article with the title of "Ready For an Attack. Two Men From Texas Who Are Walking Arsenals." In the article, the reporter said that Simms

> *enjoys the proud distinction of having killed two men. He, however "got the drop on them." The friends of the two have sworn vengeance on Simms, and so wherever he goes, he is always heavily armed, and always travels with a companion who also has his pockets filled with revolvers.*

After the article was published, reporters constantly badgered Simms for interviews, finally to the point that he returned to visit his family in Austin. While in Austin, a printer by the name of Taylor Thompson (no relation

to Ben) went on a drunken binge and bought a pistol to shoot Simms for killing Ben Thompson. He was arrested by the police and thrown in jail. Later, Billy was asked to come to the police station to identify his would-be killer. When Simms recognized that it was an old acquaintance, he asked the now sober Thompson why he wanted to kill him. Thompson answered, "I haven't anything in the world against you. It was the whiskey that did it, I expect, for I do not recollect anything about the affair."

Simms returned to San Antonio and, with his partner Max Samuels, opened a new business called the Fashion Theater on the west side of Military Plaza. The theatre featured a much bigger stage than the Vaudeville but offered the same fine cigars and liquors, as well as gambling tables. The venture was a roaring success until April 1886, when Simms, tired of dealing with performers and their problems, cashed in his interests and took an extended vacation.

Later in June, he opened a new venture, the Pickwick Saloon and Restaurant, in partnership with W.A. Lamb—this time without the problems associated with managing a theatre and gambling tables. One week after the Pickwick opened, a very drunk J.H. Franklin staggered in and yelled at Simms, "You are the man who killed King Fisher, who was my friend and I am going to kill you." Simms called in an officer, and Franklin was ushered off to jail. The next day, after Franklin had slept off his drunken spree, he apologized, saying he had too much to drink and could not remember entering the Pickwick. Another case of liquor-laced amnesia; apparently, from the printed reports of the time, this occurred frequently.

In August, Billy Simms took a short excursion to Galveston, where he was involved with yet another deadly shooting. While out drinking with a prominent saloon owner named James Odell, Simms entered the Two Brothers Saloon, where Charles Quinlan ran the gambling tables. James Odell had previously argued with Quinlan, and each had pulled pistols. No shots were fired, but there was still a smoldering resentment between the two gamblers. Odell tried his luck at the faro table upstairs, but when he began to lose, he tried to cheat. The dealer spotted the cheating and stopped the game. Simms stepped in and suggested that they go back downstairs to the bar. Once there, Odell saw Quinlan and tried to drag him to the bar for a drink. Quinlan struggled with the drunken man until Simms pulled a pistol and struck Quinlan on the head. Staggering back, Quinlan tried to leave the saloon, but Odell pulled a .44-caliber revolver and pumped two rounds into

his back just as he exited the building. Quinlan managed to make it about twenty yards before he collapsed in the street. Odell ran up to him and got in a third shot at point-blank range. The police arrived about this time and wrestled the pistol away from the shooter before he could get off another round. Poor Charles Quinlan died before he could be carried to his home, and Odell was charged with his murder. Billy Simms was also charged with aiding and abetting Odell in the shooting.

After they made bail, the legal maneuvering for Simms and Odell continued until November 15, 1887, when their trial finally convened in Galveston. The charges against Simms were dropped at the beginning of the proceedings. Then Odell's lawyer produced a witness who claimed that he saw a knife fall to the ground close to where Quinlan had fallen, and the jury returned a not guilty verdict.

Billy Simms sold out his interest in the Pickwick Saloon, and then in 1892 he formed a partnership with Richard Tommins and Samuel Berliner to open the Crystal Saloon on Commerce Street in San Antonio. The saloon was a roaring success, having the reputation of being one of the finest saloons in Texas. Later, Dan Breen joined the group in opening a gambling hall named the Crystal Turf Exchange. Both ventures made all of the partners very wealthy men.

It has been said that money and time have transformed many a desperado into a respectable man. Such was the case for Billy Simms. He became one of the leading figures in San Antonio and was a member of the most influential social organizations. Politicians and businessmen courted his favor, and he was consulted on major city projects. Unlike most of the others involved in the 1884 Vaudeville Theater shoot-out, he lived to see the new century—but not for long. Though he survived many lethal confrontations over the years, a ruptured appendix finally brought him down just one month shy of his fifty-fourth birthday. He died following surgery at the Santa Rosa Hospital on January 9, 1909. Simms's funeral procession was one of the longest ever seen in San Antonio at the time. He was buried at the Order of Redmen Cemetery.

Ben Thompson's funeral procession in 1884 was the longest ever seen in Austin. Under the auspices of Mount Bonnell Lodge No. 34 of the Knights of Pythias, a cortège of sixty-two carriages followed the body from the Thompson home to the Oakwood Cemetery. One of the carriages carried a number of orphans whom had been provided for by Thompson

through his private donations to the Knights of Pythias. Throngs of people gathered around Thompson's grave as Mr. R.B. Underhill, vice-chancellor of the Mount Bonnell Lodge, conducted the services. Ben had held a prominent position in the Knights of Pythias, and the lodge issued a newspaper statement with his eulogy. Considering Ben's violent past, this seems out of step with the fraternal principles of the organization. In its charter the organization states, "The Fraternal Order of Knights of Pythias and its members are dedicated to the cause of universal peace. Pythians are pledged to the promotion of understanding among men of goodwill as the surest means of attaining Universal Peace. We believe that men, meeting in a spirit of goodwill, in an honest effort of understanding, can live together on this earth in peace and harmony." Somehow, Ben Thompson and his usual method of solving conflict just does not fit this description.

Strangely enough, Ben Thompson's tombstone was not the fine marble slab that he won in the card game with the peddler. At the time of his death, no one could recall where it had been stored, so another was inscribed with his name. Many years later, when the building that housed the Iron Front Saloon was torn down, construction workers found the large marble slab hidden away in the basement. At first, no one knew what it was until some old-timers recalled seeing it in the Iron Front after Thompson had won it a few months before his death. They thought that it was a shame that Ben had not taken the tombstone peddler's offer to cut a fine inscription on the marker.

King Fisher's funeral was the biggest ever seen in Uvalde County. One Uvalde resident estimated that the entire population of the town had gone out to meet Fisher's train at the station one mile north of town. The Reverend J.W. Stovall presided over the graveside service in which Fisher was interred in a tear-shaped iron coffin with a glass porthole over the face. Following the burial, a letter was drafted and signed by 271 Uvalde citizens and sent to the *San Antonio Express* to take issue with the way the newspaper had covered the story of Fisher's death. The letter was printed in the March 15, 1884 issue of the newspaper and presented a totally different view of the man the community had come to know and trust. King Fisher was described as

> *kind, courteous, affable, generous, and always ready to ferret out crimes and bring criminals to justice. And* [the statement added] *he has been the means of bringing to justice some of as bad criminals as ever infested*

A photograph of the Uvalde Courthouse office used by King Fisher when he served as the deputy sheriff of Uvalde County in 1884. *Courtesy Lawrence Vivian.*

Texas…We feel that we do not exaggerate when we assert that King Fisher has accomplished as much for law and order within the last two and a half years as any man in Western Texas, and this assertion will be verified by all officers who may have been thrown in contact with him. In justice to the dead and in justice to his family we ask that this correction be made.

There is no doubt that King Fisher was able to reform himself after he left the wilds of the Nueces Strip and was well liked by the entire population. Well, maybe not everyone thought he was the epitome of a gentleman

King Fisher's coffin, unearthed and moved to a new location in Uvalde, was cast iron with a welded top. There was a glass porthole over the head, and the people moving the coffin said that Fisher was well preserved. *Courtesy O.T.T. Collection.*

and the best lawman that had ever served the county. Remember old lady Hannahan and her wild bunch, who shot it out with Fisher? The story is told in the Uvalde area that each year on the anniversary of her son's death, she would visit Fisher's grave at midnight and build a bonfire on top of the grave. She would then rant about Fisher killing her "poor son, John," and then with the flames flickering in her eyes, she would dance a devilish jig around Fisher's grave.

Eventually, over time, Mary Hannahan stopped her maniacal midnight dances, and the old-timers who actually knew Ben Thompson and King Fisher finally died off. Then the newspapers and magazines lost interest in telling the story of the San Antonio shooting until the untimely deaths of the two pistoleers faded from the public's memory. All that remained of their legacies were barroom recollections and campfire tales circulated along the Mexican border. The fascinating accounts of two of the most noted pistol fighters in Texas soon faded into obscurity like the dry, crumbling pages of a musty old book. While other figures in frontier history became celebrities through the stories written about them in *Harper's Monthly Magazine*, *Frank Leslie's Illustrated Newspaper* and the *National Police Gazette*, the amazing lives of the Texas pistoleers were largely ignored or relegated to small back-page articles.

When compared to Wyatt Earp, Billy the Kid, Jesse James or "Wild Bill" Hickok, these men were clearly just as deadly with a gun and probably better shots. In their day, the mere mention of the names Ben Thompson and King Fisher was usually enough to sober up a drunken contender or cause a sober opponent to consider his own epitaph. Yet through some strange twist of fate, the true stories of these prominent Texas gunfighters have never achieved their rightful places in the annals of the Old West.

Afterword

They say the best men are molded out of faults, and, for the most, become much more the better for being a little bad!
—Shakespeare, Measure for Measure

B en Thompson and King Fisher were certainly not saints and were most definitely sinners, but how should they be judged in light of the violent times of their era? They both broke the law at various times in their lives and were responsible for a number of premature deaths. To their credit, both men fought their gun battles "straight up" against men trying to kill them. Unlike some of the other gunfighters of the Old West who jumped at the chance to back shoot their victims given the opportunity, Thompson and Fisher faced their opponents with cool determination to stand their ground, win or lose.

Of the two men, Ben Thompson seemed to relish the tag of "desperado." He took great pleasure in reading newspaper accounts about himself and eventually honed the announcement "I'm Ben Thompson" into a fear-producing threat. When sober, he was friendly and a pleasant conversationalist. He was extremely loyal to his friends and more than willing to take up for the underdog in a fight. By all accounts, he was a good husband and father to his children. He was an attentive son who provided for his mother and suffered extreme grief at her death. After burying his mother, Thompson seemed to sink deeper into the alcoholic binges that transformed him into a belligerent, mean-spirited hellion bent on self-destruction. A few months

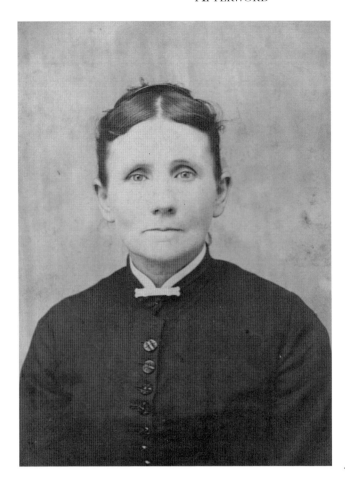

Rare photograph of Mary Thompson, Ben Thompson's mother. *Courtesy Sybil Patterson (descendant of Mary Thompson's family).*

before he was killed, a weekly newspaper, *Texas Siftings*, commissioned an artist to make a sketch of him thinking that his hell-bent sprees would soon to result in his death. The drawing appeared along with its detailed report of his death. The artist's depiction of Thompson shows a paunchy, middle-aged man with definite signs of dissipation.

King Fisher, on the other hand, eventually grew tired of the outlaw image and at the time of his death had his life "headed down a different trail." Apparently, in his early days on the Pendencia, alcohol played a role in shaping his actions, which often meant moving from being a "stock marshal" to being a rustler himself. The Vivian family credits his wife Sarah with convincing King to stay out of saloons and think about the effects that his reputation had on his daughters. He became a model citizen and a well-respected lawman.

There is still a controversy over King Fisher's role in the saloon shoot-out. Was he a co-conspirator with Simms and Foster, or was he trying to broker a truce? Some speculated that he was still carrying a grudge against Thompson from a previous encounter and got caught up in the ambush. Most people of that day felt that he was sincerely trying to get Thomson, Simms and Foster to "bury the hatchet" and end the blood feud between them. The theory is supported by the testimony at the inquest and by eyewitness accounts. This would also be in keeping with his temperament and reputation among those who knew him in Uvalde. Most people agree that Fisher, even with the best of intentions, was basically at the wrong place at the wrong time, and near the wrong man.

As to who really killed Thompson and Fisher, it is safe to say that the coroner's inquest only portrayed a portion of what really happened on that night at the Vaudeville. Most researchers think that there were shooters stationed in a screened-off portion of the balcony with orders to shoot if trouble started. They may have been a gambler, a bartender and an actor present, as Bushick claimed in *Glamorous Days*, or maybe they were employees of the theatre. In any event, it appears that someone opened up on the two as they stood near the exit to the stairs. Then, probably Billy Simms and Jacobo Coy finished them off with point-blank pistol shots to the head. Regardless of what he later stated to a reporter, Joe Foster probably brought about his own death by blowing a hole in his leg trying to get his pistol out of his pants.

Since King Fisher was a close friend of Foster's, why was he cut down by the shooters and finished off at close range? This remains a mystery, but one could speculate that the hidden shooters got carried away in the ambush and shot both men in the heat of the moment. Then, with Thompson and Fisher on the floor, someone decided that Fisher also had to be finished off, to avoid letting him give an account of the shooting.

On the night of the killings, Ben's brother, Billy Thompson, was warned not to go upstairs or he would meet the same fate as Ben. Being sober, Billy took the warning to heart and asked for police protection for the night. After he returned to Austin with his brother's body, many thought that he would soon head back in San Antonio seeking revenge. As it turned out, this was not the case. Billy stayed in Austin but tried to get authorities in Austin and San Antonio to further investigate his brother's murder. When this failed, he moved to Houston, where he continued working as a gambler. He later roamed to Cripple Creek, Colorado, for a while and then returned

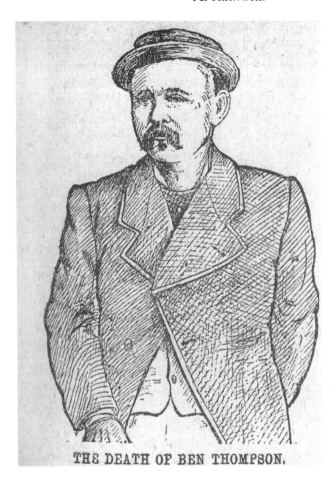

THE DEATH OF BEN THOMPSON.

Artist sketch of Ben Thompson that appeared in the *Texas Siftings* newspaper account of his death in 1884. *Courtesy Texas State Library Archives.*

to working the tables in Houston and Galveston. His brother's death seemed to have taken the starch out of Billy; he still drank heavily, but he stayed out of trouble with the law. Apparently, his old wounds from Bill Tucker's buckshot blast in Nebraska and his chronic drinking began to catch up with him in the mid-1890s, making it more and more difficult to eke out a living dealing cards. Finally, at the age of fifty-two, Billy Thompson cashed in his chips and died in a Houston hospital on September 6, 1897. He was buried in the Fairview Cemetery outside of Bastrop.

With a little bit of searching you can locate Ben Thompson's grave in the Oakwood Cemetery in Austin. The cemetery is situated in the center of town, a few blocks east of the University of Texas campus. Working your way down a narrow trail between rows of graves, you will find Thompson's

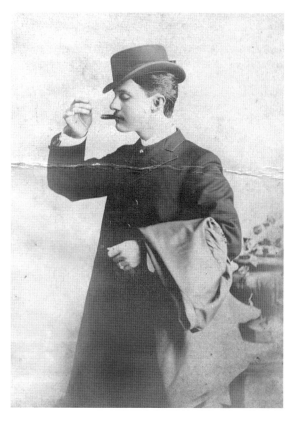

Above: King Fisher's final resting place at the Pioneer Cemetery in Uvalde, Texas. *Courtesy O.T.T. Collection.*

Right: Did he get away with murder? Billy Simms took over the management of the Vaudeville Theater after Jack Harris was killed and eventually became a prominent San Antonio businessman. He died of a ruptured appendix in 1909. *Courtesy Robert McCubbin Collection.*

tombstone standing alone under a big oak tree. Somehow the small, simple grave marker does not seem to fit the larger-than-life man buried there. On the day I visited Thompson's final resting place, it was an overcast afternoon, with the sun occasionally breaking through the clouds. As I reached the grave, sunlight highlighted the tombstone and a small patch of Texas bluebonnets that grew around the marker. It was a pleasant, tranquil setting that seemed in great contrast to the tumultuous life of one of the most feared pistoleers buried below the surface.

If you visit the Pioneer Cemetery in Uvalde, it is very easy to spot King Fisher's grave. It, too, lies beneath a large oak tree, but with a small wrought-iron fence around it. The original tombstone has been replaced with a simple granite marker. As you approach the grave site, you wonder about the iron fence surrounding it. Then you remember the tales of a crazy lady dancing around a midnight bonfire on top of the grave. Somehow, the iron fence seems to need a sign similar to the one posted on King Fisher's ranch road. Only this one should read, "This is King Fisher's grave. Visit another."

Appendix I
Card Games of the American West

Among the most popular of the card games in the American West were faro, monte and twenty-one. Poker, brag and euchre could also be found in some saloons and gambling halls, but these card games did not have the fast action as the others.

Twenty-one (now called blackjack) was played very much the same as it is today, but because faro and monte can no longer be found in casinos today, the card games are described below, taken from information in *The Little Giant Encyclopedia of Card Games*.

FARO

Play was often referred to as "bucking the tiger."

Equipment: A table covered with green baize, bearing the faro layout—the complete spades suit was normally used for the layout; a dealing box from which one card could be slid at a time; a casekeeper—a frame like an abacus used to show which cards in the deck have been played; a standard deck of cards; betting chips; Faro "coppers"—round or hexagonal chips of either red or black used for betting a denomination to lose; bet markers—small, flat oblongs of ivory or plastic used to make bets over the limit of a bettor's funds.

Players: Up to ten can play. House officials are a dealer, a lookout who supervises betting and a casekeeper official. The house always banks.

Objective: Players try to predict whether the next card to appear in the dealing box, of the denomination bet on, will be a winning or losing card. Cards appear in play two at a time—called a "turn." The first card in each turn is always the losing card, the second the winning card.

Shuffle, Cut and Bet: The dealer shuffles the cards, cuts them and puts them in the dealing box face up. The exposed top card is called the "soda" and is ignored for betting. Players now place their bets before the first turn is dealt.

First Turn: The dealer slides the soda card out of the box face up and starts a discard pile known as the "soda stack." He then slides the next exposed card from the box and places it face up on the right side of the box. This is the losing card. The card now exposed in the box is the winning card.

Between Turns: Any bets on the two exposed denominations are settled. Now the players may withdraw their bets that did not win or lose, they may change their bets or they may place new bets. The cards played are recorded on the casekeeper.

Continuing Play: Play continues until all cards are played in the deck. In each turn: the dealer removes the last winning card from the box and places it face up on the discard pile; a new losing card is taken from the box as in the first turn; and the new winning card is exposed in the box. The casekeeper has pictures of the thirteen denominations, with four colored buttons on a spindle opposite each card picture. At the beginning of the deal, all of the buttons are positioned at the inner ends of the spindles. As a card is taken from the box, one of the buttons on the relevant spindle is moved along toward the outer end of the frame. How far it is moved depends on whether it represents a winning or losing card: for a losing card, it is moved until it touches the outer frame or an earlier button on the same spindle; for a wining card, the gap of about half an inch is left between the button and the frame or between this and an earlier button. When the forth card of the denomination appears, whether it is a winning or losing card, all four buttons are pushed together against the outer frame to show that betting on this denomination is at an end.

The Last Turn: Three cards are left in the box for the last turn. The casekeeper shows which cards they are. The last card in the deck is called the "hoc" or "hock" card. For the last turn, players may normally: bet on any one of the cards to win or lose as usual; or "call the turn"—a player may also bet on the precise order of all the three cards (e.g., queen first to lose, six second to win and ace the last card). The turn is played in the usual way, except that when the losing card has been removed from the box, the winning card is partially slid out to confirm the denomination of the hoc card. A player's bet is returned if the card that he has bet to win or lose appears as the hoc card.

Continuing the Game: After the last turn, all cards are gathered and shuffled for the next deal.

Betting: There are three kinds of bets, apart from bets on the last turn: bets on a single denomination; bets on a set of denominations; and bets that take action in every turn. Bets on a single denomination are settled when a card of that denomination appears. To make the same bet again, a player places a new stake on the layout. Bets on a set of denominations are bets placed on groups of different numbers that appear close together on the layout. They are settled as soon as any one of the denominations bet on appears. To make the same bet again, a player places a new stake on the layout. Bets that take action in every turn remain on the layout until removed by the player. There are two such bets: a "high card" bet and an "even or odd card" bet. In a high card bet, the player bets that the higher denomination card of each pair will win in each turn or, if he has "coppered" the bet, the higher card will lose. The ranking has the ace as the lowest card and the king as the highest. In an even or odd card bet, the player bets that either the even card or the odd card will win in a given turn. (For this bet, the ace, jack and king count as odd, and the queen is even.)

Last Turn Bet ("calling the turn"): The stake is placed on the card bet to lose and angled toward the card bet to win. When made with a single chip, a copper is placed on the card bet to lose on the edge nearest the card bet to win. The single chip is placed on it, tilted toward the card bet to win. Another copper is placed on top of the single chip. When made with several chips, one chip is placed on the card bet to lose on the edge nearest the card bed to win. The remaining chips are tilted on the bottom

chip so that they point toward the card bet to win. When the third card lies between the winning and losing cards, the bet is tilted toward the outside of the layout. This shows that it avoids the middle card, which will be considered the hoc card.

Last Turn Bet ("cat hop"): The stake is placed as for calling the turn.

Bet Markers: These are used when a player wants to place on the layout at one time more bets than he has funds for. For each marker placed on the layout, the player must have staked an equal value in chips elsewhere on the layout. If one of the player's bet loses, the dealer takes payment in chips. The player must then remove his marker bet, unless the value of his chips on the layout still exceeds the value of the markers he has used. If one of the player's bet wins, the player wins an equivalent amount of chips.

A "Split": This occurs in a turn when a single bet has covered both winning and losing cards. A split on a single denomination occurs when two cards of the same denomination appear in a turn. The house takes half of any bet on that denomination; the other half is returned to the player. A split on a set of denominations occurs when two cards of a group bet on by a player appear in a single turn. The bet is returned to the bettor. A split on bets that take action in every turn occurs when both cards in a turn are of the same denomination or are both odd or both even. The bet remains on the table and the bettor neither makes nor receives payment.

Betting on the "cases": When only one card of a denomination is left in the box, this is called "cases" (e.g., "cases on the queen"). Most houses forbid a player to bet on cases until after he has bet on a denomination that could be a split.

"Cat Hop" Bet: On the last turn, the casekeeper may show that the three cards left are not all of denominations. "Calling the Turn" is then replaced by the "cat hop" bet. It may be made on denominations or colors. If two of the three cards are of the same denomination, a player may make a cat hop bet on denominations, predicting the order of the denominations as usual (e.g. ten, six, ten). A player may still bet one denomination to win or lose as usual. If all three cards are of the same denomination, a player may make a cat hop bet on color, predicting the order of suit colors (e.g., red, black,

red). Cat hop bets are placed in front of the dealer according to whatever temporary regulations he states.

Settlement: A player who calls the turn successfully is paid four to one. A player who makes a successful cat hop bet is paid two to one. All other bets are paid at even money (one to one).

MONTE

The game was also known as Spanish monte, monte bank or Mexican monte. It is important not to confuse monte with the sleight-of-hand con game called "three-card monte." Banker deals. Cards are matched by suit and not by denomination.

Equipment: Originally played with a Spanish deck of forty cards. Later played with a standard deck of fifty-two cards with all tens, nines and eights removed to leave a forty-card deck; betting chips.

Players: The game is for two or more players.

Objective: Players bet that one of the two cards on a "layout" (pair of cards) will be matched. A card is matched when the next card exposed from the deck is of the same suit.

Dealing the Layouts: Cards are shuffled and cut as normal. Holding the deck face down, the banker deals two cards from the bottom. He places them face up on the table, slightly apart. These form the "top layout." He then deals two cards from the top of the deck and places them face up on the table, slightly below the first two cards. These form the "bottom layout." The deal is valid whatever suit appears—even if all four cards are of the same suit.

Betting: Each player except the banker may bet on the top or bottom layout, or both. A bet on a particular layout is shown by placing the chips between the pair of cards.

Play: The banker turns the deck face up, exposing the bottom card. This card is known as the "gate." If the gate card's suit matches one (or both) of the cards in a layout, the players win any bets on that layout. If the gate card matches cards in both layouts, the players win their bets on both layouts. If no layout card is matched, all bets are lost.

Settlement: The banker collects all losing bets. Winning bets are paid at one to one, even if both cards in a layout were matched.

Continuing Play: The banker collects together the layout cards and places them to one side to form a discard pile. He then turns the deck face down, takes the next gate card from the bottom of the deck and puts it into the discard pile. He then deals the layout cards for the next hand. There is no shuffle or cut. At least ten cards should remain in the deck to prevent players from calculating which suit remains.

Appendix II
Tombstones

Today, with only the tombstones left to remind us of this infamous period in San Antonio history, it is easy to rush past the intersection of Soledad and West Commerce, oblivious to its notorious past. For the most part, the inglorious story of the violent blood feud lies buried beneath the bricks and pavement of Main Plaza. All of the men who were a part of the violence of the early 1880s have been forgotten; only their tombstones remain.

Left: The author stands besides Jack Harris's grave in the San Antonio Cemetery. The inscription reads: "D.A. (Jack) Harris—Born 1834—July 11, 1882, A Single Man." Joe Foster's tombstone is the tall obelisk in the background. His inscription reads: "Joseph C. Foster, 1837–1884." *Courtesy O.T.T. Collection.*

Below: Jack Harris's tombstone in the San Antonio City Cemetery. He was the boss of the "sporting" community and the major power broker in the Democratic Party. *Courtesy O.T.T. Collection.*

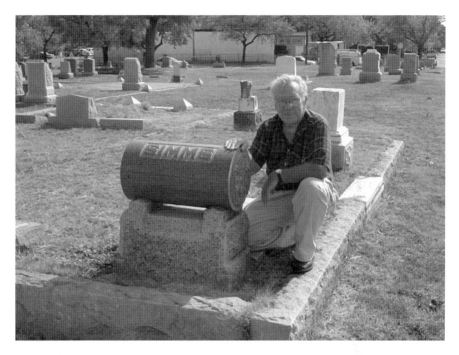

Chuck Parsons, historian and writer, kneels beside Billy Simms's tombstone in the San Antonio City Cemetery. The inscription reads: "Sacred to the memory of my beloved husband W.H. Simms. Who departed this life Jan. 10, 1909—age 53 Yrs. He died as he lived, brave and true." *Courtesy O.T.T. Collection.*

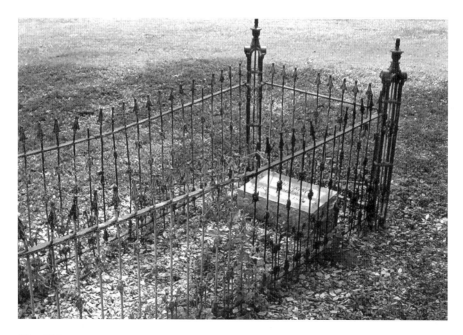

King Fisher's grave site in the Pioneer Cemetery in Uvalde, Texas. *Courtesy O.T.T. Collection.*

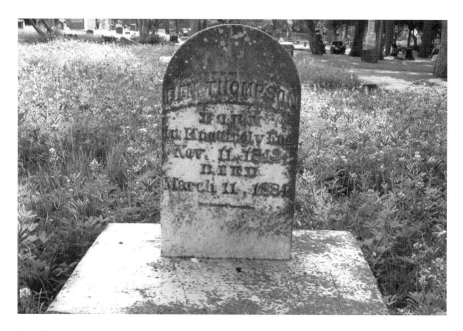

Ben Thompson's gravestone in the Oakwood Cemetery in Austin, Texas. *Courtesy O.T.T. Collection.*

Bibliography

Controversy always swirls around books on notorious characters of the American West. Historians and researchers will fervently argue over specifics of most recorded events. The compiled sources listed below represent a concerted effort to tell the stories of Ben Thompson and King Fisher as accurately as my research has directed.

Sources used frequently throughout the book, and thus not repeatedly listed here, include Frank H. Bushick's *Glamorous Days* (Naylor Company, 1934), Patrick Cox's "Thompson, Ben" in the *New Handbook of Texas* (Texas State Historical Association, 1996), George Durham's "On the Trail of 5,100 Outlaws—Beyond the Nueces" in the *Valley Morning Star* (November 8, 1959) and Durham's *Taming the Nueces Strip* (University of Texas Press, 1962), O.C. Fisher's *King Fisher: His Life & Times* (University of Oklahoma Press, 1966), Charles M. Robinson's *Men Who Wear The Star: The Story of the Texas Rangers* (Modern Library, 2000), Floyd Benjamin Streeter's *Ben Thompson: Man With a Gun* (Frederick Fell, 1957), T.T. Teel's "The Dead Desperadoes—Last of Ben Thompson and King Fisher," in the *San Antonio Express* (March 13, 1884) and William H. Walton's *Life and Adventures of Ben Thompson* (reprint, Frontier Press, 1954).

CHAPTER 1

Adams, Paul. "The Unsolved Murder of Ben Thompson, Pistoleer Extraordinary." *Southwestern Historical Quarterly* (July 1954).

Bonnett, W.A. "King Fisher—A Noted Character." *Frontier Times* (July 1945).

Evett, Alice. "The Fatal Corner." *San Antonio Monthly*, July 1982.

Frontier Times 19, no. 5. "Killing of Ben Thompson and King Fisher" (February 1942).

Galley, Joseph. *From Alamo Plaza to Jack Harris' Saloon.* The Hague, Holland: Mouton & Co. N.V., 1970.

Gregory, A.H. "Death of Ben Thompson and King Fisher." *Frontier Times* (June 1928; August 1949).

Hunter, J. Marvin. "Ben Thompson—Killer of Men." *Frontier Times* (May 1939).
———. "Ben Thompson, Texas Gun Fighter." *Frontier Times* (May 1948).

Hunter, J. Marvin, and Noah H. Rose. *Album of Gunfighters.* Bandera, TX: J.M. Hunter, 1951.

James, Vinton Lee. *Recollections of Early Days in San Antonio and West Texas.* San Antonio, TX: self-published, 1938.

Lunsford, John R. "How Ben Thompson Died With His Boots On." *Frontier Times* 9, no. 2 (November 1931).

Masterson, William Barclay. "Famous Gun Fighters of the Western Frontier." *Human Life* 4 (January 1907).

Metz, Leon Clair. *The Shooters.* New York: Berkley Books, 1976.

Travis, Edmonds. "Austin's Premier Gun Fighter." *Bunker's Monthly* 2 (September 1928).

White, Owen Payne. "Belligerent Ben." *Collier's* 80 (September 24, 1927).

Wilson, R.L., and Greg Martin. *Buffalo Bill's Wild West: An American Legend.* New Jersey: Chartwell Books, 1998.

CHAPTER 2

Castellanos, Henry C. *New Orleans As It Was.* New Orleans, LA: L. Graham Son, 1905.

Hatch, James. "When Ben Thompson Killed His First Man." *Frontier Times* 1 (August 1924).

Hendricks, George D. *The Bad Man of the West.* San Antonio, TX: Naylor Company, 1942.

Hunt, J.M., Sr. "Ben Thompson, Texas Gun Fighter." *Frontier Times* (May 1948).

Hunter, J. Marvin. "Ben Thompson—Killer of Men." *Frontier Times* (May 1939).

Hunter, J. Marvin, and Noah H. Rose. *Album of Gunfighters*. Bandera, TX: J.M. Hunter, 1951.

O'Neal, Bill. *Encyclopedia of Western Gunfighters*. Norman: University of Oklahoma Press, 1979.

Smyth, R.P. "Knew Ben Thompson." *Frontier Times* (July 1939).

Time-Life Books. *The Gamblers*. The Old West (Series). Alexandria, VA: Time-Life Books, 1978.

———. *The Gunfighters*. The Old West (Series). Alexandria, VA: Time-Life Books, 1974.

Travis, Edmonds. "Austin's Premier Gun Fighter." *Bunker's Monthly* 2 (September 1928).

White, Owen Payne. "Belligerent Ben." *Collier's* 80 (September 24, 1927).

CHAPTER 3

Frontier Times. "Ben Thompson, Slain 50 Years Ago, Still Talked About" (September 1934).

Hunter, J. Marvin. "Ben Thompson—Killer of Men." *Frontier Times* (May 1939).

———. "Ben Thompson, Texas Gunfighter." *Frontier Times* (May 1948).

Travis, Edmonds. "Austin's Premier Gun Fighter." *Bunker's Monthly* 2 (September 1928).

White, Owen Payne. "Belligerent Ben." *Collier's* 80 (September 24, 1927).

CHAPTER 4

Hunter, J. Marvin. "Ben Thompson—Killer of Men." *Frontier Times* (May 1939).

———. "Ben Thompson, Texas Gunfighter." *Frontier Times* (May 1948).

Minatra, Odie. "Some Exploits of Ben Thompson." *Frontier Times* (September 1941).

Travis, Edmonds. "Austin's Premier Gun Fighter." *Bunker's Monthly* 2 (September 1928).

CHAPTER 5

Askins, Charles, Colonel. *Texans, Guns & History*. New York: Bonanza Books, 1990.

Chapman, Arthur. "The Men Who Tamed the Cow Towns." *Outing* 45 (November 1904): 131–39.

Connelley, William Elsey. *Wild Bill and His Era: The Life and Adventures of James Butler Hickok*. New York: Press of the Pioneers, 1934.

Cunningham, Eugene. *Triggernometry*. New York: Press of the Pioneers, 1934.

Farrow, Marion H. *Troublesome Times in Texas*. San Antonio, TX: Naylor Co., 1959.

Halloway, Carroll C. *Texas Gun Lore*. San Antonio, TX: Naylor Co., 1951.

Hunter, J. Marvin. "Ben Thompson—Killer of Men." *Frontier Times* (May 1939).

———. "Ben Thompson, Texas Gunfighter." *Frontier Times* (May 1948).

Lake, Stuart N. *Wyatt Earp, Frontier Marshal*. Boston: Houghton, Mifflin, 1931.

Lunsford, John R. "How Ben Thompson Died With His Boots On." *Frontier Times* (November 1931).

Masterson, William Barclay. "Famous Gun Fighters of the Western Frontier." *Human Life* 4 (January 1907).

O'Neal, Bill. *Encyclopedia of Western Gunfighters*. Norman: University of Oklahoma Press, 1979.

Time-Life Books. *The Gamblers*. The Old West (Series). Alexandria, VA: Time-Life Books, 1978.

Travis, Edmonds. "Austin's Premier Gun Fighter." *Bunker's Monthly* 2 (September 1928).

Triplett, Frank. *Romance and Philosophy of Great American Crimes and Criminals*. New York: N.D. Thompson, 1884.

White, Owen Payne. "Belligerent Ben." *Collier's* 80 (September 24, 1927).

CHAPTER 6

Hunter, J. Marvin. "Ben Thompson—Killer of Men." *Frontier Times* (May 1939).

———. "Ben Thompson, Texas Gunfighter." *Frontier Times* (May 1948).

Hunter, J. Marvin, and Noah H. Rose. *Album of Gunfighters*. Bandera, TX: J.M. Hunter, 1951.

Travis, Edmonds. "Austin's Premier Gun Fighter." *Bunker's Monthly* 2 (September 1928).

Warman, Cy. "Capturing a Railroad in Colorado." *Denver Republican*, October 4, 1896.

White, Owen Payne. "Belligerent Ben." *Collier's* 80 (September 24, 1927).

Chapter 7

Adams, Paul. "The Unsolved Murder of Ben Thompson, Pistoleer Extraordinary." *Southwestern Historical Quarterly* (July 1954).

Askins, Charles, Colonel. *Texans, Guns & History*. New York: Bonanza Books, 1990.

Cude, Elton R. *The Wild and Free Dukedom of Bexar*. San Antonio, TX: Munguia Printers, 1978.

Cunningham, Eugene. *Triggernometry*. New York: Press of the Pioneers, 1934.

Douglas, C.L. *Famous Texas Feuds*. Dallas, TX: Turner Co., 1936.

Evett, Alice. "The Fatal Corner." *San Antonio Monthly*, July 1982.

Fitzgerald, Hugh Nugent. "Captain Lucy Explodes the Ben Thompson Myth: A True Story." *Austin American*, March 14, 1927.

Halloway, Carroll C. *Texas Gun Lore*. San Antonio, TX: Naylor Co., 1951.

Hunt, J.M., Sr. "Ben Thompson, Texas Gun Fighter." *Frontier Times* (May 1948).

Hunter, J. Marvin. "Ben Thompson—Killer of Men." *Frontier Times* (May 1939).

Hunter, J. Marvin, and Noah H. Rose. *Album of Gunfighters*. Bandera, TX: J.M. Hunter, 1951.

James, Vinton Lee. *Recollections of Early Days in San Antonio and West Texas*. San Antonio, TX: self-published, 1938.

Lunsford, John R. "How Ben Thompson Died With His Boots On." *Frontier Times* (November 1931).

Minatra, Odie. "Some Exploits of Ben Thompson." *Frontier Times* 18 (September 1941).

O'Neal, Bill. *Encyclopedia of Western Gunfighters*. Norman: University of Oklahoma Press, 1979.

Raine, William MacLeod. *Famous Sheriffs and Western Outlaws*. New York: Doubleday, 1929.

Smyth, R.P. "Knew Ben Thompson." *Frontier Times* (July 1939).

Time-Life Books. *The Gamblers*. The Old West (Series). Alexandria, VA: Time-Life Books, 1978.

———. *The Gunfighters*. The Old West (Series). Alexandria, VA: Time-Life Books, 1974.

Travis, Edmonds. "Austin's Premier Gun Fighter." *Bunker's Monthly* 2 (September 1928).

White, Owen Payne. "Belligerent Ben." *Collier's* 80 (September 24, 1927).

Woodhull, Frost. *Southwestern Lore*. Austin: Texas Folklore Society, 1931.

CHAPTER 8

Adams, Paul. "The Unsolved Murder of Ben Thompson, Pistoleer Extraordinary." *Southwestern Historical Quarterly* (July 1954).

Askins, Charles, Colonel. *Texans, Guns & History*. New York: Bonanza Books, 1990.

Cude, Elton R. *The Wild and Free Dukedom of Bexar*. San Antonio, TX: Munguia Printers, 1978.

Douglas, C.L. *Famous Texas Feuds*. Dallas, TX: Turner Co., 1936.

Evett, Alice. "The Fatal Corner." *San Antonio Monthly*, July 1982.

Frontier Times. "Georgetown Editor Defied Ben Thompson" (April 1938).

Galley, Joseph. *From Alamo Plaza to Jack Harris's Saloon*. The Hague, Holland: Mouton & Co. N.V., 1970.

Gillette, J.B. "Ben Thompson and Billy Simms." *Frontier Times* (October 1934).

Gregory, A.H. "Death of Ben Thompson and King Fisher." *Frontier Times* (June 1928; August 1949).

Halloway, Carroll C. *Texas Gun Lore*. San Antonio, TX: Naylor Co., 1951.

Hendricks, George D. *The Bad Man of the West*. San Antonio, TX: Naylor Co., 1942.

Hough, Emerson. *The Story of the Outlaw*. New York: Grosset & Dunlap, 1907.

Hunter, J. Marvin. "Ben Thompson—Killer of Men." *Frontier Times* (May 1939).

———. "Ben Thompson, Texas Gunfighter." *Frontier Times* (May 1948).

Hunter, J. Marvin, and Noah H. Rose. *Album of Gunfighters*. Bandera, TX: J.M. Hunter, 1951.

James, Vinton Lee. *Recollections of Early Days in San Antonio and West Texas*. San Antonio, TX: self-published, 1938.

Lunsford, John R. "How Ben Thompson Died With His Boots On." *Frontier Times* (November 1931).

Metz, Leon Claire. *The Shooters*. New York: Berkley Books, 1976.

O'Neal, Bill. *Encyclopedia of Western Gunfighters*. Norman: University of Oklahoma Press, 1979.

Raine, William MacLeod. *Famous Sheriffs and Western Outlaws*. New York: Doubleday, 1929.

Ramsdell, Chas. *San Antonio*. Austin: University of Texas Press, 1959.

Smyth, R.P. "Knew Ben Thompson." *Frontier Times* (July 1939).

Time-Life Books. *The Gamblers*. The Old West (Series). Alexandria, VA: Time-Life Books, 1978.

———. *The Gunfighters*. The Old West (Series). Alexandria, VA: Time-Life Books, 1974.

Travis, Edmonds. "Austin's Premier Gun Fighter." *Bunker's Monthly* 2 (September 1928).

Triplett, Frank. *Romance and Philosophy of Great American Crimes and Criminals*. New York: N.D. Thompson, 1884.

White, Owen Payne. "Belligerent Ben." *Collier's* 80 (September 24, 1927).

Chapter 9

Bell, Verner Lee. *Memories of Peter Tumblinson Bell 1869–1956*. Saint Jo, TX: S.J.T. Printing, 1980.

Cox, Mike. *Texas Ranger Tales*. Plano: Republic of Texas Press, 1997.

Cunningham, Eugene. *Triggernometry*. New York: Press of the Pioneers, 1934.

Dobie, J. Frank. *The Longhorns*. New York: Bramhall House, 1941.

———. *A Vaquero of the Brush Country*. Austin: University of Texas Press, 1998.

Farrow, Marion H. *Troublesome Times in Texas*. San Antonio, TX: Naylor Co., 1959.

Fenley, Florence. "New Grave For King Fisher Recreates Interest in Former Deputy Sheriff." *Uvalde Leader News*, October 11, 1959.

Fisher, O.C. "The Life and Times of King Fisher." *Southwestern Historical Quarterly* 64, issue 2: 232–47.

Gardner, Amanda. "King of the Road." *Texas Highways* (December 1998).

Gillette, J.B., Captain. *Six Years With the Texas Rangers*. New Haven, CT: Yale University Press, 1925.

Hendricks, George D. *The Bad Man of the West*. San Antonio, TX: Naylor Co., 1942.

Hough, Emerson. *The Story of the Outlaw.* New York: Grosset & Dunlap, 1907.

Jennings, N.A. *A Texas Ranger.* New York: Scribners, 1899.

Kilstofte, June. "Western Union." *San Antonio Express*, September 30, 1951.

Leakey, John (as told to Nellie Snyder Yost). *The West that Was.* Dallas, TX: Southern Methodist University Press, 1958.

O'Neal, Bill. *Encyclopedia of Western Gunfighters.* Norman: University of Oklahoma Press, 1979.

Webb, Walter Prescott. *The Texas Rangers.* New York: McMillian Co., 1935.

Williams, Crystal S. "A History of Dimmitt County." *Carrizo Springs Javelin,* February 18, 1960.

Woodhull, Frost. *Southwestern Lore.* Austin: Texas Folklore Society, 1931.

CHAPTER 10

Bell, Verner Lee. *Memories of Peter Tumblinson Bell 1869–1956.* Saint Jo, TX: S.J.T. Printing, 1980.

Cox, Mike. *Texas Ranger Tales.* Plano: Republic of Texas Press, 1997.

Cunningham, Eugene. *Triggernometry.* New York: Press of the Pioneers, 1934.

Dobie, J. Frank. *The Longhorns.* New York: Bramhall House, 1941.

———. *A Vaquero of the Brush Country.* Austin: University of Texas Press, 1998.

Farrow, Marion H. *Troublesome Times in Texas.* San Antonio, TX: Naylor Co., 1959.

Fenley, Florence. "New Grave For King Fisher Recreates Interest in Former Deputy Sheriff." *Uvalde Leader News*, October 11, 1959.

Fisher, O.C. "The Life and Times of King Fisher." *Southwestern Historical Quarterly* 64, issue 2: 232–47.

Fritterer, Gary P. "Let Justice Be Done Our Western Citizens." *NOLA Quarterly* 16, no. 3 (July–September 1992): 10–21.

Gardner, Amanda. "King of the Road." *Texas Highways* (December 1998).

Gillette, J.B., Captain. *Six Years With the Texas Rangers.* New Haven, CT: Yale University Press, 1925.

Hendricks, George D. *The Bad Man of the West.* San Antonio, TX: Naylor Co., 1942.

Hough, Emerson. *The Story of the Outlaw.* New York: Grosset & Dunlap, 1907.

Jennings, N.A. *A Texas Ranger.* New York: Scribners, 1899.

Kilstofte, June. "Western Union." *San Antonio Express*, September 30, 1951.

Leakey, John (as told to Nellie Snyder Yost). *The West that Was*. Dallas, TX: Southern Methodist University Press, 1958.

O'Neal, Bill. *Encyclopedia of Western Gunfighters*. Norman: University of Oklahoma Press, 1979.

Webb, Walter Prescott. *The Texas Rangers*. New York: McMillian Co., 1935.

Williams, Crystal S. "A History of Dimmitt County." *Carrizo Springs Javelin*, February 18, 1960.

Woodhull, Frost. *Southwestern Lore*. Austin: Texas Folklore Society, 1931.

CHAPTER 11

Bell, Verner Lee. *Memories of Peter Tumblinson Bell 1869–1956*. Saint Jo, TX: S.J.T. Printing, 1980.

Cox, Mike. *Texas Ranger Tales*. Plano: Republic of Texas Press, 1997.

Cunningham, Eugene. *Triggernometry*. New York: Press of the Pioneers, 1934.

Dobie, J. Frank. *The Longhorns*. New York: Bramhall House, 1941.

———. *A Vaquero of the Brush Country*. Austin: University of Texas Press, 1998.

Farrow, Marion H. *Troublesome Times in Texas*. San Antonio, TX: Naylor Co., 1959.

Fenley, Florence. "New Grave For King Fisher Recreates Interest in Former Deputy Sheriff." *Uvalde Leader News*, October 11, 1959.

Fisher, O.C. "The Life and Times of King Fisher." *Southwestern Historical Quarterly* 64, issue 2: 232–47.

Gardner, Amanda. "King of the Road." *Texas Highways* (December 1998).

Gillette, J.B., Captain. *Six Years With the Texas Rangers*. New Haven, CT: Yale University Press, 1925.

Hacket, C.W. "Recognition of the Díaz Government by the U.S." *Southwestern Historical Quarterly* (July 1924).

Jennings, N.A. *A Texas Ranger*. New York: Scribners, 1899.

Kilstofte, June. "Western Union." *San Antonio Express*, September 30, 1951.

Leakey, John (as told to Nellie Snyder Yost). *The West that Was*. Dallas, TX: Southern Methodist University Press, 1958.

Webb, Walter Prescott. *The Texas Rangers*. New York: McMillian Co., 1935.

Williams, Crystal S. "A History of Dimmitt County." *Carrizo Springs Javelin*, February 18, 1960.

Woodhull, Frost. *Southwestern Lore*. Austin: Texas Folklore Society, 1931.

CHAPTER 12

Bell, Verner Lee. *Memories of Peter Tumblinson Bell 1869–1956*. Saint Jo, TX: S.J.T. Printing, 1980.

Cox, Mike. *Texas Ranger Tales*. Plano: Republic of Texas Press, 1997.

Cunningham, Eugene. *Triggernometry*. New York: Press of the Pioneers, 1934.

Farrow, Marion H. *Troublesome Times in Texas*. San Antonio, TX: Naylor Co., 1959.

Fenley, Florence. "New Grave For King Fisher Recreates Interest in Former Deputy Sheriff." *Uvalde Leader News*, October 11, 1959.

Fisher, O.C. "The Life and Times of King Fisher." *Southwestern Historical Quarterly* 64, issue 2: 232–47.

Fritterer, Gary P. "Let Justice Be Done Our Western Citizens." *NOLA Quarterly* 16, no. 3 (July–September 1992): 10–21.

Gardner, Amanda. "King of the Road." *Texas Highways* (December 1998).

Gillette, J.B., Captain. *Six Years With the Texas Rangers*. New Haven, CT: Yale University Press, 1925.

Hendricks, George D. *The Bad Man of the West*. San Antonio, TX: Naylor Co., 1942.

Hough, Emerson. *The Story of the Outlaw*. New York: Grosset & Dunlap, 1907.

Jennings, N.A. *A Texas Ranger*. New York: Scribners, 1899.

Leakey, John (as told to Nellie Snyder Yost). *The West that Was*. Dallas, TX: Southern Methodist University Press, 1958.

O'Neal, Bill. *Encyclopedia of Western Gunfighters*. Norman: University of Oklahoma Press, 1979.

Webb, Walter Prescott. *The Texas Rangers*. New York: McMillian Co., 1935.

Williams, Crystal S. "A History of Dimmitt County." *Carrizo Springs Javelin*, February 18, 1960.

Woodhull, Frost. *Southwestern Lore*. Austin: Texas Folklore Society, 1931.

CHAPTER 13

Bell, Verner Lee. *Memories of Peter Tumblinson Bell 1869–1956*. Saint Jo, TX: S.J.T. Printing, 1980.

Cox, Mike. *Texas Ranger Tales*. Plano: Republic of Texas Press, 1997.

Cunningham, Eugene. *Triggernometry*. New York: Press of the Pioneers, 1934.

Farrow, Marion H. *Troublesome Times in Texas.* San Antonio, TX: Naylor Co., 1959.

Fenley, Florence. "New Grave For King Fisher Recreates Interest in Former Deputy Sheriff." *Uvalde Leader News*, October 11, 1959.

Fisher, O.C. "The Life and Times of King Fisher." *Southwestern Historical Quarterly* 64, issue 2: 232–47.

Gardner, Amanda. "King of the Road." *Texas Highways* (December 1998).

Gillette, J.B., Captain. *Six Years With the Texas Rangers.* New Haven, CT: Yale University Press, 1925.

Jennings, N.A. *A Texas Ranger.* New York: Scribners, 1899.

Leakey, John (as told to Nellie Snyder Yost). *The West that Was.* Dallas, TX: Southern Methodist University Press, 1958.

O'Neal, Bill. *Encyclopedia of Western Gunfighters.* Norman: University of Oklahoma Press, 1979.

Parsons, Chuck. "Gunfight at Espantosa Lake." *True West* 44, no.10 (October 1997).

Webb, Walter Prescott. *The Texas Rangers.* New York: McMillian Co., 1935.

Williams, Crystal S. "A History of Dimmitt County." *Carrizo Springs Javelin*, February 18, 1960.

Woodhull, Frost. *Southwestern Lore.* Austin: Texas Folklore Society, 1931.

CHAPTER 14

Cox, Mike. *Texas Ranger Tales.* Plano: Republic of Texas Press, 1997.

Fenley, Florence. "New Grave For King Fisher Recreates Interest in Former Deputy Sheriff." *Uvalde Leader News*, October 11, 1959.

Fisher, O.C. "The Life and Times of King Fisher." *Southwestern Historical Quarterly* 64, issue 2: 232–47.

Gardner, Amanda. "King of the Road." *Texas Highways* (December 1998).

Gillette, J.B., Captain. *Six Years With the Texas Rangers.* New Haven, CT: Yale University Press, 1925.

Jennings, N.A. *A Texas Ranger.* New York: Scribners, 1899.

Leakey, John (as told to Nellie Snyder Yost). *The West that Was.* Dallas, TX: Southern Methodist University Press, 1958.

Nolen, Oran Warder. "Tom Sullivan, Frontier Darkey." *Frontier Times* 27 (November 1949). *San Antonio Express* article, reprinted.

O'Neal, Bill. *Encyclopedia of Western Gunfighters.* Norman: University of Oklahoma Press, 1979.

Webb, Walter Prescott. *The Texas Rangers.* New York: McMillian Co., 1935.

Williams, Crystal S. "A History of Dimmitt County." *Carrizo Springs Javelin*, February 18, 1960.

Woodhull, Frost. *Southwestern Lore.* Austin: Texas Folklore Society, 1931.

CHAPTER 15

Adams, Paul. "The Unsolved Murder of Ben Thompson, Pistoleer Extraordinary." *Southwestern Historical Quarterly* (July 1954).

Bonnett, W.A. "King Fisher—a Noted Character." *Frontier Times* (July 1945).

Cox, Mike. *Texas Ranger Tales.* Plano: Republic of Texas Press, 1997.

Cude, Elton R. The *Wild and Free Dukedom of Bexar.* San Antonio, TX: Munguia Printers, 1978.

Evett, Alice. "The Fatal Corner." *San Antonio Monthly*, July 1982.

Fenley, Florence. "New Grave For King Fisher Recreates Interest in Former Deputy Sheriff." *Uvalde Leader News*, October 11, 1959.

Fisher, O.C. "The Life and Times of King Fisher." *Southwestern Historical Quarterly* 64, issue 2: 232–47.

Galley, Joseph. *From Alamo Plaza to Jack Harris's Saloon.* The Hague, Holland: Mouton & Co. N.V., 1970.

Gardner, Amanda. "King of the Road." *Texas Highways* (December 1998).

Gillette, J.B. "Ben Thompson and Billy Simms." *Frontier Times* (October 1934).

———. *Six Years With the Texas Rangers.* New Haven, CT: Yale University Press, 1925.

Gregory, A.H. "Death of Ben Thompson and King Fisher." *Frontier Times* (June 1928; August 1949).

Hunter, J. Marvin. "Ben Thompson—Killer of Men." *Frontier Times* (May 1939).

———. "Ben Thompson, Texas Gunfighter." *Frontier Times* (May 1948).

Hunter, J. Marvin, and Noah H. Rose. *Album of Gunfighters.* Bandera, TX: J.M. Hunter, 1951.

James, Vinton Lee. *Recollections of Early Days in San Antonio and West Texas.* San Antonio, TX: self-published, 1938.

Jennings, N.A. *A Texas Ranger.* New York: Scribners, 1899.

Lunsford, John R. "How Ben Thompson Died With His Boots On." *Frontier Times* (November 1931).

Metz, Leon Claire. *The Shooters.* New York: Berkley Books, 1976.

Nolen, Oran Warder. "Tom Sullivan, Frontier Darkey." *Frontier Times* 27 (November 1949). *San Antonio Express* article, reprinted.

O'Neal, Bill. *Encyclopedia of Western Gunfighters.* Norman: University of Oklahoma Press, 1979.

Ramsdell, Chas. *San Antonio.* Austin: University of Texas Press, 1959.

Senter, E.G. "Ben Thompson Wins a Tombstone." *Frontier Times* 2 (March 1925). Reprinted from *Houston Chronicle,* December 21, 1924.

Smyth, R.P. "Knew Ben Thompson." *Frontier Times* (July 1939).

Time-Life Books. *The Gamblers.* The Old West (Series). Alexandria, VA: Time-Life Books, 1978.

———. *The Gunfighters.* The Old West (Series). Alexandria, VA: Time-Life Books, 1974.

Travis, Edmonds. "Austin's Premier Gun Fighter." *Bunker's Monthly* 2 (September 1928).

White, Owen Payne. "Belligerent Ben." *Collier's* 80 (September 24, 1927).

CHAPTER 16

Adams, Paul. "The Unsolved Murder of Ben Thompson, Pistoleer Extraordinary." *The Southwestern Historical Quarterly* (July 1954).

Bonnett, W.A. "King Fisher—a Noted Character." *Frontier Times* (July 1945).

Cude, Elton R. *The Wild and Free Dukedom of Bexar.* San Antonio, TX: Munguia Printers, 1978.

Evett, Alice. "The Fatal Corner." *San Antonio Monthly,* July 1982.

Fenley, Florence. "New Grave For King Fisher Recreates Interest in Former Deputy Sheriff." *Uvalde Leader News,* October 11, 1959.

Fisher, O.C. "The Life and Times of King Fisher." *Southwestern Historical Quarterly* 64, issue 2: 232–47.

Gardner, Amanda. "King of the Road." *Texas Highways* (December 1998).

Gillette, J.B., Captain. *Six Years With the Texas Rangers.* New Haven, CT: Yale University Press, 1925.

Gregory, A.H. "Death of Ben Thompson and King Fisher." *Frontier Times* (June 1928; August 1949).

Hunter, J. Marvin. "Ben Thompson—Killer of Men." *Frontier Times* (May 1939).

———. "Ben Thompson, Texas Gunfighter." *Frontier Times* (May 1948).

Hunter, J. Marvin, and Noah H. Rose. *Album of Gunfighters*. Bandera, TX: J.M. Hunter, 1951.

James, Vinton Lee. *Recollections of Early Days in San Antonio and West Texas*. San Antonio, TX: self-published, 1938.

Lunsford, John R. "How Ben Thompson Died With His Boots On." *Frontier Times* (November 1931).

Senter, E.G. "Ben Thompson Wins a Tombstone." *Frontier Times* 2 (March 1925). Reprinted from *Houston Chronicle*, December 21, 1924.

Travis, Edmonds. "Austin's Premier Gun Fighter." *Bunker's Monthly* 2 (September 1928).

White, Owen Payne. "Belligerent Ben." *Collier's* 80 (September 24, 1927).

AFTERWORD

Bicknell, Tom. "Billy Simms: A Lover of Fair Play." *NOLA Quarterly* (July–September 2004).

Evett, Alice. "The Fatal Corner." *San Antonio Monthly*, July 1982.

Fenley, Florence. "New Grave For King Fisher Recreates Interest in Former Deputy Sheriff." *Uvalde Leader News*, October 11, 1959.

Fisher, O.C. "The Life and Times of King Fisher." *Southwestern Historical Quarterly* 64, issue 2: 232–47.

Galley, Joseph. "Ben Thompson and Billy Simms." *Frontier Times* (October 1934).

Gardner, Amanda. "King of the Road." *Texas Highways* (December 1998).

Gillette, J.B. "Ben Thompson and Billy Simms." *Frontier Times* (October 1934).

Gregory, A.H. "Death of Ben Thompson and King Fisher." *Frontier Times* (June 1928; August 1949).

Hunter, J. Marvin. "Ben Thompson—Killer of Men." *Frontier Times* (May 1939).

———. "Ben Thompson, Texas Gunfighter." *Frontier Times* (May 1948).

Lunsford, John R. "How Ben Thompson Died With His Boots On." *Frontier Times* (November 1931).

McKinney, T.H. "In Defense of King Fisher." *Frontier Times*.

White, Owen Payne. "Belligerent Ben." *Collier's* 80 (September 24, 1927).

Index

About the Author

G.R. Williamson lives in Kerrville, Texas, with his wife and trusty chihuahua Shooter. He spent his early years living in Crystal City, Texas, which is located twenty miles west of King Fisher's ranch in Dimmitt County. As a Boy Scout, he hunted for arrowheads on the land that once belonged to King Fisher, and he fished in the alligator waters of Espantosa Lake.

He has written many articles on Texas historical figures and events in Texas history. In addition, he has penned several western film screenplays that make their way to California from time to time. Currently he is at work on two nonfiction books—one on the last old-time Texas bank and train robber and the other on frontier gambling.

Visit us at
www.historypress.net